Producing Independent 2D Character Animation

he re on of hef

focal press visual effects & animation

Producing Independent 2D Character Animation

Making and Selling a Short Film

Mark Simon

with a Foreword by Linda Simensky
Senior Vice President, Original Animation, Cartoon Network

An Imprint of Elsevier Science
AMSTERDAM BOSTON LONDON NEW YORK OXFORD PARIS
SAN DIEGO SAN FRANCISCO SINGAPORE SYDNEY TOKYO

Focal Press is an imprint of Elsevier Science.

∞ Recognizing the importance of preserving what has been written, Elsevier Science prints its books on acid-free paper whenever possible.

Library of Congress Cataloging-in-Publication Data

Simon, Mark.
 Producing independent 2D character animation : making and selling a short film /
Mark Simon; with a foreword by Linda Simensky.
 p. cm.—(Focal Press visual effects and animation series)
 Includes bibliographical references and index.
 ISBN 0-240-80513-5 (pbk. : alk. paper)
 1. Animation (Cinematography). I. Title. II. Series.

 TR897.5 .S54 2003
 791.43'3—dc21

 2002033935

British Library Cataloguing-in-Publication Data
A catalogue record for this book is available from the British Library.

The publisher offers special discounts on bulk orders of this book.
For information, please contact:

Manager of Special Sales
Elsevier Science
200 Wheeler Road
Burlington, MA 01803
Tel: 781-313-4700
Fax: 781-313-4882

For information on all Focal Press publications available, contact our World Wide Web home page at:
http://www.focalpress.com

10 9 8 7 6 5 4 3 2 1

Printed in Italy

For years I have worked as smart and as hard as I thought possible. A few years ago I became a father to identical twin boys, Luke and Reece. I was suddenly hit with the urge to provide more for my family, not to mention hit with large bills. All of a sudden I was inspired to do more, faster. Reece and Luke, I dedicate this book, and its proceeds, to you.

I love you.

Dad

Contents

Foreword

When I was in high school, I took a course in filmmaking because I wanted to try animating. I had always loved watching animation, but I had absolutely no idea what was involved in actually animating a film. All I knew was that I'd be drawing a lot of drawings for 12 weeks, and at the end of the class, I'd show my film, and everyone would think it was hilarious. After those three months, I had made a fairly uninspired ten-second, never-quite-finished film that, I think, involved a rolling ball. The course ended, and so did my career as an animator. It was apparent to me at age 16 that the world did not need another mediocre animator. But who knows, maybe if a book like this on how to produce animation had been in our school library, I'd be an animator today.

Nevertheless, I continued to love animation. From the first time I saw a short, independent animated film, I was fascinated by the art form. In the college library, instead of studying, I often found myself in the animation section, looking at the few books they had on animation and old issues of *Funnyworld*. I was content to be a fan, and I never did try to animate again (unless you count the bouncing basketball in the corners of textbook pages.)

Fast forward to the present, and somehow, I have managed to end up working in animation—although not as an animator. Instead, I am a corporate cog. However, I am a corporate cog who helps animators make shorts and series and get them on Cartoon Network. I still think about making my own film, but I seem to stick to drawing on my notes at work. At least I know that now, if I needed a guide to making a film, it's out there.

If you have this book in your hands right now, there is a pretty good chance that you are thinking about making your own film. If you are feeling the urge to animate, do it. You should absolutely be making your own films. With advancements in technology, it is easier to make a film these days than it ever has been. Films are hard work, no doubt about that. You will put in long hours drawing thousands of drawings, each one only slightly different from the one before, and you will draw many of those drawings over and over until you get them perfect. But when you finish, you'll be a filmmaker! You'll have a film.

Once you screen your film in public, at a festival, or an ASIFA (International Association of Animators) open screening, people will suddenly recognize your name and know your drawing style. They'll think you're funny, or perhaps sensitive and deep. You'll be famous, and everyone will want to hang out with you. It's true. Development executives will casually come up to you at festivals, saying, "Hey, let's go grab a cup of coffee before the 4 P.M. screening." Furthermore, you'll join the community of independent animators who make their own films. This community is filled with people who love the art form, who are driven by the desire to see movement spring from inanimate objects—or perhaps they just want to hear animals talk.

If you make your own film, you will have a place in the pantheon of animation. And don't forget, the industry moves forward through the work of independent animators as much as it depends on animated features, television series, and technological advancements. Even more importantly, after making a film, you'll be a better animator. Once you've handled the entire process, you'll be better at being a member of an animation production crew, even if you have worked in animation for years. If you are just learning to animate, you won't have to wonder about the mysteries of animation, or spend years trying to figure them out.

Those mysteries are all explained here. Buy a couple of books on how to animate, and you'll have nearly every question answered. If you need more encouragement to get started, consider this: I've noticed that people, even students, who make their own animated films tend to be highly motivated, dedicated, ambitious, and most often successful. Now, who wouldn't want that? I'll bet that if I had this book in high school, I would have finished animating a film or two—and someone else would be writing this foreword. Maybe not. Either way, I suggest that you read this book, get to work, and do what Mark says—go make films.

Linda Simensky
Senior Vice President,
Original Animation,
Cartoon Network

Preface

Times have changed. Years ago I used to fill my home and office with hundreds of acetates, or cels, as they dried with different colors of expensive animation paint. Cels were expensive (Figure P-1). Paints were expensive. Cameras and stands were expensive. Film was expensive. Keeping the cels clean and free of fingerprints was a pain. Inking and painting was time-consuming. Doing an independent animated short meant giving up months of your life and every square inch of space you had available, even for the shortest of pieces. I was also limited in how many levels of cels I could stack under the camera, and limited animation was truly limited.

To paint on cels, you first had to ink the image onto the face of the cel. Then you had to turn over the cel and start painting, one color at a time, on the back (Figure P-2). Any mistake meant starting over on a new cel. To minimize fingerprints on the plastic, you had to wear cotton gloves the entire time. During shooting, all the layers of cels had to be stacked in a certain order. Even though the cels were very clear, they weren't perfect, and we couldn't stack more than five to seven layers (Figure P-3). Each layer also had to stay in the same position in the depth of the stack of cels or you would notice a slight shift in the colors on that layer.

Now, with the advent of fast computers, all of that has changed. Computers and animation software have made it easier, faster, and more efficient for independent filmmakers to produce their own animations. Each drawing is quickly and easily painted in the computer, and updating colors is as simple as a click of a button. Limited animation is now less limited—camera moves are easier, smoother, and faster. There is no limit to how many levels of drawings you can use, and changes no longer mean starting over. Animations can be adjusted and enhanced fairly easily at any stage of production.

Computer-generated (CG) animation is also flourishing. Effects, realism, and camera moves never before thought possible are being produced every day. Although this book mostly deals with producing hand-drawn animation, most of the chapters pertain to all forms of character animation, including cel, CG, claymation, and others.

Figure P-1 Shooting animation cels on a rigged stand—the old way of production.

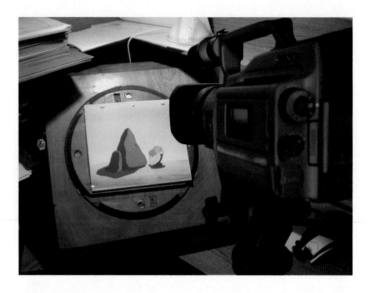

Figure P-2 Colors were painted, one at a time, on the back of clear acetates, or cels.

Rapidly falling prices of computers and equipment have made purchasing the tools for animation accessible to millions of people. Although professional-grade equipment can still cost quite a bit, you can purchase everything you need to get started and produce your own animation for just a few thousand dollars.

Years ago when I was first working with animation, constraints of space, time, money, and lack of great

Figure P-3 Six layers of cels; notice the brighter colors on the top layer on the right and how diluted the colors are on the bottom layer on the left.

equipment led me away from animation for a while and pushed me into live-action production. When I first discovered Macromedia Director and all the great animation it was capable of, I dove head first into the burgeoning world of digitally enhanced character cel animation. I quickly started getting more hardware and software components that allowed me to do even better animation. Since then I have launched two animation houses, produced numerous commercials and animated shorts, and won many animation awards using equipment accessible to most everyone.

One of the series of animated shorts I produce is called *Timmy's Lessons in Nature*. Timmy is a moron. He unwittingly demonstrates, through one disaster after another, basic wildlife survival rules. These shorts not only allow everyone in my studio to have fun, but they also act as calling cards for my company and the talents of everyone involved (Figure P-4).

This book follows every step of production for Lesson 3, the third episode in the series. Following the entire production of one animated episode should help those hoping to learn about the process of animation as well as those pros looking for some ideas to help make their process more efficient. The more you know about every step of animation production, the more valuable you are. You will be able to anticipate and avoid potential production problems. Plus, animating is also a lot of fun!

Figure P-4 Title card from *Timmy's Lessons in Nature.*

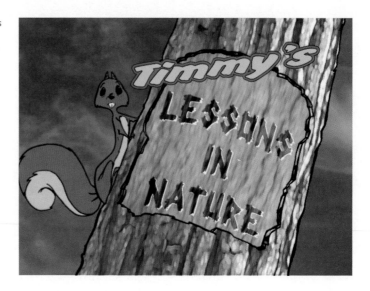

Big studios all work a little differently, but the general flow of production will be the same as the one shown here. There are also many specialized jobs on large projects that I won't discuss in this book. Smaller studios and individuals have the ability to move faster, and each person usually does more than one job. The steps outlined here will help you stay organized and complete an animation with (I hope) fewer headaches. You may skip a few steps in certain projects of your own, but understanding each step of the process is still important.

The hardware and software that we used for this episode will be noted in relevant chapters. At times, alternate software will be mentioned. Hardware will continue to improve in speed and ability at a phenomenal rate, but you don't need the newest and fastest computer to produce cel animation. Older systems than ours will still work, and newer systems will be out before this book hits print.

Lesson 3, on the enclosed CD-ROM, is a special edition, enhanced specifically for this book. The original episode had no dialogue. Since dialogue is an important part of most animations, we added one scene of a character speaking to illustrate easy ways of handling the recording and lip synching of your characters.

The CD-ROM included with this book includes the animatics and final animation of Lesson 3. It also includes demo

Figure P-5 Director Mark Simon amidst art, computers, and old pizza boxes.

versions of a number of different animation and audio software programs that are referred to in this text and that you can try out.

As you get inspired from this book and begin animating late into the night, try to start with some short projects. Far too many people try to produce huge films that take too long and too many resources to complete. It is much better to have a finished short project than an incomplete long one. Even just one minute of animation can take months of full-time work to complete.

A warning, however: Venturing forth into the world of animation is addictive. You may find yourself months from now buried in a pile of drawings and x-sheets, trying desperately to figure out the proper movement of SuperSlug. Bathing will drop to every other week, and the pizza delivery boxes will be stacked to the ceiling, all signs that you've joined the rest of us in the most exhilarating profession around—animation (Figure P-5).

Acknowledgments

A book like this doesn't happen alone. A lot of people spent a lot of their time and talent working on many parts of this book.

I want to thank T.J. for his talent and willingness to work with me on our *Timmy's Lessons in Nature* series; his designs and animation were a gift to work with. R.B., an amazing raw talent, added his phenomenal talent to some designs and other animated sequences. Roseann did great work on her opening scene.

We have outstanding layouts and backgrounds due to the talents of T.J., R.B., and background painter, J.P. Thank you all.

Tricks of the trade are never as useful if they're the result of only one person's work and experience. To those who responded to my request for their long-guarded and hard-won secrets and let me spill them to the world, thanks from all of us who will benefit.

To the crew at Sound"O"Rama, K.C. Ladnier, Kays Al-Atrakchi, and Steven Bak, you have been extremely generous with your time and talent in supporting our project development. I can't thank you enough. Your audio and music helps make our work come alive.

To the invisible names of those who reviewed this book in its infancy, your comments helped make this a much better book. You made me look at what I was putting together in a different way, and I thank you for that.

The software vendors have helped with answering my questions, sending sample software, and providing screen shots. Thank you, and I hope your inclusion in this book helps you too.

My assistants have kept me partially sane during the process of writing this book, running two companies, and producing numerous shorts. I want to thank Angela Barriga and Jeremy Tate for your help in transcribing the long and wonderful interviews and helping on the digital ink and paint on Timmy. Mostly I want to thank Karl Haglund for his tremendous support on training other assistants, keeping the computers running, having an eagle eye for things that needed to be fixed, and many, many other things. I should

also thank his wife, Gillian, for putting up with Karl's many long hours at the studio helping me.

To the crew at Focal, thanks. You have made this easy. My editor Amy Jollymore has been a delight and has raised the standards for other editors.

I'd also like to thank my parents. My mom, for having supported every crazy idea I had and making me believe I was the best. Now everyone else has to put up with my ravings about how it should be done. And my dad, for making sure that if I said things, I damn well better be able to back it up.

Of course the people I have to thank the most are my wife, Jeanne, and my kids, Luke and Reece. They have put up with innumerable nights of my working late to accomplish the huge to-do list I always give myself. Their love has given me the strength to get through it all.

Producing Independent 2D Character Animation

Section A
Before We Get Started

Chapter 1
Frame Rate

Film runs at 24 frames per second (fps), NTSC (National Television System Committee) video/TV (North America and Japan) runs at 30 fps, and PAL (phase alternate line) video/TV (Europe, Hong Kong, and Middle East) runs at 25 fps. So at what rate should you animate? There are two different answers.

Generally, you will want to animate at 24 fps. The basic reason is that 24 fps is 25% fewer frames than 30 fps to animate ($24 \times 1.25 = 30$). The fewer frames to animate helps your schedule and budget come in up to 25% lower than it would otherwise.

Even when your final output is to video, you will want to animate at 24 fps. At some point in your digital compositing or nonlinear editing, you will do a 3:2 pulldown, or telecine, of your animation, which converts your frame rate from 24 fps to 30 fps. You can only use telecine on your scene when exporting to a video file in a format such as AVI or MOV (Windows and Mac video file extensions). Exporting to frames does not allow you to telecine. The reason for this is that telecine uses the upper and lower fields of video to stretch the footage, and exporting frames does not incorporate fields. (In some programs you may set the Time Stretch to 125% or the Clip Speed to 80% [30/24 = 80] to create the same effect and still export to frames; see Figures 1-1 and 1-2.) When you convert from 24 to 30 fps, you won't see a difference in the look of your animation. If you think about it, all features, live and animated, are shot at 24 fps on film and are released on video at 30 fps, and you can't tell the difference.

Is there ever a time when you would animate at the more time- and effort-consuming 30 fps? When a project has live-action video footage on which you have to composite an animated character, you will need to animate over each frame to keep your character locked to the movement of each live-action frame (Figure 1-3). If you don't animate over every live-action frame, your animated character may slide around on the live-action background, and the effect of including the animated character as part of the frame won't work as well.

Animation is so time and budget consuming that you will want to save wherever you can. Whenever possible, animate at 24 fps.

Figure 1-1 Time Stretch window within After Effects.

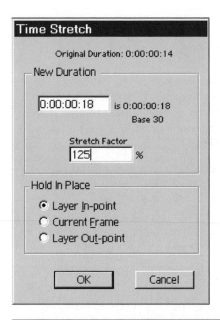

Figure 1-2 Clip Speed window in Premiere.

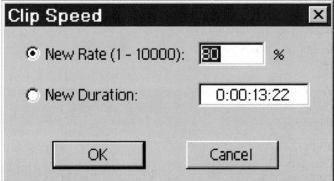

Figure 1-3 In order to track the characters onto the shot, we had to animate over each frame.

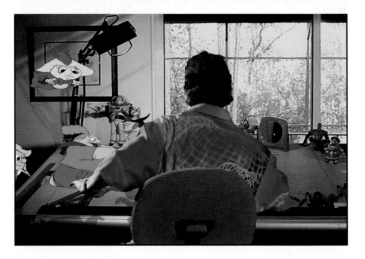

Chapter 2
Time versus Footage

Cel animation uses an antiquated system of measurement that needs to change with the times. Currently, most North American studios measure animation time and pay artists based on footage. Footage refers to one lineal foot of 35 mm motion picture film.

There are a number of problems with this method of measurement. The first problem is that animation is based on time, not physical length. Does anyone watching a cartoon really care how many feet their videotape is, or that there are more frames in a foot of 16 mm film than in 35 mm? Time is broken into seconds and frames. In every format of production, in every country, on every linear or nonlinear edit suite, seconds and frames are consistent.

When you are acting out and timing a scene, a stopwatch will tell you how many seconds the action took to complete. A finished half-hour show is 22.5 minutes long (the rest of the time is reserved for commercials and credits). The lineal length of a piece of film is not relevant to any of these measurements of time.

When editing video, time code is used to track time. Time code measures hours, minutes, seconds, and frames (Figure 2-1).

00;00;14;28

Figure 2-1 Time code.

The second problem with footage measurement is that many European studios measure in meters. One meter equals 3.2808 feet—not exactly an even standard to work in. Every time a translation calculation is made, there is the potential for a mistake.

Problem three is that there are 16 frames in each foot of 35 mm film, but there are 24 frames of film per second and 30 frames per second in video, and 16 frames does not directly relate to any standard of time. When a scene is $2\frac{1}{2}$ seconds long, it should be obvious to calculate the scene length as being 2 seconds plus 12 frames, or 60 frames total (when working in 24 fps of film). When you are animating on 2s (1 drawing for every 2 frames), that would require 30 drawn frames.

A fourth problem is that film is used less and less every day. The use of digital ink and paint or computer-generated

imagery requires no film at all during production, and digital standards use seconds and frames. Our standard of measurement should match our production process.

Problem five is that more and more animation mixes hand-drawn and computer-generated (CG) animation. CG measures time in seconds and frames. Cel and CG animation need to use the same method of calculating time when they share the same scenes. It does not make sense for some scenes to measure in frames and for others to measure in footage.

Finally, a sixth problem with measuring scenes by feet is that the dialogue audio to which we time our animation is recorded and edited in frames and seconds, not footage. The reasons for changing time measurement to seconds and frames could continue to add up, but the reasons for staying with footage are few and shallow.

The argument to move away from footage as a measurement is not new, but it has not gotten very far—yet. Gene Deitch, the great Oscar-winning animation director, has taken it upon himself to wean the industry from what he calls the Great Footage Fallacy. Deitch documents his reasoning for leaving footage behind in his book *How to Succeed in Animation*, which can be found online at the Animation World Network at www.AWN.com. I agree with Deitch that the time has come to move away from footage as a measurement. The argument that "that's the way we've always done it" does not hold any weight. If it was a reasonable argument we would never have moved from slide rules to computers, records to CDs, or carriages to cars.

Besides, footage was never a good idea to begin with. The entire entertainment industry works with minutes, seconds, and frames, and we should too. Any time we combine cel animation with live action or CG we need to use common measurements. The only logical measurement to use is the one prevalent in every other form of entertainment.

My studio works only in minutes, seconds, and frames. Many of our animators are used to working only in footage, but they have no difficulty making the transition to time measurement. Everybody already knows how to work in seconds and frames, so there is nothing new to learn. We have also revised the animation dope sheets we use (visual

SHOW:	Timmys Lessons in Nature			
SCENE	TITLE	CLIENT	SHEET	
1			1 OF 2	

START

Timmy's Eyes · Timmy

ANIMATION STARTS →

ACTION	FRAME	DIALOGUE	8	7	6	5	4	3	2	1	BIG	CAMERA INSTRUCTIONS
	1							X				
	2											
	3											
	4											
	5											
	6											
	7											
	8											
	9											
ANIMATION STARTS	10							10				
	1											
	2							12				
	3											
	4							14				
	5											
	6							16				
	7											
	8							18				
	9											
	20							20	20			
	1											
	2											
	3											
	4							24				
	5											
	6							26				
	7											
	8							28				
	9											
	30							20				
	1											
	2							X 32				
	3											
	4							34				
	5											
	6							36				
	7											
	8							38				
	9											
	40							40				
	1							42				
	2							42				
	3											
	4							44				
	5											
	6							46				
	7											
	8							48				
	9											
	50							50				

E:\Quatro File\Forms\dope sheet.wb3 designed by Animatics & Storyboards, Inc. Rev. 1/13/99

Figure 2-2 A&S Animation, Inc. dope sheet with 50 even frames and every 5th frame marked out. Dope sheet shown is from *Timmy's Lessons in Nature*, Lesson 3, Scene 1.

Footage Chart

Footage	Frames	Seconds
1	16	0.6666
2	32	1.33333
3	48	2
4	64	2.6666
5	80	3.33333
6	96	4
7	112	4.6666
8	128	5.33333

Frames to Footage Chart

Frames		Footage
1		0.0625
2		0.125
3		0.1875
4		0.25
5		0.3125
8		0.5
11		0.6875
16		1
24		1.5

Seconds/Frames Chart

Seconds	Frames	Total Frames
1	0	24
1	12	36
2	0	48
2	12	60
3	0	72
3	12	84
4	0	96
4	12	108

Figure 2-3 Chart comparing the simplicity of frames to the complexity of footage.

guides that place the proper drawing on the proper frame). Most industry dope sheets mark every 16th frame as a foot. We simply delineate every 5th frame so that the sheet is easy to read. Our dope sheet also has an even 50 frames, which makes the numbering of subsequent sheets easy (Figure 2-2). Deitch has a custom dope sheet that marks out every 24th frame to delineate seconds.

Although measuring in time is the better choice, those of you who work in or want to work in many other animation studios will need to know how to measure footage and know the conversions to and from the time and footage (Figure 2-3).

When you measure time in seconds and frames, once you know a scene is a certain number of seconds and frames long, that's all you need to know. No conversion necessary, and there are fewer chances for mistakes or confusion.

I urge all studios to complete the move to a digital world where we work in time. Production moves faster and more smoothly when the only measurement used is seconds and frames. No new training is needed for this method, and it works instantly with all other entertainment mediums and processes.

Figure 2-2 A&S Animation, Inc. dope sheet with 50 even frames and every 5th frame marked out. Dope sheet shown is from *Timmy's Lessons in Nature*, Lesson 3, Scene 1.

SHOW: TIMMY'S LESSONS IN NATURE

SCENE	TITLE	CLIENT	SHEET
1			1 OF 2

START

TIMMY'S EYES
TIMMY

ACTION	FRAME	DIALOGUE	8	7	6	5	4	3	2	1	B/G	CAMERA INSTRUCTIONS
	1							✕				
	2											
	3											
	4											
	5											
	6											
	7											
	8											
	9											
ANIMATION STARTS	10							10				
	1 1											
	1 2							12				
	1 3											
	1 4							14				
	1 5											
	1 6							16				
	1 7											
	1 8							18				
	1 9											
	20							20	20			
	2 1											
	2 2											
	2 3											
	2 4							24				
	2 5											
	2 6							26				
	2 7											
	2 8							28				
	2 9											
	30							20				
	3 1											
	3 2							✕ 32				
	3 3											
	3 4							34				
	3 5											
	3 6							36				
	3 7											
	3 8							38				
	3 9											
	40							40				
	4 1							42				
	4 2							42				
	4 3							44				
	4 4											
	4 5							46				
	4 6							46				
	4 7											
	4 8							48				
	4 9											
	50							50				

E:\Quattro File\Forms\Dope sheet.wb3 designed by Animatics & Storyboards, Inc. Rev. 1/13/99

Footage Chart

Footage	Frames	Seconds
1	16	0.6666
2	32	1.33333
3	48	2
4	64	2.6666
5	80	3.33333
6	96	4
7	112	4.6666
8	128	5.33333

Frames to Footage Chart

Frames		Footage
1		0.0625
2		0.125
3		0.1875
4		0.25
5		0.3125
8		0.5
11		0.6875
16		1
24		1.5

Seconds/Frames Chart

Seconds	Frames	Total Frames
1	0	24
1	12	36
2	0	48
2	12	60
3	0	72
3	12	84
4	0	96
4	12	108

Figure 2-3 Chart comparing the simplicity of frames to the complexity of footage.

guides that place the proper drawing on the proper frame). Most industry dope sheets mark every 16th frame as a foot. We simply delineate every 5th frame so that the sheet is easy to read. Our dope sheet also has an even 50 frames, which makes the numbering of subsequent sheets easy (Figure 2-2). Deitch has a custom dope sheet that marks out every 24th frame to delineate seconds.

Although measuring in time is the better choice, those of you who work in or want to work in many other animation studios will need to know how to measure footage and know the conversions to and from the time and footage (Figure 2-3).

When you measure time in seconds and frames, once you know a scene is a certain number of seconds and frames long, that's all you need to know. No conversion necessary, and there are fewer chances for mistakes or confusion.

I urge all studios to complete the move to a digital world where we work in time. Production moves faster and more smoothly when the only measurement used is seconds and frames. No new training is needed for this method, and it works instantly with all other entertainment mediums and processes.

Chapter 3
DPI versus Pixels

The DPI (dots per inch) fallacy that runs rampant through our industry is that images need to be scanned at 72 DPI for broadcast. DPI as a measurement alone has no relevance in broadcast resolution. Images of different sizes need to be scanned at different DPIs in order to achieve broadcast resolution.

An image on your TV screen is made up of a specific number of dots called pixels. No matter how big your TV is, they all show the same number of pixels. A 13-inch TV has 720 pixels across the screen and a 42-inch TV has 720 pixels across the screen. Broadcast resolution is based on the number of total pixels in each image. Some digital editing systems use different resolutions, such as NTSC at 640 pixels wide by 480 pixels high, or NTSC D1 at 720 by 486. High-definition television (HDTV) resolution is not only much higher at 1920 × 1080, but the image is also much wider, compared to its height, than standard broadcast TV. For the following examples we will concentrate on the dominant NTSC D1 television standard of 720 × 486 (Figure 3-1).

Scanner settings will vary depending on the size of each image. For example, if we take a printed or drawn image

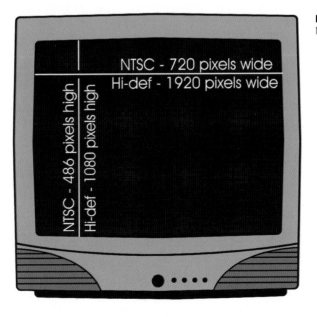

Figure 3-1 Screen resolution of NTSC and high-definition TV.

that is 4 inches by 3 inches and scan it at 72 DPI, it will be 288 pixels wide by 216 pixels high, which is not even close to broadcast resolution. We will need to scan that size image at 180 DPI for it to be 720 pixels wide. If we take an image that is 12 inches by 8.1 inches and scan it at 60 DPI, the resultant image will be 720 × 486 pixels.

On the flip side, if you export a frame from a video project, it will be 720 × 486 pixels. You can print that image as small or as large as you like. It doesn't matter how big or small you make it, it is still going to consist of 720 × 486 pixels. The larger you print the image the poorer the quality will seem, since there will be more room between the pixels, but it will always have exactly the same image information. If you print the image at 4 inches by 3 inches, the printed image quality will be equivalent to 180 DPI (720 pixels divided by 4 inches). Whereas if you print the same image at 8 inches by 6 inches, the printed image quality will be equivalent to 90 DPI (720 pixels divided by 8 inches).

So how do you determine how to scan your images to fit broadcast resolution? The easiest thing to do is use your scanning software to scan the image to the size you need, for example 720 × 486 pixels. Most commercial scanning software allows you to preview the final size of your image in a number of ways, including DPI, total inches, or total pixels (Figure 3-2). In your scanning software, select pixels and adjust your scan settings until the pixel settings match your desired size.

The chart in Figure 3-3 shows you the resolutions at which you need to scan, depending on the size of your art, so that the resultant image will be in broadcast resolution. Notice that a 12-field image will need to be scanned at 60 DPI and a smaller 8-field image will need to be scanned at 90 DPI in order for both to have a resolution of 720 × 486.

For compositing and animation purposes, the size of a television image is broken into fields. (These should not be confused with the upper and lower fields that represent how an image is projected on the screen of your TV.) The outer borders of the 12-field markings on a sheet of animation paper are 8.75 inches high by 12 inches wide (Figure 3-4). These 12 fields are broken into increasingly smaller units, down to 1 field. These 12 overlapping fields become increasingly smaller, down to the center field, 1 field wide, which is centered on the page and is .75 inches high by 1 inch wide. Breaking the image size into fields allows

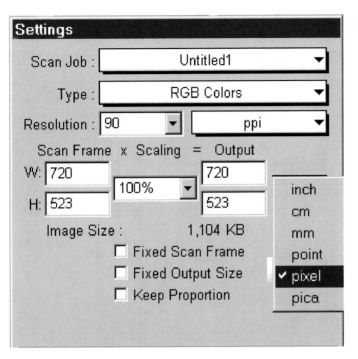

Figure 3-2 Set the Output sizing in your scanning software to pixels.

Figure 3-3 The charts shows scanner settings for images of different sizes to be scanned at broadcast resolution.

	Broadcast Scanner Settings						
	640 x 480 Frame				720 x 540 Frame		
Image	DPI		Pixels	Image	DPI		Pixels
12 x 9	54	648 x	486	12 x 9	60	720 x	540
11 x 8.25	59	649 x	487	11 x 8.25	66	726 x	545
10 x 7.5	64	640 x	480	10 x 7.5	72	720 x	540
9 x 6.75	72	648 x	486	9 x 6.75	80	720 x	540
8 x 6	80	640 x	480	8 x 6	90	720 x	540
7 x 5.25	92	644 x	483	7 x 5.25	103	721 x	541
6 x 4.5	107	642 x	482	6 x 4.5	120	720 x	540
5 x 3.75	128	640 x	480	5 x 3.75	144	720 x	540
4 x 3	160	640 x	480	4 x 3	180	720 x	540
3 x 2.25	214	642 x	482	3 x 2.25	240	720 x	540
2 x 1.5	320	640 x	480	2 x 1.5	360	720 x	540

animators, compositors, and camera operators to track how far to zoom in and pan over on an image. You can purchase pegged animation field guides from any animation supply source. (See Appendix 3 for animation supplies.)

Many animation software packages scan cel drawings at a much higher resolution than will be needed in a shot. When the software processes the scanned images, it converts the image resolution to allow for the field zoom (zooming in or out of a specified number of fields) you input. If you want to

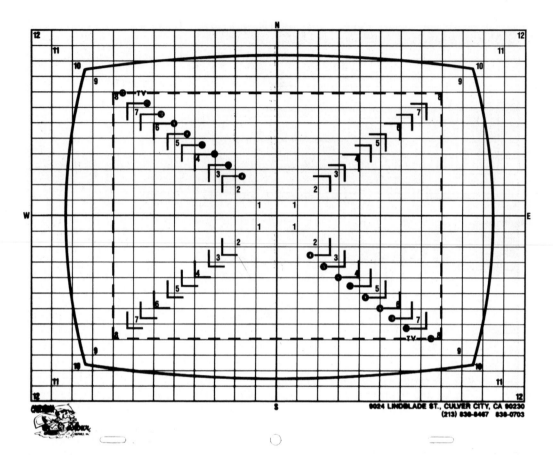

Figure 3-4 Field guide.

determine the size of the background or foreground image yourself, you will need to set the scan settings for your 12-field image so that the final image in your zoom is still broadcast resolution. Use Figure 3-5 as an example. Say you want to zoom in from a full 12-field image into an 8-field image. You will need to use the chart in Figure 3-6, go down to the line representing the size of an 8-field image, 8" wide × 5.8" high. Read across the line to see that the 12-field image will need to be scanned at 90 DPI for a total image size of 1088 × 784 pixels. The larger resolution is so that when you zoom in, the resultant 8-field image will consist of 720 × 486 pixels.

DPI alone has no relevance to broadcast resolution. Just as a digital photo does not rely on DPI but only total image pixels, so do all scanned images for video. Whether the original image is large or small, the only information that is important is that the scanned image should be at least 720 × 486 pixels to be considered broadcast resolution.

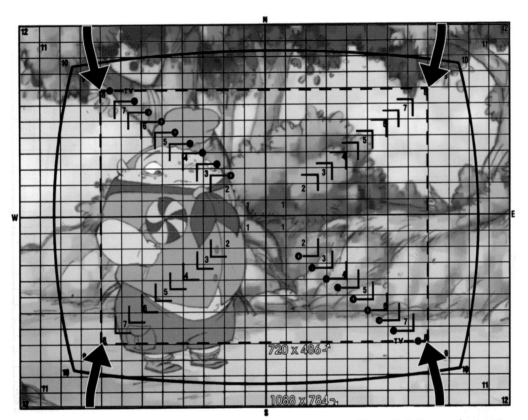

Figure 3-5 Zooming from a 12-field image to an 8-field image means that your 12-field image needs to be scanned at 1088 × 784 pixels. See Figure 3-6 for image sizes.

Size of 12 Field Scan for Zoom				
720 x 520 frame				
Zoom	**DPI**		**Pixels**	
12" x 8.75"	60	721	x	521
11" x 8"	66	786	x	566
10" x 7.25"	72	872	x	627
9" x 6.5"	80	967	x	697
8" x 5.8"	90	1088	x	784
7" x 5.1"	103	1246	x	897
6" x 4.33"	120	1452	x	1045
5" x 3.625"	144	1742	x	1254
4" x 2.9"	180	2178	x	1567
3" x 2.2"	240	2892	x	2081
2" x 1.45"	360	4332	x	3117

Figure 3-6 Scanning sizes for a 12-field image when zooming in to smaller fields.

Chapter 4
Scenes

Scene numbering is different in animation than it is in live action. In live action, a new scene number begins every time there is a shift in location or a shift in time. In cel animation you have a new scene number every time there is a cut, even if it's in the same room. In live action, once you are in a location you can turn the camera in any direction and shoot. In cel animation, every shot has a different background and is composited separately, so each shot is a scene unto itself.

Computer-generated animation (CG) breaks down scenes as in live action in some instances and as in cel animation in others. When an entire project is animated in CG, it is usually broken into scenes just as in a live-action project, since the camera setups are almost identical. If a project combines cel and CG, then all the scenes have to be numbered the way cel animations are numbered. This is necessary to keep all the numbering consistent.

Often times scenes need to be deleted or added after a numbering scheme has been set for a project. Once scenes have been numbered, they should not be changed. If prenumbered scenes were to have their numbers changed, the organization of the production would fail since different people would be working with differently numbered scenes.

The proper way to add scenes after they have been numbered is to letter them as A, B, C, and so on. For example, if you need to add a scene between scenes 7 and 8, the new scene would be "7A." Scenes 7 and 8 would keep the same scene number for consistency.

When scenes are deleted, it needs to remain clear during production that each of those scenes were intentionally deleted and are not just missing. On storyboards, always put in a blank or crossed-out frame with the deleted scene number and the note "Scene Deleted." Each drawing in a storyboard is considered one frame or panel. Every scene needs to be represented by at least one frame. Otherwise, crew members may keep looking for a scene that's no longer part of the project. Scripts should also have notes stating that specific scenes have been deleted.

Scene 5, panel 2

Scene 5, panel 3

Scene 6, panel 1

Scene 6, panel 2

Scene 6, panel 3

Scene 7, panel 1

The following storyboards from Lesson 3 in Figure 4-1 demonstrate scene breaks and frames per scene. This numbering is also helpful when we schedule who will animate which scene. For instance, even though the close-up of the fox is just a tighter shot than the wide shot preceding it, we had different animators on each scene, and each scene had its own number. Proper scene numbering helped keep us organized as to who was doing what on each scene.

Figure 4-1 Properly numbered scenes and frames from Lesson 3.

Chapter 5
File Organization

It is extremely important to set up an effective organization for saving files. This includes audio files, backgrounds, props, characters, and any other file you may need during production and post-production.

There are so many scenes and elements that go into an animated project that it is easy to lose track of where your files are. When there is more than one person involved, it is even harder to keep track. Once you have a proper system for saving your files, it becomes very clear where all your elements are. A good system also helps in backing up your projects. You will be less likely to misplace files if they are all grouped together.

Every project should have all of its files under one master directory. Refer to Figure 5-1 for an example. Our master directory for Lesson 3 is *Project, Ep 03*.

When naming scenes and projects, make sure you always number them with at least two or three numerals. Consistent numbering with the same number of numerals will keep your directories in the proper order. Notice in Figure 5-1 how all the scenes are in the correct order: *Scene 10* is shown directly after *Scene 09*. Now refer to Figure 5-2, where you will see *Scenes 1–9* numbered with only one numeral, as in *Scene 9*, and *Scene 10* with two numerals. Thus the computer inconsistently places *Scene 10* between *Scene 1* and *Scene 2*. You may find a need for more directories for your project, but this sample shows you the basics.

Under the master directory, you will have a series of subdirectories. Each subdirectory is then broken into more defined directories. For example, the *Audio* subdirectory is divided into *Edited Audio, Music, Raw Audio*, and *Sound Effects*. The *Raw Audio* directory is for your raw, or unedited, dialogue recordings, which may also be broken into directories for each scene. The *Edited Audio* directory is for the files that have been edited and cut to the length of each scene.

The Raw Audio files should be saved according to scene, actor, and take. A sample file name would be *Scene 01, Herbert, take 3, raw.wav*. This file naming structure specifies all the relevant information and makes the files easy to work with.

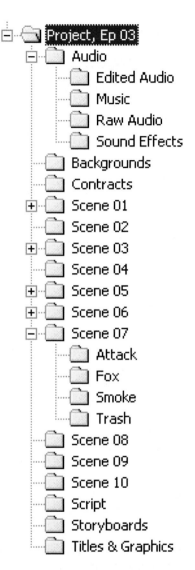

Figure 5-1 Proper file structure and many of the necessary directories to keep your production organized.

Each scene directory will have your ink and paint program files in them along with any composited files. If you composite multiple characters or objects in each scene, each item should then have its own subdirectory. In Figure 5-1, for example, if you refer to *Scene 7* from our sample short, Lesson 3, you will see directories for *Attack, Fox, Smoke,* and *Trash.* Each of these directories have the final sequential files that were composited as individual elements. Keeping elements organized in this way makes it easy to track them as needed for compositing each scene.

Figure 5-2 The scene numbers are improperly numbered and thus are arranged out of order.

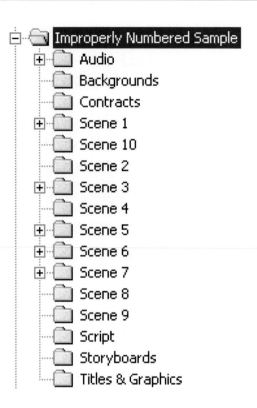

If you scan all your animation drawings and save them as files before you import them into your ink and paint software (which is necessary if your scanner is on a different computer than your ink and paint software), then you will need to add a *Scans* directory for each scene. Each scan should be numbered according to its first occurrence on your dope sheet, or according to the standards of your ink and paint software. A common practice is to name your files as *L1F001, L2F005*, etc. These file names stand for Level 1, Frame 1, and Level 2, Frame 5. Many software programs will automatically import these files into the proper position in your animation (Figure 5-3). The *Backgrounds* directory may either be placed as shown in Figure 5-1 or as a subdirectory within each scene. Since we tend to reuse backgrounds, I prefer to have one background directory, which allows me to keep them all in one place.

If you don't scan your boards, you may not need a *Storyboards* directory. We always scan our boards so we can use them to produce an animatic (a video storyboard for timing; see Chapter 18, "Animatics") of each project. Some

Figure 5-3 Proper cel numbering in the lower right corner of the pegged animation sheet.

artists are starting to draw their storyboards directly onto the computer with their graphics tablet, in which case they can simply save all their files to this directory.

The numbering of your storyboard panel scans should follow the same numbering system as written on your panels, such as: *Sc 01, panel 1.jpg; Sc 01, panel 2.jpg*, and so on.

Spend a little time organizing your project, and you will save a lot of time during production.

Chapter 6
Tricks of the Trade

Everyone learns or discovers some trick to help them in production. Some tricks are simple, and others are a bit more complex, but they all help us do our work. Following is a sample of decades of experience from many animators around the world.

DRAWING TOOLS

• For fine lines and small drawings, mechanical pencils maintain a fine line and don't need sharpening.

• When pencils get short, use an extender. They can be found at many art stores (Figure 6-1). The Koh-I-Noor Pencil Lengther is sold at www.DickBlick.com and many art supply stores. Any extender will extend the life of your pencils.

• You can also make your own extension by simply splitting the end of a small, stiff tube and inserting the back of your pencil into it.

• Use a spring pencil holder on your slanted desktop to keep your pencils where you want them (Figure 6-2).

• Install a switch on your animation stand that allows you to quickly switch between your top light and your back light (Figure 6-3).

• Peg bars can be taped to any surface. This allows you to animate anywhere and to quickly add inexpensive animation tables.

• Keep toys around for reference. Workout Barbie flexes just like a human and is much better reference for poses than the old "Woody" art store figures (Figure 6-4).

• Make your own maquettes from Sculpey or modeling clay. They will serve as great references when you're animating, and the process of sculpting often teaches you more about the shape of your character (Figure 6-5).

• Electric erasers are a godsend. Small battery-powered erasers with thin erasers work best on the soft leads. The Helix is a great little eraser, and it doesn't cost much. It can be found at some office supply stores (Figure 6-6).

• Nonstick tape. Use either drafting tape or regular tape with less tack (by pressing it against your pants a few times)

Figure 6-1 Pencil extender.

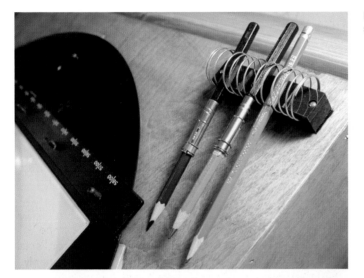

Figure 6-2 Spring pencil holder for slanted desk tops.

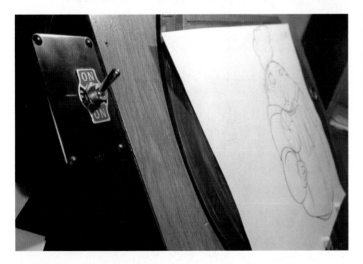

Figure 6-3 Three-way switch allows quick switching between top and bottom light. When the switch is up, the top light is on. When the switch is down, the bottom light is on. When the switch is in the middle, both lights are off.

to hold your drawings or tracing keys in other positions for inbetweens (see Chapters 22 and 28 for more information on keys and inbetweens).

• Desk lamps. Place your light on the opposite side of your drawing arm. For example, if you're right handed, place it on the left. This helps you avoid drawing in shadows all the time.

• Desk lamp bulbs. Use either a halogen or a combo of fluorescent and incandescent bulbs to simulate the color of natural daylight.

Figure 6-4 Reference figure of Workout Theresa (Barbie's friend) and the classic "Woody" poseable.

Figure 6-5 Maquettes that we sculpt in our studio to help us animate our characters.

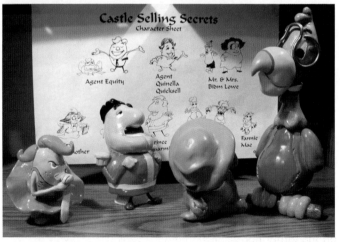

• Keep a small scrap of paper or fine sandpaper taped to your desk for rubbing your pencil tip on to keep it sharper.

STORYBOARDS

• Use more than one panel per scene or big action. Always show starting and ending action and any major key poses in between for each scene.

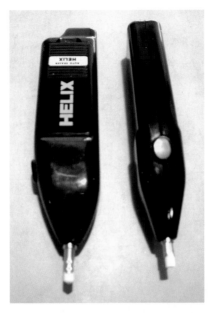

Figure 6-6 Cordless Helix eraser.

Figure 6-7 Tangents, as shown, draw the eye away from where it should be looking. Notice how your eye is drawn to the back of the character's head, where the structure looks as though it is attached. Also notice how the sun looks like a ball sitting on the horizon.

• Do quick, small thumbnails of sequences before you start on the larger boards. The smaller size is a quick way to work out your thoughts, and they usually allow you to be freer with your layouts. You may even want to do these thumbnails on the script as you read through it.

LAYOUTS

• Avoid tangents. Don't have the edge of a character line up with the edge of an object. Always use overlaps or gaps in your design (Figure 6-7).

Figure 6-8 The PC "Print Screen"
button acts as a screen capture.

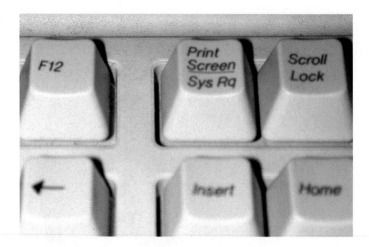

• Use negative space to guide the viewers eye to where you want it.

COMPUTERS

• Windows NT is not compatible with many newer sound programs and with the audio portions of ink and paint and compositing programs. Windows 2000, and newer versions, are much better with audio.

• The "Print Screen" button on your PC keyboard acts as a screen capture. Use your "Paste" command to paste the captured image into any program you wish (Figure 6-8).

ANIMATING

• Produce a quick animatic (see Chapter 18 for more information) for timing so you only animate what's necessary.

• Don't watch TV or listen to music while you animate. The more you concentrate on what you're doing, the faster you will improve and the better your animation will be.

• Start with short projects ranging from a few seconds to one minute long and complete them. Don't try animating 5 to 10 minutes for your first few samples—you may never get them done. Short and complete is good.

• Life drawing. Life drawing. Life drawing.

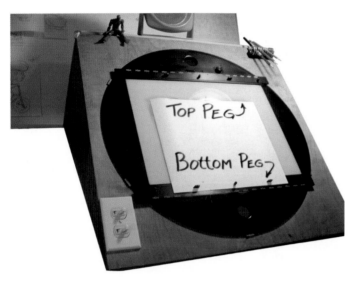

Figure 6-9 Peg bars.

• Do all of your extremes, extreme points of action (see Chapter 22), first. This allows you to plot the scene and keep your character consistent.

• Use the top peg bar (Figure 6-9) if you don't want your hand to lay on the bottom screws and bottom pegs while you're drawing. Use the bottom peg bar if you prefer to flip, flipping multiple sheets to see the motion (see Chapter 22), while animating.

• Allow yourself to think about a scene for a while before you start animating. Spend a little time thinking about the action, the motivation, the humor, the follow-throughs, and anything else that will enhance the scene.

• With digital compositing, it is now easier and more accurate to matte out, or remove, a portion of a character that goes behind a foreground object than it is to animate the cut line, the point where a character moves behind an object, where the character is blocked.

• Use mirrors on and around your desk. Mugging into a face mirror on your desk helps you with expressions (Figure 6-10), posing for a full-length mirror next to your desk helps for full-body shots, and holding the face mirror allows you to see your back in the full-length mirror. If you're adventurous, hang a mirror over your desk to see high-angle poses of yourself.

Figure 6-10 Use mirrors while
animating for reference.

Figure 6-11 Smoke animated with
black charcoal: the line color is
changed to white then blurred for
the effect.

- A great way to animate smoke is to use chalk on black
paper, scan the image, remove the black using the screen
mode in paint or compositing programs, and blur the
image. You can also use charcoal on white, use "multiply"
on the image (a command that removes white in most
compositing programs; it's also automatic in most ink and
paint programs), change the line color to white, and then
take it out of focus (Figure 6-11). There is an animated
sample of this process on the included CD-ROM in the
Sample Movies directory.

- Animation always works best when it does what live
action can't do.

Figure 6-12 Flipping the art down to quickly shoot each frame.

• Run pencil tests while you are working on a scene. Pencil tests are quick videos of your animation drawings.

• The quickest way to run pencil tests is to place all the art on the peg bar with the first frame on the bottom, then flip each drawing down after the previous one is shot. This is much quicker than individually placing each drawing down for each frame. Another version of quick pencil tests is to place all your art in reverse order, with the first frame on top, and pull each sheet off for the next frame. This version also keeps your arm out of the light (Figure 6-12).

• Stretch a rubber band over the pegs of your peg bar to hold your paper down. This is especially helpful when flipping your art (Figure 6-13).

• For complicated 3D models that are animated by hand, paint a model of the item white, draw thick black lines along the edge and creases, and photograph the model against a white background (Figure 6-14). Shoot a photo for every frame of action, as if you're doing stop motion animation. The images can then be used as art and painted like your other drawn images. Of course, with computer animation, it's easier and faster to do complicated models in CG.

Figure 6-13 A rubber band holds the art on your peg bar as you flip.

Figure 6-14 Model of a truck painted white and outlined in black. When shot frame by frame against white, it can be painted like hand-drawn cels.

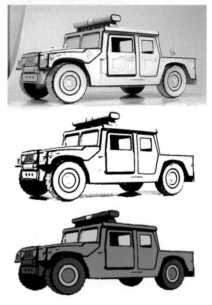

• Research not only the look of objects, but their motions and reactions too. Many great ideas came from the Disney artists who went to China for *Mulan* and to Africa for *The Lion King*.

• To create the strongest impact when a character hits another object, have the character stretch out and just touch the surface on the frame immediately before making full

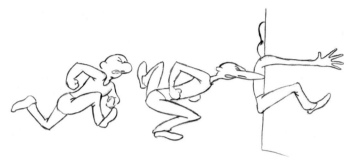

Figure 6-15 Stretch a character to just touch a surface prior to full contact. Kudos to Richard Williams for revealing this technique in his wonderful book, *The Animator's Survival Kit*.

contact. The same tip applies to walks: have the heel touch before the rest of the foot flattens out on the ground (Figure 6-15).

• Realistic moves are visually boring in animation. Very exaggerated moves look good, and extremely exaggerated moves look great.

• Inbetweening. When you mark on the paper where the inbetweens, the drawings that are in between the keys, need to go, you can lift your current drawing off the peg bar and position it over a previous frame to accurately draw your character. Make sure you put the art back on the peg when you are done and flip the art to ensure that the drawings line up properly.

• Vary your timing. Use a combination of slow moves and fast moves to keep your work visually interesting.

• When animating dialogue, hard consonants, such as a *k* or a *p*, should be held for at least two frames or they won't be seen by the viewer.

• Make a back light for your camera stand when shooting pencil tests that consist of more than one level of animation (each piece of paper is one level). A top light works best for one level of animation, but a bottom light works best for multiple layers (Figure 6-16).

ANIMATION DRAWINGS

• Don't color in the shadows on the final clean-up art. The shading will show up in the scans.

• Use a red pencil for shadow lines. They will still scan black, but then they can also be used as a reference by the digital ink and paint crew to indicate which lines are the shadow lines (Figure 6-17).

Figure 6-16 Top light is used in a pencil test for one level of testing. Use a bottom light when testing multiple levels of animation.

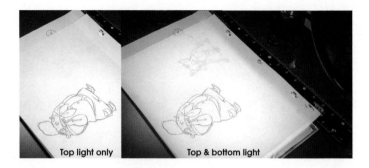

Top light only Top & bottom light

Figure 6-17 The red line on the original art acts as the shadow line. Notice in the colored cel how the red line has been colored to match the shadow.

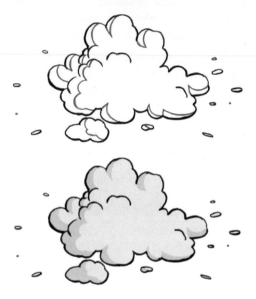

• When you do the final clean up over blue-line roughs (rough animation using a blue-line pencil) on the same sheet, rub down (erase to make the lines lighter) the blue lines first so they don't show on the scan.

• Use peg hole reinforcements, much like binder paper hole reinforcements, but sized and shaped to fit over peg-bar pegs, when the paper holes start to get loose.

• To mark areas that should not be colored or filled in, place a light blue "X" (so the scanner won't pick it up) to let the digital ink and paint crew know not to fill that area.

BACKGROUNDS

• Scan your rough layouts and paint the background in your computer, using the scan as a guide.

• Paint foreground items in your backgrounds as separate elements or layers to speed up compositing characters behind those elements.

ORGANIZATION

• You can't be too organized. Use forms and track everything in writing. The more information you can track during production, the easier it is to make adjustments.

• Each printed scene folder should track your ink and paint software input and output settings, frame size, scene length, dope sheet, storyboard, and production notes.

• Number your animation drawings according to the frame number in which that drawing first appears. This makes dope sheets easier to read, compositing simpler, numbering added drawings easier, and compositing multiple levels of art simpler.

SCANNING

• Save scanner software settings, such as DPI, contrast, position, etc. This allows you to rescan portions of scenes without having to start over, and all the drawings will stay registered.

• If you have a peg bar taped to your scanner, mark its exact placement in case you need to remove and replace it.

• Many scanners have a black back on their lid. Tape a piece of white paper over it or the black will show through your semitransparent animation paper.

• Autofeed scanners may cost a lot, but they save a tremendous amount of time (Figure 6-18).

• Scan your animation and your backgrounds larger than you need to allow room to zoom in or reframe your scene as needed.

INK AND PAINT

• Paint with one color through an entire scene, then pick another color and go through the scene again. This is much faster than painting every color on every frame as you go because you don't have to change colors and tools as often.

Figure 6-18 Fujitsu M3096GX
Autofeed scanner.

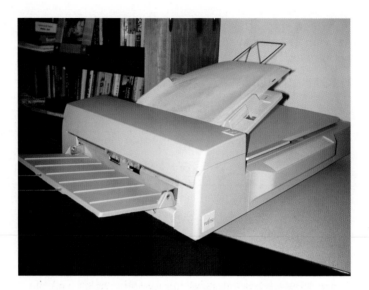

• Every object in your drawings needs to have its own palette position, even if many of them are the same RGB (red, green blue—the color channels used in computers) value. If you ever need to change the color of an object, you will only need to change that single RGB value of that palette position, and the object will be automatically updated in your ink and paint software. For example, if you use the same palette position for white socks and for the whites of eyes, and then you want to change the color of the socks to red, you would either end up with red eyes too, or you would have to repaint all the socks in the entire scene.

• Refer to the original art when digitally filling areas, adding shadow colors, and erasing stray marks. Instructional markings (in light blue) on the original art will help you paint everything correctly.

• When scanning charcoal or pastel drawn cels, use a mounted peg bar on your scanner. Do *not* use an autofeed or ADF (automatic document feeder), because the rollers on the autofeed will smear the art.

• Mark down the RGB values of each palette position on a sheet in case you have to rebuild a palette (Figure 6-19).

• A quick way to save your palette for reference is to do a screen capture of your open palette. On PCs, simply press the "Print Screen" keyboard key to save the image.

PROJECT: *LESSONS IN NATURE*

CHARACTER: *FOX*

SCENE:

	line color	face fur	Ear tip	Tongue	white of eyes	right eye	teeth	inside mouth				
Fox head {	58 25 138	196 3 41	97 63 23	153 2 32	248 252 235	166 168 25	250 252 235	46 39 40				
white	mouth fur 251 252 203	inside ear 223 224 160	nose 41 33 35	left eye 211 165 60	inside right eye 246 255 0	gums 236 145 175						
Body underside	251 252 203	fur 196 3 41	feet 97 63 23	paw pads 0 0 0	tip of tail 97 63 23							
Foam	220 220 220											

Figure 6-19 Palette reference sheet for the fox in Lesson 3.

Open your image editor, Photoshop or Photopaint, and paste the image and save the file (Figure 6-20).

• Do an autofill of one color for the entire scene. Pick the color that has the highest number of places to fill on the character, then go through and fill in the other colors individually.

AUDIO

• When you are using an inexpensive microphone, use two windshields on it to cut down on excessive noise and pops.

• Digitally remove all background noise from your recordings so that all the audio elements will edit together better (Figure 6-21).

• Casting and recording really funny voices can inspire better animation.

• Videotape recording sessions to get motion references from the voice actors. Actors tend to move a lot when doing their sessions, and their expressions and movements can be very helpful and inspiring.

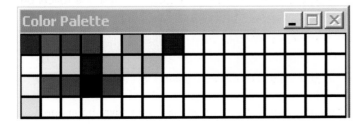

Figure 6-20 Reference image of the fox's palette captured from Digicel and saved.

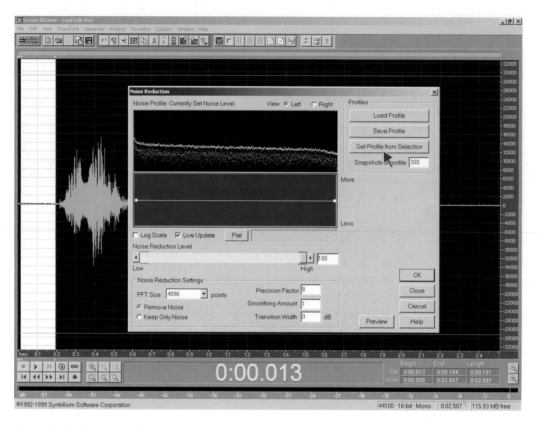

Figure 6-21 Removing audio noise using Cool Edit Pro. Grab a selection from the audio that should be silent, get the noise reduction profile from the selection, and then apply that profile to the entire file. Any background noise in that profile will be removed.

• Lip sync. When using Magpie to break down your audio, make sure you set the frame count to start with frame 1, not the default of frame 0. If you do not start the file with frame 1, your sync will be off by one frame.

• When you are developing character voices, think of an animal or a person who is like your character.

• Actors should not drink cold water before a session; it changes the way they sound. They should drink only room temperature water.

• When an actor has a stuffy nose, honey and lemon in warm water helps break up the phlegm.

• The Internet offers a number of free sound effects. The sites constantly change, so do a search for "free sound effects."

• Record rehearsals. You will often get better readings when the actors don't think they are being recorded.

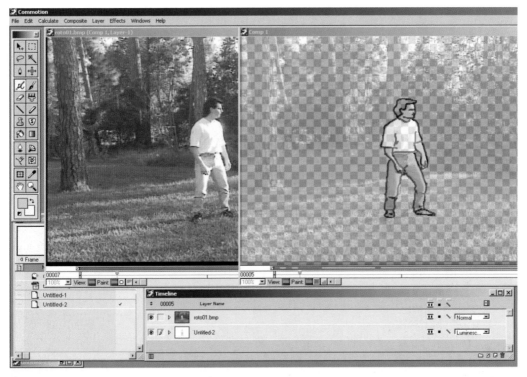

- Show the actors your storyboards so that they have an idea of what their characters are doing.

- The sound effects of a hit or a pop should happen one frame after the visual of the hit, not on the same frame, for a greater impact.

- Don't give your actors a line reading, acting out a line for an actor. Most take offense at having their lines read to them.

- Smiling while delivering a line makes it sound happier; frowning will make you sound more sad.

Figure 6-22 Rotoscope sample using live-action footage in Commotion Pro.

ROTOSCOPING

Rotoscoping means animating over live action (see Chapter 23).

- Have your character be as large in frame as possible when you are shooting reference. Characters that are small in frame have too little detail to be much help.

- Make sure your reference character colors stand out against the background.

• Use a progressive scan video camera when possible. Progressive scan records full frames rather than normal video cameras, which reduce every frame into two fields, each of which only has half of the interlaced video frame. This eliminates the issue of fields and in effect doubles the resolution you have to work with.

• Have the shutter speed set very fast so your subject does not blur when moving fast (Figure 6-22). Clear subjects are easier to animate over.

Chapter 7
Supplies, Hardware, and Software

Animation hardware consists of desks, pencils, paper, peg bars, computers, and more. Before we can scan or capture our animation art into the computer we need to have the right drawing equipment. It doesn't have to be fancy, it just has to work.

Beginning animators always ask the same questions—as do some pros looking for new tools and approaches: What pencils should I use? What paper is best? And what type of animation disc should I buy?

The most common blue pencil that animators use is the Col-erase blue by Sanford. You can order these by the dozen from art stores and animation supply houses. You can also get the red Col-erase pencils to use for your shadow lines (see Chapter 29, "Clean-Ups"). Few animations use ink for the final clean-up since most animation is now scanned and not painted on cels. It is best to use a soft lead for clean-up, 2B or softer, so that you have a nice black line that the scanner can easily read. Sanford also makes a 2B pencil called Turquoise that is very popular. Some artists prefer the 6B or an Ebony pencil, which are both extremely soft lead pencils. The one problem with especially soft leads is that they tend to smear a lot. For very detailed scenes, some artists use a 2B lead in a mechanical pencil. One benefit of this choice is that the mechanical lead always stays the same width and does not need sharpening.

Electric erasers are also extremely helpful. I've found that the ones with small erasers work the best on the soft leads we use. The Helix is a very good battery-operated eraser (Figure 7-1).

There are just a few different types of animation paper. Some are thinner, and others are sturdier. The thin paper (16#) allows you to see through more layers, but the thick (24# or the premium Ingram paper) holds up better with heavy erasing. We use a combination of both. We use the thin paper for rough animation and the thicker, more expensive paper for clean-up. You should use just one style of paper through an entire scene, however, so your line quality does not change.

Figure 7-1 Cordless Helix eraser.

Unpunched animation paper (no peg holes) is less expensive than punched paper, but the Acme Standard peg hole punch is quite expensive. Unless you use a tremendous amount of paper, unpunched paper is not a bargain.

Animation discs, the plexi-backed rotating discs with peg bars for holding your paper while you animate, are not cheap, but you may find a good price on E-bay. They can cost over $300 each new. You can find a selection of discs at the animation supply houses and on their Websites listed in Appendix 3, "Supplies." (See Figure 7-2.) You can also simply tape a peg bar onto a light table and animate just fine. Plastic peg bars cost only $3 to $4 and metal ones cost $12 to $36.

You can also build an animation disc. I built an animation disc and table when I was in high school that my studio still uses (see Figure 7-3). The biggest benefit is that the disc is quite light-weight and spins easily. People who are handy with tools can build their own. See Figure 7-4 for general disc measurements.

There was a time when I was working in Los Angeles without my disc. To get by with what was available, I taped a peg bar to a glass table. When I put a lamp under the table, I had a working animation stand. If cost is an issue, you can easily get around it.

Figure 7-2 Aluminum animation disc in a custom desk.

Figure 7-3 Homemade animation disc and table.

Whether you buy or build an animation stand, it is handy to have a switch on the side that switches between the top light and the back light. Radio Shack has plenty of three-way switches that have two "On" positions and an "Off" position in the middle. The top "On" position can be for your top light and the bottom "On" position can be for your bottom, or back, light (Figure 7-5).

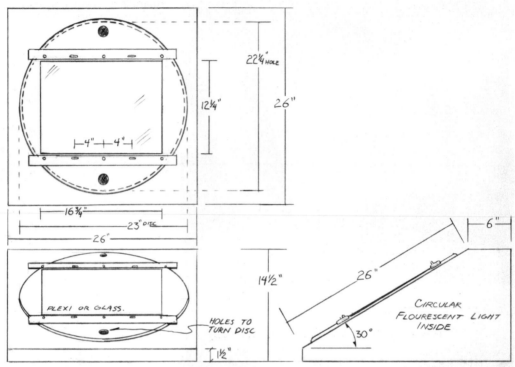

Figure 7-4 Design of animation disc and table. Measurements can vary as long as the glass is large enough to cover the 12-field area.

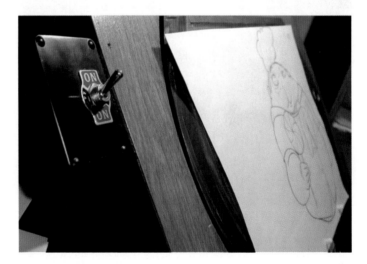

Figure 7-5 Top light/bottom light switch on animation desk.

Pencil tests can be shot with any video or computer camera. (See Figure 7-6.) To run pencil tests you can use the capture mode of your nonlinear edit suite, capture video or scan images into a number of digital ink and paint programs, or

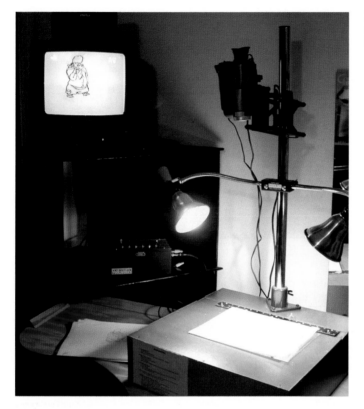

Figure 7-6 Custom-built pencil test stand using the original Video Lunchbox.

use the Video Lunchbox Sync to capture images frame-by-frame. (See Appendix 3, "Supplies.") For more information on pencil tests, refer to Chapter 25, "Pencil Tests."

Computers constantly get faster and software is getting increasingly more sophisticated. The most basic computer systems being sold these days are capable of producing animation. The faster the computer, including processor speed, bus speed, RAM, video card, and other accessories, the faster you will be able to process your images and the less time you will spend waiting. Each software program has different hardware needs, so check on those you are interested in to determine what your system may need.

All of the software packages mentioned in this book and included on the accompanying CD-ROM run on the PC platform, and some will also work on a Mac. Check Appendix 4, "Software," for a listing of which software works on which operating system. You will find that there

Figure 7-7 Photo of two computer systems in the A&S Animation, Inc. studio. All computers in the studio run Windows 2000.

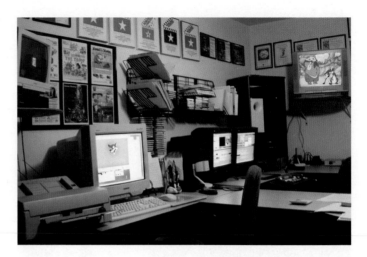

are more choices for animation and production software for the PC than there are for the Mac.

The hardware we used for *Timmy's Lessons in Nature* included a DAT recorder; a dual P4 1.7 Ghz PC with 1.5 GB RAM running a Targa 3000 video card; a dual Pentium 400 PC with 512 MB RAM and a Targa 2000 video card; a Pentium 600 with 256 MB RAM and a 32 MB video card; a standard PC microphone; a high-speed Fujitsu oversized scanner with a document feeder; a 12 × 17 color scanner; and a video camera and the Video Lunchbox for pencil tests. Of course, all the original art was drawn by hand using light boxes and animation peg bars. (See Figure 7-7.)

We use a combination of software applications for each step of production. This book will detail examples from a number of available software packages for each relevant step of production. There are other programs available that will do an equally good job, but we concentrated on those that we have had good experiences with and that are affordable for independent animators.

Chapter 8
Production Crew

Crew sizes on independent projects tend to stay quite small. The benefit of being small is having more control over every aspect of your production. The problem with being small is that you are responsible for doing almost every aspect of your production, which is almost always bigger and more time-consuming than you anticipate.

As productions get bigger, the different aspects of production are split between more people of different skills in order to spread the burden as well as get the job done more quickly. Every production house deals with animation job titles and duties a little differently, but in any case we should discuss the basic roles in an animation production.

Every production starts with a **producer**. The producer is the person responsible for everything, and often holds the overall creative vision. The term **executive producer** is used for the person who funds the project, created the project, or oversees the project for the funding studio.

The **production manager** sets up the production systems and oversees who is working and when. The **production coordinator** handles all the details for the production manager and schedules all the individuals. The **production assistants** help every area of production to allow the crew to do their jobs and not get bogged down in time-consuming duties.

There may be more than one **director**. Many feature-length animations split directorial duties between two people. Generally, one director will deal with the acting portion of the movie, while the other deals with the artistic and technical aspects of the movie. Many animated television series will have a dialogue director and a separate animation director. In *Timmy's Lessons in Nature*, T.J. directed the look of the animation while I directed the story, timing, and audio.

Although the best movies usually have just one writer, television series will have a **head writer**, or **story editor**, and there will be a number of staff and freelance writers who write the different episodes. The story editor makes sure that the writing and characters stay consistent and does the final rewrites on each episode.

Figure 8-1 The figurative producer dragging crew members into a production.

The **talent** is recorded and the dialogue is edited. At times the dialogue is recorded prior to storyboarding, which helps the **storyboard artists**. At other times, the recording sessions happen after boarding, and the actors refer to the boards as inspiration for their acting.

When storyboarding starts, there is a **storyboard supervisor** who oversees the different episodic storyboard artists. He will give notes and make changes on the storyboards to make sure they properly tell the story, stay in character, and are ready for production. There may also be **story sketchers**, or **rough board artists**, and **clean-up artists**. Storyboard artists are also called **story artists**.

The **sheet timers** will do the slugging, determining how much time must be left between the dialogue segments for the action shown in the boards. Then the dialogue is edited together with the proper timing.

Art directors design the characters and the look of the project. They will oversee the design of the backgrounds, the color palettes, and the props. There may also be **conceptual illustrators** whose drawings inspire the look of the project.

Once the storyboards are ready, the **layout department** finalizes the line art of the backgrounds, designs the camera moves, plots the field guides, and makes the workbook. The workbook is a shot-by-shot detail of how the camera moves over each scene. (Of course, these days it's a digital camera within a computer.)

As the layouts are completed, they go to the **background department** where they are painted and readied for the animators to animate over.

Supervising animators manage the other lead animators and make sure that their characters are consistent

Figure 8-2 An overly-enthusiastic producer running his crew.

in movement and look. **Lead animators** often oversee minor characters that need only one animator. Animators work under supervisors and do the rough animation for the characters.

Effects animators animate everything that is not the characters, like water, snow, props, and shadows.

Rough inbetweeners handle the inbetweens for all the animators and lead animators.

Clean-up is headed up by the lead who oversees the **key assists** and makes sure the characters are on model. Characters are "on model" when they look exactly as they do on the character model sheets. The key assists tie down the rest of the rough animation. The **breakdown artists** handle the animation shown on the charts, and the inbetweeners finish the rest of the drawings between the keys and the breakdowns.

The **checkers** go over the final animation to make sure that the lines are closed, the drawings are properly numbered, and the art is ready to be digitized.

The **scanners** digitize the cleaned up animation and the **ink and painters** fill in all the proper colors.

The **compositors** take all the backgrounds, characters, props, and effects and seamlessly blend them together with the proper camera moves. The **editor** takes all the composited scenes and dialogue and edits them together in the proper sequence, timing the edits such that the story flows with just the right timing. The **sound designer** builds and adds the sound effects and balances the music, voice, and effects so that all are easily heard and understood.

Obviously there are many more potential roles in an animation production, but this should help you understand many of the main positions.

Section B
Pre-Production

Chapter 9
The In-House Pitch

You've done the easy part: you have decided to animate a short film or video on your own. Now what? You need a story, a concept, something—anything—to draw.

The pitch is a short description of an idea that will excite people and make them want to see the finished piece. You can pitch your concepts to other people until you come up with something that others seem generally interested in, or you can listen to pitches from other people whose ideas you trust. The pitch is also what you will use to get others interested in helping you complete your animation. The more excited you can get other people to be about your idea, the more people will want to help.

When you pitch ideas to other people, the idea is to come up with an idea that is worth producing. The story should be solid. There should be a reason for it. Even if you are only doing a short scene to show what you can do, have a purpose for that scene. Keep working and reworking your concept until it's as good as you can get it. Of course, you also should keep in mind the realities of actually getting something done and not just endlessly developing it.

The pitch for *Timmy's Lessons in Nature* originally came from an incredibly talented animator I work with, T.J. He had a concept about a kid who's always bringing different animals home for a children's book he was writing called *Can I Keep It?* T.J. had some great sketches of this weird-looking kid who kept bringing snakes and skunks into his mom's house (Figure 9-1).

I thought the character looked great, and I liked the idea of animals, but I wanted the idea to work as a series of quick, stand-alone shorts that wouldn't need dialogue. Having no dialogue allows the shorts to be viewed and understood around the world. We sat around and brainstormed ideas about how to make this weird-looking kid into a series of shorts. At first we were thinking of calling it *Life's Lessons*, where this kid showed us how not to do basic things (Figure 9-2).

The idea was starting to come together, but it still wasn't quite there as a solid series concept. I asked Jeanne Pappas Simon, a seasoned producer from Nickelodeon and the

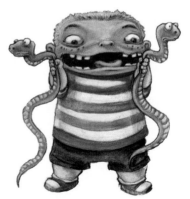

Figure 9-1 The original inspirational sketch that developed into Timmy.

Figure 9-2 Early sketch of an opening title card before we had the title of the show.

Figure 9-3 Rough sketch of what later became our main show title card in the episodes.

Cartoon Network, to sit down with us and work out how these lessons could be structured into a series of shorts. *Life's Lessons* soon turned into *Lessons in Nature*, and we decided to deal only with creatures out in nature, never in a home or in a city. An animator helping out on the series, R.B., suggested that we make the title more personal with Timmy's name. We all agreed, and we ended up with *Timmy's Lessons in Nature* (Figure 9-3).

We built the structure into a very simple series of elements that would be consistent throughout the series. After the

Figure 9-4 Lesson 3 title card.

Figure 9-5 Text card that teaches an obvious lesson to all but our moronic hero.

opening credits we would show Timmy in action approaching an animal. We would then cut to a card that would identify the lesson number—Lesson 3 in our sample (Figure 9-4).

We would then see Timmy do some incredibly stupid thing, and each animal would quickly exact its revenge. The next card would come up quickly with the lesson title—"Avoid Rabid Animals" in the case of Lesson 3 (Figure 9-5). We

would then cut back to Timmy and the animal for a quick wrap-up gag. With all the episodes built this way, they would work very well as a series, and they would be short, about one minute long, and funny.

Here is the pitch for *Timmy's Lessons in Nature:*

> Timmy is a moron. He unwittingly demonstrates, with one disaster after another, basic wildlife survival rules.

The episode pitch we worked from on Lesson 3 went something like this:

> Timmy walks up to a rabid fox that is foaming at the mouth. He tosses his candy bar at the fox and the fox attacks him.

Once we agreed that this premise was the next episode to animate, we worked out the details to make it fit our series design and to make it as funny as possible.

Chapter 10
Character Design

Before storyboarding, we need to know what the character looks like. We will, however, often work on both storyboarding and design at the same time as we determine what we want the character to look like. We then finalize the storyboards with the approved character design.

Character design normally starts with a series—or huge pile—of sketches until a specific look starts to develop that works for the character. It may take dozens, or hundreds, of drawings to work out the subtleties of a character (Figure 10-1). We will often work from silhouettes to come up with a

Figure 10-1 Many of the early sketches of Timmy.

Figure 10-2 Expression sheet for Timmy.

general form for our character. Remember, characters are seldom alone, and they need to work with other characters. The combination of character shapes should be interesting. Animated motion tests may also help determine the look of a character.

Once a drawing of a character is approved, you will start working out expressions. Expressions are drawings of a character expressing different emotional behaviors, such as crying, laughing, yelling, being sneaky, and many others. Capturing the proper expressions for a character is important, but finding expressions that a character would never have can be equally important (Figure 10-2).

Phonemes, or the different mouth shapes needed for each sound, will also need to be designed. Different styles of animation often draw mouth shapes in different ways. Each character needs a defined set of mouth positions so that it

will be consistent (Figure 10-3). Anime, the Japanese visual style of animation, characters often just have three or four mouth positions, but the average number of mouth shapes in animation is eight. Excitable and cartoony (not realistic) characters may have many more mouth positions than that.

The turn-around (Figure 10-4) is one of the most important parts of the character design. It shows the character from every angle and finalizes all details to and maintain a consistent look for the character as he moves.

If you have more than one animator working on a character, it is also important to do constructions. Constructions break a character down into simple shapes to help speed up rough animation and, again, to help maintain the consistent look of the character (Figure 10-5).

The final step in character design is color. Color design needs to work on the character as well as with the other characters and the backgrounds. When the script calls for dark shots, there will also be a set of night colors for each character. Timmy's final design and colors may be seen in Figure 10-6.

Elements to watch for in character design include not only the ones that enhance or hurt the look of the character, but also those that affect the animation process. Small details may be too hard to animate. Details such as shaggy fur,

Figure 10-3 Examples of different shaped mouths.

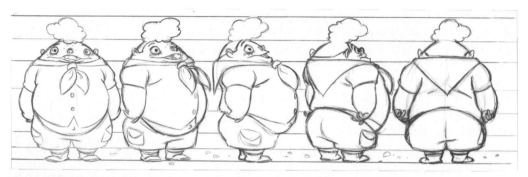

Figure 10-4 Timmy turn-around.

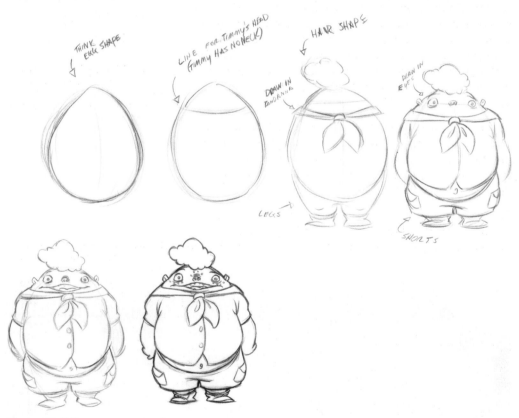

Figure 10-5 Timmy construction sheet.

spots and speckles, scales, and fabric designs may look great in sketches, but animators have to be able to duplicate such details in a timely and accurate manner. Loose clothing may have to have a lot of animated follow-through. High-budget animation makes good use of flowing cloth and hair, but low-budget animation needs to stay away from too much secondary animated motion because it increases the number of drawings that must be done.

Character design tends to evolve during a long story process. In our case, Timmy looked a little different in the first lesson we animated. In Figure 10-7 you will see how the first incarnation of Timmy evolved. As we started Lesson 3, T.J. said he wanted Timmy to look goofier.

To help develop Timmy's look, we sketched him doing things such as grabbing porcupines, fishing with his mouth, getting stomped by a moose, and other weird actions. Seeing characters in action often helps develop their look—not only what they need to be able to do, but also how they need to look when they do it. In our case, Timmy needs to look like a moron who doesn't understand consequences (Figures 10-8, 10-9, and 10-10).

As T.J. was giving Timmy taller hair and working out other character specifics, we were further developing the character. We decided that Timmy should be in the Boy Rangers, a less-than-successful version of the Boy Scouts. That led us to put Timmy in an ill-fitting uniform.

T.J. designed Timmy to be somewhat easy to animate. The overall shape is blobish. Timmy's shirt is tight to his stomach to keep his body one consistent shape. Since Timmy has no

Figure 10-6 Final Timmy design and final colors. The ink and paint palette was developed using these colors. Even the line color is part of the design.

Figure 10-7 Evolution of Timmy. Timmy in Lesson 1 and Lesson 3, respectively.

Figure 10-8 Timmy sucking on a porcupine.

Figure 10-9 Timmy goes fishing.

neck, sketching in his body shape in rough animation is fairly quick. (See Figure 10-11.)

Tying down and cleaning up the animation, however, takes longer with the new design than with the older design, as seen in Figure 10-7. The buttons, pant pockets, and neck scarf have a lot more detail, but we decided to keep them since they help Timmy's character—and they're funny.

Timmy now has hair that bobs as he walks, he's lost any semblance he had to a neck, and we let his stomach hang out of his shirt.

Normally, we would also do a series of phonemes for each character, but since Timmy doesn't talk, he doesn't need them. We only have one short scene of a nonreturning fox talking, which one animator did alone, so we didn't need phonemes for him either.

As mentioned earlier, phonemes are the different mouth shapes needed for each sound. For instance, a simple set of phonemes for the phrase "Polish Vampire" might look like those found in Figure 10-12.

Figure 10-10 Timmy gets friendly with a moose.

Figure 10-11 Final Timmy design.

Figure 10-12 Generic phonemes that sound out the phrase, "Polish Vampire."

Figure 10-13 Phonemes for the rabid fox saying "ranger dude." Notice how an animal's phonemes are often shaped completely different from those of a human character.

Here you can see some of the actual mouth shapes, or phonemes, we used for the fox when he says "ranger dude" (Figure 10-13).

Since characters usually have more than one facial expression, we need to have a sampling of various expressions. A sheet of expressions guides our animators in how Timmy reacts to things so that he will look consistent throughout the animation process. As we went through the expressions, we revised how they should look and tossed out the ones that didn't seem to fit his character. In Figure 10-14 you can see one sketch of Timmy screaming. This is an example of an expression he will never have. He's too stupid to know he's getting hurt, and if he did react to pain he would probably learn a lesson. Timmy never learns, so we decided never to show him reacting to pain (Figure 10-14).

Even if you are animating alone, it is beneficial to go through these steps. It helps you define your character and work out exactly how he or she should look and act before you start animating. Drawing and seeing the character from all angles will greatly increase the speed you can animate as well as keeping your character looking consistent throughout.

Figure 10-14 Timmy is not smart enough to know he's in pain, so this is an expression that he will never have.

Chapter 11
Story and Storyboards

Back in the golden era of cartoon animation, there were no scripts, just directors storyboarding their ideas. They would come up with a basic story in a bull session and then storyboard the action. Good physical gags can't be written, only drawn. Gags are made funny by the expressions of the characters and the actions they go through, not necessarily by written descriptions. Dramatic scenes and situational humor, on the other hand, are best when scripted first.

It is up to you to determine what best suits the needs of your project—writing a full script and then storyboarding, or doing the storyboards straight from a concept. If you are working for a client, always start with a script. At my company, A&S Animation, we work both ways on different projects.

If you script your story ideas, make sure that you write your scripts in the proper script format. Even if no one but you sees the script, it will be good practice for when you need to show a client or potential employer that you know what you're doing. There are plenty of great books that explain script formatting.

When you storyboard an animated project, make sure you board out all key motions and the beginning and ending of each action, not just one drawing per scene. These storyboards will function as a reference for all your key animation. Notice in the following samples, in which Timmy walks up to and past the camera, bobbing his head side to side, that we use a number of frames to show how he moves. This is also true for when Timmy throws the candy at the fox. There are hundreds of ways a character could throw something, but we needed Timmy to look like he was just tossing his candy without any malicious intent. To save time and money, it was important for us to work out the proper action in storyboards rather than in animation. (See Figure 11-1.)

Storyboards should never be drawn on the art supply store pads that have black around the panels or that have rounded corners. The black keeps you from drawing outside the image or from making notes. Rounded corners are generally frowned upon because rectangular boards are much easier to crop. The art supply store pads are also not the right size paper.

Figure 11-1 We used multiple panels to show Timmy walking up to and past the camera. One drawing would not have accurately shown the action.

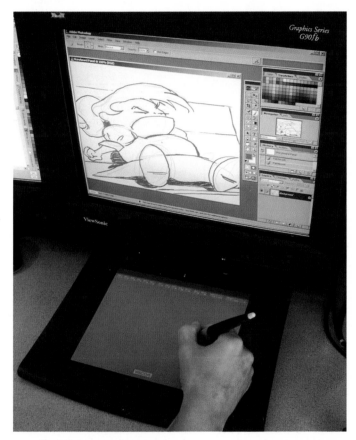

Figure 11-2 Drawing storyboards straight onto the computer. Notice the light grey lines that were used as a rough layout and the darker lines for a quick final. The light lines can be drawn on a separate layer and removed when saving the file.

Storyboard sheets should be letter or legal size ($8\frac{1}{2}'' \times 11''$ or $8\frac{1}{2}'' \times 14''$) for ease of copying and storing. Some artists are starting to draw storyboards straight onto their computer using a graphics tablet. With some practice, this can work very well. One benefit of drawing on the computer is the time it saves when you need to produce an animatic. Since editing programs need digitized art to edit with, having the art digital to start with saves the step of scanning (Figure 11-2). To speed the process even more, make your storyboard canvas 720 pixels by 480 pixels (720×540 if your editing software uses

Project: Timmy's Lessons In Nature, Lesson 3

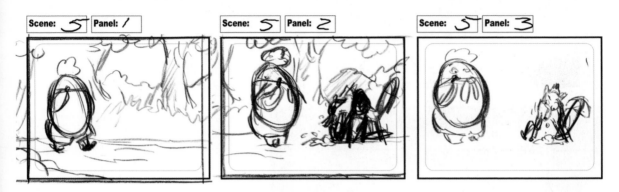

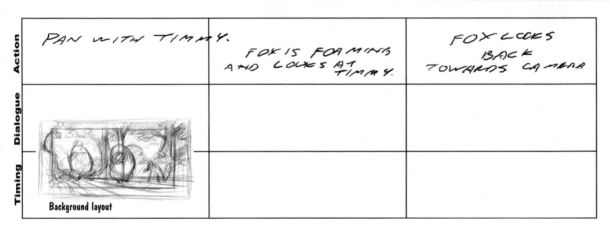

Figure 11-3 A page of storyboards with the layout taped on the bottom for reference.

nonsquare pixels). This size will import into almost any editing or compositing program. One of the upsides to using the computer is that when you need to make small adjustments to only one part of the frame, you don't have to redraw the rest. There are downsides to drawing on the computer as well. You can't write notes on your boards, nor can others who are looking at your work; it takes longer to make simple copies; and the artwork is generally not as good or as fast as hand-drawn work.

Storyboards are often translated into layouts that provide the background design and position of the characters. Very tight storyboards, clean and well-rendered, are sometimes blown up and used as the layouts for a scene. At other times, layouts are provided for the storyboard artists. When layouts are provided, they will often be pasted below the storyboard panels as a reference for both the storyboard artist and production (Figure 11-3).

Figure 11-4 *Storyboards: Motion in Art*, 2nd Edition (published by Focal Press).

Props are sometimes designed first, and the drawings of them are given to the storyboard artist. At other times the storyboard artist does all the designs. Creating layouts and prop designs while boarding takes longer and makes it harder for the artist to concentrate completely on proper story flow. It is best to supply the artist with as much reference and design as possible.

The main reason for storyboarding is to preplan and enhance the story. Don't be overly concerned with the quality of the art. Concentrate on determining the proper shots to help the story flow. There are hundreds of elements that make up a great storyboard, far too many for this book. For all the details you may refer to my book, *Storyboards: Motion in Art* (Figure 11-4).

Here are the top 25 elements that help make a great storyboard.

Figure 11-5 Close-up of
character. Normally head and
shoulders or a bit tighter.

1. Varied shots. Make some shots wide, others close.

2. Building tension. Show the audience what the characters don't see. Cut to a bomb counting down. Show shadowy figures in the background.

3. Use Close-ups (CUs). Draw the viewer into the action (Figure 11-5).

4. Establishing shots. Give your viewers an overview of who is where to help them follow the action.

5. Cut-aways. Shots of a character's fingers twitching, or trophies on a wall can say more about a character than lengthy dialogue.

6. Extreme Close-ups. An extremely close shot of a character's eye, mouth or finger will help enforce the urgency in what is happening (Figure 11-6).

7. Point of View shots (POV). Show the audience what your character sees from the character's view point.

8. Motivate your shots. For instance, in order to have a POV, you need to first show the character looking toward something, which motivates a cut to their POV (Figure 11-7).

9. Over the Shoulder shots (OTS). This draws the viewer into the action and makes a scene more intimate (Figure 11-8).

10. Use as many drawings as necessary to show the action.

11. Canted frames (Dutch angles). These disorient the viewer (Figure 11-9).

Figure 11-6 Extreme close-up. The shaking finger of the character tells the audience he's not sure about what he's doing.

Figure 11-7 The shot of the character looking up motivates the next shot of his POV.

Figure 11-8 Over the shoulder shot.

Figure 11-9 Canted frame.

Figure 11-10 Labeling arrows makes the action perfectly clear.

12. Zoom in or out. Never do both in the same shot. Zooming in draws more attention to the main subject, and zooming out either reveals the situation a character is in or emphasizes how alone they are.

13. Proper numbering. The boards need to make sense to production and help keep everyone organized.

14. Proper use of arrows. Whether the camera or an object is moving should be very clear. The easiest way is to label the arrows so there is no confusion (Figure 11-10).

Figure 11-11 Notice how the tangent points make his feet look like he's walking on the edge of the frame. The focus of our vision is also drawn to his hand tangent to the side of the frame.

15. Don't allow tangents. Don't have any part of a character tangent, or adjacent to, the edge of the frame, it gives the impression that the edge of the frame is a wall or the floor (Figure 11-11).

16. Use movement. Move the camera, actors, or objects around to prevent the scenes from being too static.

17. Move the camera to follow or lead a character. This draws the viewer into the scene.

18. Have an object fly out at or drop toward the camera. This makes viewers feel as if they are in jeopardy (Figure 11-12).

19. Don't cross the line (of action). The rule is that once you establish a character looking or moving right to left or left to right, he needs to keep looking in that direction in each connected scene. If we see him change the direction he's looking, or the camera moves to a straight-on shot as a neutral angle, then a change in direction can follow. (This rule is much like a televised sporting event in which all the camera angles show one teams' goal to the same side of the screen, which makes the action easier to follow.)

20. Use big action. Animation is almost always more interesting when the action is much bigger than reality. Scenes never play quite as big as they seem when you design them, so go for the gusto.

Figure 11-12 Rocks dropping toward the camera make the viewer feel in jeopardy.

Figure 11-13 The man looking through the binoculars motivates the POV silhouette shot from inside the binoculars.

21. Design visual balance into each frame. Don't just center characters, always allow more room in front of them than behind them in the frame. Use foreground and background elements for asymmetrical balance.

22. Use the silhouette of an object that a character is looking through for an interesting POV, such as looking though binoculars (Figure 11-13).

23. Exaggerate. Do things that can't be done in live action. That's why we animate.

24. Show funny or exaggerated expressions. The artist is the actor in animation.

25. Act out the action. Going through the motions yourself often stimulates ideas of how to move the characters (Figure 11-14).

For *Timmy's Lessons in Nature*, which is completely gag-oriented and has no dialogue, we work mainly with

Figure 11-14 Co-director/ producer Mark Simon acting out Timmy's action when he gets attacked—or perhaps he was just told the actual budget of the animation he's financing.

storyboards and not written scripts. In the special edition of Lesson 3, completed for this book, we added one line of dialogue in order to demonstrate how to lip sync.

EXT FOREST—DAY

CU fox as he turns and looks at Timmy.

Fox

I need a hit, ranger dude.

Wide shot as fox continues to shake, shiver, and foam while Timmy stares, blankly.

The premise of Lesson 3 is that Timmy meets up with a rabid fox who attacks him. Each episode has two main visual gags, the second being a follow-up of the first. Here, we needed to design two gags involving the fox attacking

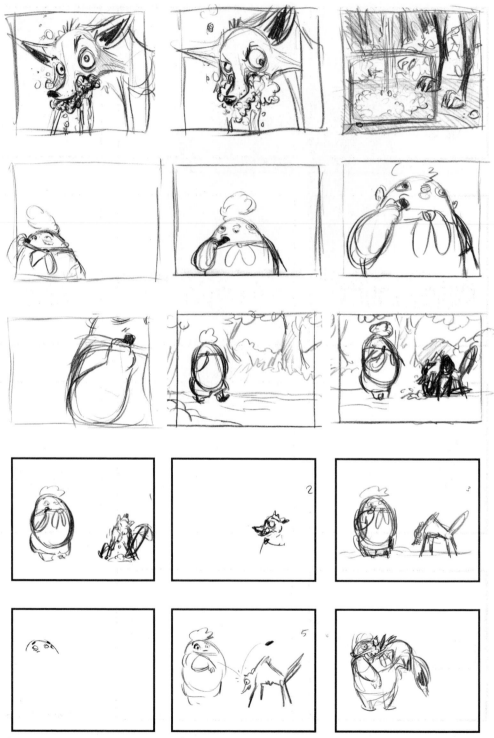

Figure 11-15 The first set of storyboards for *Timmy's Lessons in Nature*, Lesson 3. These boards were quickly sketched out during a meeting and were used to finish developing the short. The rough quality of the boards helps show the energy in the action.

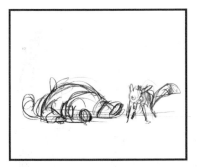 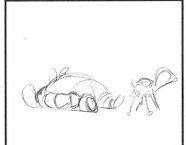 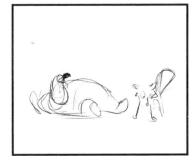

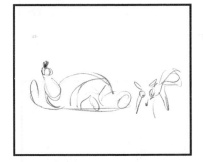

Figure 11-16

Timmy, and Timmy had to instigate the attacks without appearing malicious.

Our story had to follow the rules we set up for Timmy and the series. Timmy can't be mean; he can't understand what is about to happen to him; he can't understand what just happened to him; and he pretty much just can't understand. We always need to introduce Timmy first, and then the animal. Then we cut to the Lesson number text card followed by the first gag. We quickly cut to a text of the lesson learned and cut back to the follow-up gag. We also have to make it funny, and the second gag has to be funnier than the first gag. These rules keep Timmy consistent as a character, ties the shorts together as a series, and allows the audience to anticipate Timmy's next move.

In the first set of boards T.J. drew and presented to me (Figures 11-15 and 11-16), you will see how we started with a shot of the foaming rabid fox, then cut to a shot of the foam hitting the ground. Then we cut to a shot of Timmy walking past the camera eating a candy bar. We follow Timmy in a wide pan as he walks up to the fox, pauses, and then tosses the candy bar at the fox. The fox viciously attacks Timmy. (At this point in the board presentation I was thinking, "OK, it's funny, but not hysterical.") While Timmy is lying on the ground moments later, he pulls another candy bar from his pocket, and again throws it at the fox. (I laughed out loud at this follow-up gag. Timmy doing the same dumb-ass thing two times in a row sold me.)

These boards are quite rough and were sketched out quickly for our own approval to move forward in production. Rough as they are, the boards show a great deal of energy and accurate action. Since we were going to do all the animation in our studio, we didn't need the boards to be perfectly on-character (looking exactly like the character), as is needed for boards that go overseas for animation.

Animation production often goes overseas for budgetary reasons. Storyboards that are sent overseas for animation have to be much more clear than in-house boards. Many overseas animators speak English as a second language, if at all, so the visuals of the boards are the only guidance they have. They use any boards they receive as exact blueprints. If you sketch a character wearing the wrong outfit, the animators may animate them in the wrong outfit.

If a character is tangent to the edge of the frame in the boards, don't assume that an overseas animator will adjust the framing; he probably won't. This is not a problem with the animators; they are simply following exactly what they have been given to animate.

Once we agreed on the story for Lesson 3, we quickly started making notes as to where the title cards would go in this sequence and how we could enhance some of the shots. While we worked on finalizing the boards and the gags, we used these boards to start breaking down who would animate the different sequences.

Chapter 12

Budget

Before you get too deep into production, you need to know what costs you're likely to run into, even when you are working on a project alone. When you produce animation for a client, you obviously need to create a budget to ensure, among other things, that you pay yourself and make a profit. When you produce an independent project, you should make sure that you are prepared for all the expenses.

It is very easy to underestimate, for example, the number of paper copies you will make, how much animation paper will be used, or even how long different people will work on any section of a project. Budgeting properly is an ability that comes with experience in the area of production. Simply preparing budgets does not make you better at it. Tracking a budget during production and comparing it to your estimated budget, on the other hand, will help you understand actual costs. The more accurate you are in tracking all costs, the better off you will be on each subsequent production.

As far as personnel goes, each position on a project will have different pay rates depending on the type of project and the skill of the person involved. A lead animator with many years of experience deserves a higher rate than a lead animator who's been given the position for the first time. An experienced producer deserves to be paid more because he should be able to prevent problems and overages more than an inexperienced one. The only way to know the range of rates is to ask people what they get paid and what they pay others.

The type and length of project makes a difference to the budget as well. Commercials generally pay a higher cost per drawing or a higher day rate for personnel than films and TV series. The main reason for this is the length of the projects. Since commercials are very short, they are likely to create more downtime between projects for the artists who work on them. The shorter the project is, the higher the day rate. The higher day rate balances out the greater number of down days. On a bigger project, the lower rate is compensated for by a consistent paycheck over a longer period of time and with fewer down days.

When you are selling a project, you need to know all of your costs in order to make a profit. When you pitch and sell projects, one of the main questions you will be asked is, "What is the budget?" You need to be prepared with an answer regarding both your hard costs, such as equipment, rent, supplies, and the cost to hire the proper personnel.

Budget forms help to speed up this process and to ensure that no potential expenses were missed. By going over each line of a prebuilt budget, you will be reminded of all the possible costs.

The following blank forms belong to a custom-made version of a budget we use on our animations. You may fill all the blanks in by hand, or build a similar spreadsheet in Microsoft Excel or Corel Quattro Pro. When you use a spreadsheet program, you can have all the numbers automatically totaled as you work. You may also buy a prebuilt budgeting program from Screenplay Systems Inc. Movie Magic Builder. The form for animation is called Animation Budget Builder and is much like the one shown here. Movie Magic has a number of built-in advantages. It has been customized for ease of use within our industry, and it is the main budgeting software for the entertainment industry. You may find it online at www.MovieMagicProducer.com or www.CreativePlanet.com.

When it comes to taxes, each state has different tax rates for employees. Consult with an accountant to determine your withholding, benefits, and taxes when dealing with crew rates. (See Figure 12-1.)

A&S Animation Budget Form

Production Title:

Date:

Salesman:

Client:
Contact:
Address:

Phone:
Fax:

Project Description:

Specs:

See attached assumptions

Final Length

Schedule	Date		Date
Script		Final Pencil Test	
Final boards		Color Test	
Rough Pencil Test		Final Delivery	

Story & Script Development

Description	Number	# Unit	Unit	Amount	Estimate	Actuals
Prep			wk			
Option Fees						
Rights Payments						
Bonuses						
Royalties						
Writer(s) - Script Fees						
Writer(s) - Bible Fees						
Story Editor						
Script Coordinator						
Secretary						
Consultants						
Research and Reference Materials						
Script Copy Fees						
Clearance Fees						
Title Registration Fees						
Copyright Fees						
Writer Travel and Accomodation						
Fringe Benefits						
Total Story & Script Development						

Producer's Unit

Description	Number	# Unit	Unit	Amount	Estimate	Actuals
Executive Producer			wk			
Producer			wk			
Co-Producer			wk			
Line Producer			wk			
Associate Producer			wk			
Producer's Assistant			wk			
Producer Travel and Accomodations						
Entertainment						
Fringe Benefits						
Consultant Accomodations			mo			
Total Producer's Unit						

Director's Unit

Description	Number	# Unit	Unit	Amount	Estimate	Actuals
Director Mark Simon, No extra fee			wk			
Supervising Director			wk			
Sequence/Episode Director			wk			
Assistant Director			wk			
Director's Assistant			wk			
Director Travel & Accomodations						
Entertainment						
Fringe Benefits						
Total Director's Unit						

Figure 12-1 Animation budget form developed in Corel Quattro Pro. Each category and the total are automatically summed as new numbers are entered.

Casting & Recording

Description	Number	# Unit	Unit	Amount	Estimate	Actuals
Principal Cast						
Supporting Cast						
Casting Director						
Dialogue Director						
Welfare Worker/ Teacher						
Vocal Coach						
Casting Coordinator/Assistant						
Studio Costs						
Editing						
Stock & Transfers						
ADR Recording						
Loop Group						
Working Meals						
Mileage/Parking						
Travel & Accomodations						
Cast Exams						
Fringe Benefits						
Total Casting & Recording						

Total Above The Line

Production Staff

Description	Number	# Unit	Unit	Amount	Estimate	Actuals
Production Manager			wk			
Production Supervisor						
Assistant Production Manager						
Production Coordinator			wk			
Production Assistant			wk			
Production Secretary						
Production Accountant						
Production Consultant			wk			
Temporary Help						
Materials & Supplies						
Rentals						
Working Meals						
Overtime, 10%						
Prod Manager Accomodations			mo			
Fringe Benefits						
Total Production Staff						

Art Direction & Visual Development

Description	Number	# Unit	Unit	Amount	Estimate	Actuals
Production Designer						
Art Director			wk			
Artistic Coordinator						
Character Designer						
Location Designer						
EFX Designer						
Background Painter						
Color Stylist						
CGI Artist						
Sculptures/Maquettes						
Research and Reference Materials						
Travel & Accomodations						
Materials & Supplies						
Overtime						
Fringe Benefits						
Total Art Direction						

Model Design

Description	Number	# Unit	Unit	Amount	Estimate	Actuals
Character Design						
Location Design						
EFX Design						
Prop Design						
Materials & Supplies						
Overtime						
Fringe Benefits						
Total Model Design						

(continues)

Storyboard

Description	Number	# Unit	Unit	Amount	Estimate	Actuals
Storyboard Supervisor			day			
Storyboard Artist			wk			
Storyboard Clean Up Artist			day			
Materials & Supplies						
Overtime			day			
Fringe Benefits						
Accomodations & per diem			mo			
Freight			day			
Total Storyboards						

Song Production

Description	Number	# Unit	Unit	Amount	Estimate	Actuals
Song Composition Fees						
Lyricist						
Demos						
Song Copyrights						
Original Song Purchase						
Song Producer						
Singers/Chorus						
Song Coach						
Orchestrator/Arrangement Fees						
Conductor						
Musicians						
Instrument Cartage						
Instrrment Rentals						
Music Editor						
Copyist/Proofreader						
Studio Session Fees						
Travel & Accomodations						
Overtime						
Fringe Benefits						
Total Song Production						

Animation Direction; Pre-Editing/Feature Editing

Description	Number	# Unit	Unit	Amount	Estimate	Actuals
Editor						
Assistant Editor						
Apprentice Editor						
Dialogue Editor						
Animation Timer - Slugging Sheets			hr			
Track Reader						
Editorial Equipment						
Animatic Scanner						
Animatic Editor			wk			
Materials & Supplies						
Overtime						
Fringe Benefits						
Total Animation Direction; Pre-Editing						

Transportation & Shipping

Description	Number	# Unit	Unit	Amount	Estimate	Actuals
Messenger & Courier Services						
Mileage						
Fuel						
Taxis & Limousines						
Postage						
Freight Charges						
Custom Brokers & Fees						
Materials & Supplies						
Coordinator						
Fringe Benefits						
Total Transportation & Shipping						

Total Pre-Production

Layout

Description	Number	# Unit	Unit	Amount	Estimate	Actuals
Workbook/ Layout Supervisor						
Workbook Artist						
Layout Artist						
Blue Sketch Artist						
Assistant Layout Artist						
Materials & Supplies						
Overtime						
Fringe Benefits						
Total Layout						

Animation

Description	Number	# Unit	Unit	Amount	Estimate	Actuals
Directing Animator			wk			
Animation Lead			wk			
Animator			wk			
Animator 2			wk			
Animator 3			wk			
			wk			
Assistant Animator			wk			
Rough Inbetweener			wk			
Animator Accommodations			mo			
Materials & Supplies						
Overtime, 15%						
Overseas Animators			min			
Overseas In-Between						
Overseas On Time Bonus						
Fringe Benefits						
Total Animation						

Scanning

Description	Number	# Unit	Unit	Amount	Estimate	Actuals
Scanning Supervisor			wk			
Line Art Scanner			day			
Color Scanner			day			
Overtime, 20%						
Outside Labor						
Fringe Benefits						
Total Scanning						

Scene Planning

Description	Number	# Unit	Unit	Amount	Estimate	Actuals
Scene Planning Supervisor						
Scene Planner						
Materials & Supplies						
Timer			ft			
Overtime						
Fringe Benefits						
Total Scene Planning						

Cleanup

Description	Number	# Unit	Unit	Amount	Estimate	Actuals
Clean Up Supervisor						
Lead Clean Up Artist			wk			
Key Clean Up Assistant						
Clean Up Assistant			wk			
Clean Up Breakdown Artist						
Clean Up Inbetweener			wk			
Materials & Supplies						
Overtime, 20%						
Overseas Cleanup			min			
Overseas On Time Bonus						
Fringe Benefits						
Total Cleanup						

(continues)

Visual Effects

Description	Number	# Unit	Unit	Amount	Estimate	Actuals
EFX Supervisor						
EFX Animator						
EFX Assistant Animator						
EFX Breakdown Artist						
EFX Inbetweener						
Materials & Supplies						
Overtime						
Fringe Benefits						
Total Visual Effects						

Backgrounds

Description	Number	# Unit	Unit	Amount	Estimate	Actuals
Background Supervisor						
Background Painter						
Assisatant Background Painter						
Materials & Supplies						
Overtime						
Fringe Benefits						
Total Backgrounds						

Animation Checking

Description	Number	# Unit	Unit	Amount	Estimate	Actuals
Animation Checking Supervisor						
Animation Checker			wk			
Materials & Supplies						
Overtime						
Pencil Test machine						
Fringe Benefits						
Total Animation Checking						

Ink & Paint

Description	Number	# Unit	Unit	Amount	Estimate	Actuals
Color Styling Supervisor						
Color Stylist						
Color Model Mark Up Supervisor						
Color Model Mark Up Artist						
Ink & Paint Mark Up Artist						
Ink & Paint Supervisor						
Ink & Paint Artist			wk			
Materials & Supplies						
Overtime						
Overseas Ink & Paint			min			
Overseas On Time Bonus						
Fringe Benefits						
Total Ink & Paint						

Final Checking

Description	Number	# Unit	Unit	Amount	Estimate	Actuals
Final Check Supervisor						
Final Checker						
Materials						
Overtime						
Fringe Benefits						
Total Final Checking						

Camera

Description	Number	# Unit	Unit	Amount	Estimate	Actuals
Camera Supervisor						
Camera Operator						
Materials & Supplies						
Overtime						
Fringe Benefits						
Total Camera						

Subcontractors

Description	Number	# Unit	Unit	Amount	Estimate	Actuals
Traditional Subcontract Fee						
Digital Subcontract Fee						
Pencil Test						
On Time Bonus						
Overseas Supervisor Salary			wk			
Overseas Supervisor Per Diem			wk			
Overseas Supervisor Transportation			trip			
Overseas Supervisor Accommodations			mo			
Other Charges						
Total Subcontractors						

Character Modeling - CGI

Description	Number	# Unit	Unit	Amount	Estimate	Actuals
Lead Character Modeler						
Character Modeler						
Lead Rigger						
Rigger						
Overtime						
Stock Model Fee						
Fringe Benefits						
Total Character Modeling - CGI						

Environmental Design - CGI

Description	Number	# Unit	Unit	Amount	Estimate	Actuals
Lead Environmental Modeler						
Environmental Modeler						
Overtime						
Stock Model Fee						
Fringe Benefits						
Total Environmental Design - CGI						

EFX/Prop Design - CGI

Description	Number	# Unit	Unit	Amount	Estimate	Actuals
Lead EFX/Prop Modeler						
EFX/Prop Modeler						
Overtime						
Fringe Benefits						
Total EFX/Prop Design - CGI						

Surfaces: Texture & Color - CGI

Description	Number	# Unit	Unit	Amount	Estimate	Actuals
Surface Lead						
Texture Painter						
Digital Painter						
Overtime						
Fringe Benefits						
Total Surfaces: Texture & Color - CGI						

Staging/Workbook - CGI

Description	Number	# Unit	Unit	Amount	Estimate	Actuals
3D Workbook/Layout Supervisor						
Workbook Artist						
Layout Artist						
Overtime						
Fringe Benefits						
Total Staging/Workbook - CGI						

(continues)

Animation - CGI

Description	Number	# Unit	Unit	Amount	Estimate	Actuals
Directing Animator						
Animator Lead						
Animator						
Lead Technical Animator						
Technical Animator						
Overtime						
Fringe Benefits						
Total Animation - CGI						

Lighting - CGI

Description	Number	# Unit	Unit	Amount	Estimate	Actuals
Lighting Supervisor						
Lighting Artist						
Overtime						
Fringe Benefits						
Total Lighting - CGI						

EFX Animation - CGI

Description	Number	# Unit	Unit	Amount	Estimate	Actuals
Lead EFX Animator						
EFX Animator						
Overtime						
Fringe Benefits						
Total Lighting - CGI						

Render

Description	Number	# Unit	Unit	Amount	Estimate	Actuals
Rendering Supervisor			wk			
Renderer						
Overtime						
Fringe Benefits						
Total Render						

Composite

Description	Number	# Unit	Unit	Amount	Estimate	Actuals
Compositing Supervisor						
Compositor						
Overtime						
Fringe Benefits						
Total Composite						

Technical Direction

Description	Number	# Unit	Unit	Amount	Estimate	Actuals
Chief Technical Director						
Senior Technical Director						
Technical Director						
Overtime						
Fringe Benefits						
Total Technical Direction						

Software

Description	Number	# Unit	Unit	Amount	Estimate	Actuals
Research and Development Manuals						
Researcher						
Programming Supervisor						
Programmer						
Consultants						
Purchases						
License Fees						
Overtime						
Maintenance Contracts			yr			
Fringe Benefits						
Total Software						

Hardware

Description	Number	# Unit	Unit	Amount	Estimate	Actuals
Workstations			pc			
Render Stations						
Digital Disk Recorder						
Servers						
Installation Fees						
Rentals						
Scanners						
Network Equipment						
Maintenance Contracts						
Consultants						
Upgrades						
Total Hardware						

Systems Administration

Description	Number	# Unit	Unit	Amount	Estimate	Actuals
Systems Administration Manager						
Systems Administrator						
Audio Visual Engineer						
Overtime						
Fringe Benefits						
Total Systems Administration						

(continues)

Other Production Costs

Description	Number	# Unit	Unit	Amount	Estimate	Actuals
Incorporation Fees						
Legal Fees			hr			
Bonuses						
Insurance						
Severance Fees						
Rent/Leaseholds						
Utilities						
Janitorial Services						
Office Supplies						
Working Meals			meals			
Research Materials						
Furniture/Equipment Purchases- Animation Stands			Pcs			
Furniture - Drafting table set ups			Pcs			
Furniture - Desks, etc			Pcs			
Furniture/ Equipment Rentals						
Depreciation						
Copiers						
Repair and Maintenance						
Dues and Subscriptions						
Telephone						
High Speed Lines/DSL/Internet						
Technical Expendables						
Storage						
Wrap Party						
Crew Gifts						
Training						
Recruiting						
Final Continuity Script						
Paper, Animation Bond, 12 fld			ream			
Paper, Animation Ingram punched, 12 field			ream			
Paper, Legal for boards			ream			
Paper, Tab for layouts			ream			
Paper, Letter for everything else			ream			
Pencils			dozen			
Reinforcements, 500 flat, 500 round			box			
Peg Hole Strips, 500			box			
Paint						
Acetate, 12 fld punched, 500			ream			
Xerography			copy			
Stats/ Kodaliths			copy			
Photographs						
Jazz Disks, up to 6 minutes of video			disk			
Zip Disks			disk			
Catering			crew			
Craft Service			day			
Copies, Script			page			
Copies, Boards			page			
Copies, misc			page			
Long Distance Phone						
Long Distance Fax			page			
Printing, Laser			page			
Printing, Color			page			
Tape Stock			tape			
Shipping						
Messenger						
Camera & Stand						
Monitor						
Total Other Production Costs						

Stop Motion

Description	Number	# Unit	Unit	Amount	Estimate	Actuals
Studio			day			
Rigging						
Expendables						
Camera Package			day			
Animator			day			
Lighting Equipment			day			
Gaffer			day			
Grip			day			
Production Assistant			day			
Camera Man			day			
Backgrounds			day			
Blacks/ Drops			day			
Camera Test						
Power						
Fringe Benefits						
Total Stop Motion						

Below the Line Travel

Description	Number	# Unit	Unit	Amount	Estimate	Actuals
Airfares						
Hotel			rm nts			
Ground Transportation			wk			
Per Diems			day			
Total Below the Line Travel						

Total Production

Post Production Staff

Description	Number	# Unit	Unit	Amount	Estimate	Actuals
Post Production Supervisor						
Sound Supervisor						
Post Production Coordinator						
Editor						
Assistant Editor						
Materials & Supplies						
Overtime						
Fringe Benefits						
Total Post Production Staff						

Video

Description	Number	# Unit	Unit	Amount	Estimate	Actuals
Film to Tape Transfer						
Tape to Film Transfer						
One-Light Transfer						
Off-line Editing						
On-Line Editing						
Color Correction						
Cassette Duplication						
Protective Masters						
Element Reel						
Character Generator						
Materials & Supplies						
Total Video						

Film and Lab

Description	Number	# Unit	Unit	Amount	Estimate	Actuals
Telecine						
Film Development						
Lo-Con Prints						
Negative Cutting and Assembly						
Interpositive						
Internegative						
Answer Print						
Composite Check Print						
Re-Print						
Digital Film Printing						
Film Stock						
Tests						
Protective Masters						
Release Print						
Stock Footage						
Materials & Supplies						
Total Film and Lab						

Titles & Opticals

Description	Number	# Unit	Unit	Amount	Estimate	Actuals
Main and End Titles						
Bumpers						
Interstitials						
Commercials						
Trailers						
Total Titles and Opticals						

(continues)

Music

Description	Number	# Unit	Unit	Amount	Estimate	Actuals
License Fees						
Underscore Composer						
Demos						
Music Producer						
Conductor						
Orchestration						
Musicians						
Instrument Cartage						
Instrument Rentals						
Music Editor						
Copyists/Proofreaders						
Studio Session Fees						
Travel & Accommodations						
Album Mastering						
Other Charges						
Overtime						
Fringe Benefits						
Total Music						

Post Production Sound

Description	Number	# Unit	Unit	Amount	Estimate	Actuals
Audio Transfers and Stock						
Sound Design						
Effects Editing						
ADR/Looping Facility						
Dialogue Editing						
Foley Recording						
Foley Editing						
Temp Dubs						
Final Re-Recording Mix						
Foreign M&E Mix						
Optical Track Negative						
Equipment Rental						
Working Meals						
Sound Package Deal						
Sound Effects Purchase						
Other Charges						
License Fee - Dolby Digital						
License Fee - SDDS						
License Fee - DTS						
Total Post Production Sound						

Screenings & Previews

Description	Number	# Unit	Unit	Amount	Estimate	Actuals
Facility Charges						
Projectionist						
Catering Costs						
Audience Testing Fees						
Preview Expense Miscellaneous						
Travel & Accommodations						
MPAA Rating Administration Fee						
Fringe Benefits						
Total Screenings & Previews						

Total Post Production

Publicity

Description	Number	# Unit	Unit	Amount	Estimate	Actuals
Publicist						
Entertainment						
Travel & Accommodations						
Total Publicity						

Sub-Total Budget

Contingency

Description	Number	# Unit	Unit	Amount	Estimate	Actuals
20% of Budget						
Total Contingency						

Overhead Allocation & Markup

Description	Number	# Unit	Unit	Amount	Estimate	Actuals
Overhead Allocation						
Mark-up 20%						
Total Overhead Allocation						

Total Budget

(continues)

Budget Summary	Subtotals	Estimate	Actual
Story Fees & Script Development			
Producer's Unit			
Director's Unit			
Casting & Recording			
Subtotal Above The Line			
Production Staff			
Art Direction & Visual Development			
Model Design			
Storyboard			
Song Production			
Animation Direction; Pre-Editing/Feature Editing			
Transportation & Shipping			
Subtotal Pre-Production			
Layout			
Animation			
Scanning			
Scene Planning			
Clean Up			
Visual EFX			
Backgrounds			
Animation Checking			
Ink & Paint			
Final Checking			
Camera			
Subcontractors			
Character Modeling - CGI			
Environmental Design - CGI			
EFX/Prop Design - CGI			
Surfaces: Texture & Color - CGI			
Staging/Workbook - CGI			
Animation - CGI			
Lighting - CGI			
EFX Animation - CGI			
Render			
Composite			
Technical Direction			
Software			
Hardware			
Systems Administration			
Other Production Costs			
Stop Motion			
Below the Line Travel			
Subtotal Production			
Post Production Staff			
Video			
Film and Lab			
Titles & Opticals			
Music			
Post Production Sound			
Screenings & Previews			
Subtotal Post Production			
Publicity			
Subtotal Budget			
Contingency			
Overhead Allocation & Markup			
Total Budget			

Chapter 13
Crewing Up

One of the tricks to doing independent production is attracting enough people to help. The other trick is completing all the work and accomplishing the desired quality. This is where the producer has to be both a salesperson and a motivational speaker. You need to be able to inspire people to believe in your vision and to feel that they are an important part of the project. People tend to do better and more creative work when they feel responsible and have a sense of pride in what they are doing (Figure 13-1).

Medium to large animation houses have staffers who can work on in-house projects between paying jobs. It often inspires staffers if you allow them the freedom to work on their own projects at work, as long as it doesn't interfere with delivering to clients. Smaller animation houses and independents do not have this luxury, though, and they will have to make deals with outside artists to get the project done. Even larger companies may not have staff available for every aspect of production, such as custom music and sound effects.

Figure 13-1 T.J.'s designs and drawings were inspirational and instrumental in getting artists to help on the Timmy series.

Audio and music are extremely important in helping make animations come to life. You can produce these yourself with available programs, as we will discuss later (see Chapter 17, "Audio Recording and Editing"), or you can try to make a deal with a person or company to help you out.

Every negotiation should be a win-win situation. If everyone benefits, the final product will always be better and more fun to work on. Every project has different benefits it can offer people, and each person may have different motivations. It's up to the producer to figure all that out and make it work. Following are general motivations to entice people to work on your project:

• Pay them. (Everyone likes this choice the best.)

• Give a crew person his first stab at a higher position to help his career. People will often offer their time for free or a deeply discounted rate to further their career.

• Use the project as training ground for someone who hasn't worked professionally in the field and needs experience. Interns from schools fit this category (Figure 13-2).

• Give them, in writing, a percentage of the project that is equal to the amount of their invested time. Their percentage is calculated from a complete budget; divide the dollar

Figure 13-2 Enoc Castaneda was an intern on one Timmy episode, then was subsequently hired by A&S Animation to work on other projects.

amount of their invested time and resources by the total budget to get their percentage. (This is "back-end participation with ownership.")

• Give them, in writing, a percentage of income from the project. This can either be open-ended or up to a certain amount. (This is also back-end participation, but without ownership.)

• Partner with other people who also need to prove themselves and who have a desire to build a portfolio. Share the project and profits as needed. Just make sure everything is in writing.

• Contact a school or teacher about helping on a project as part of a class project that will give the students and school real credits, experience, and publicity.

• Create a project that is so compelling that people ask you to be a part of it. (We actually had a few people ask us if they could participate in the *Timmy's Lessons in Nature* series, they believed in it that much.)

Always be sure to give proper credit to those who help. You should also be certain that they all get copies of the final project. People who help on a project, whether for free or for pay, should never have to pay for anything themselves. The producer or funding source should always pay for any materials, computer back-up materials, and dubs (copies of the final video).

Make sure that any negotiations you do are done in writing. This prevents a lot of misunderstandings and hurt feelings later on. Contracts also protect you, the producer. They make sure everyone knows who owns what and is owed how much. (You don't want to be in the position of producing a big hit, then finding that a number of people are suing you with claims that they own part of the show when they don't.)

In our case, we had a few things going for us in putting together a crew. First, we had T.J.'s great designs that are fun and inspiring, and that artists want to animate. Second, we had already completed one short with Timmy, and everyone loved it. The character and the humor were already proven.

We had a relatively short time in which to animate this lesson, so we needed to break the work up for three different animators to work simultaneously. As we finalized

the storyboards we decided on how to separate the sequences between animators so that it wouldn't be obvious that different artists were drawing the characters. We gave the first close-up scene of Timmy to one animator. Since that first scene did not edit directly to another shot of Timmy, it wouldn't be very obvious if there were differences in the look of the character from one artist to another. We gave the fox animation to another artist. That left the bulk of Timmy for T.J. to animate.

Our crew was eventually made up of the following people:

Mark Simon: I produced it, owned the equipment, did the pencil tests, compositing, titles and credits, and editing, as well as co-directing. I did it because it's the best and funniest series I've worked on, and I have a totally warped sense of humor.

T.J.: He designed the characters, developed the background style, animated, and co-directed. He did it because he created the concept—and I wouldn't leave him alone until it was done.

Jeanne Pappas Simon: She helped us with the general show concepts to make the series work. She did it because she's my wife and believes in the series.

R.B.: He helped on the fox design and the layouts as well as animating the fox. He helped because he loves the characters and had more fun working on this series than anything else he had worked on.

R.U.: She animated Scene 1. She did it because she wanted to move from clean-up into key animating, and this gave her the opportunity.

Kara Morris: She was our intern from a local animation school. She did the scanning and digital ink and paint to add practical experience to her resume.

J.P.: He digitally painted our backgrounds. He did it as a favor to T.J. and because he loves to paint.

Sound"O"Rama: This is a local music and sound design company that has worked with us on other projects. K.C. Ladnier, the owner, was the sound designer, Kays Al-Atrakchi composed the original score, and Steven Bak was the supervising sound editor (Figure 13-3). They helped

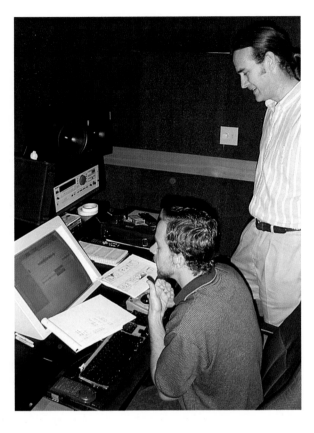

Figure 13-3 Steven Bak (sitting) and K.C. Ladnier (standing) of Sound"O"Rama agreed to help produce the original music and sound effects for Lesson 3.

because they believe in the project and want to work on the series if we are able to sell it to a network.

We offered the unpaid crew members a percentage of the profits from the series up to a cap of 200% of what their original fee would have been (we doubled their fee as a payment for their investment of time and effort). We also gave them proper credits and copies of the project. But most importantly, we provided them with a quality project in which to let their creative juices flow in a fun atmosphere. (OK, maybe the money is more important, but I can dream, can't I?)

Chapter 14
Revised Storyboards

You may need to revise your script and storyboards many times prior to starting and even during your production. Revisions of storyboards are the fastest and cheapest way to change and enhance your production. If you make changes once production has started, you've wasted resources, time, and money, and the crew will feel somewhat disheartened that some of their work has been for naught.

While I was budgeting and finding crew, we also started redrawing the storyboards. Once we had a chance to look over and make notes on the original rough boards, we sat down and quickly revised the boards. We moved scenes around to make the sequence funnier. We added more key frames and drew Timmy more on character (Figures 14-1 and 14-2). Notice that even though the sketches are rough, they are accurate. These better-drawn characters are more helpful to the other animators.

It often pays to sit on a sequence for a while and come back to it when it's fresh. With a fresh view of the boards, you are more likely to pay attention to details and make better decisions.

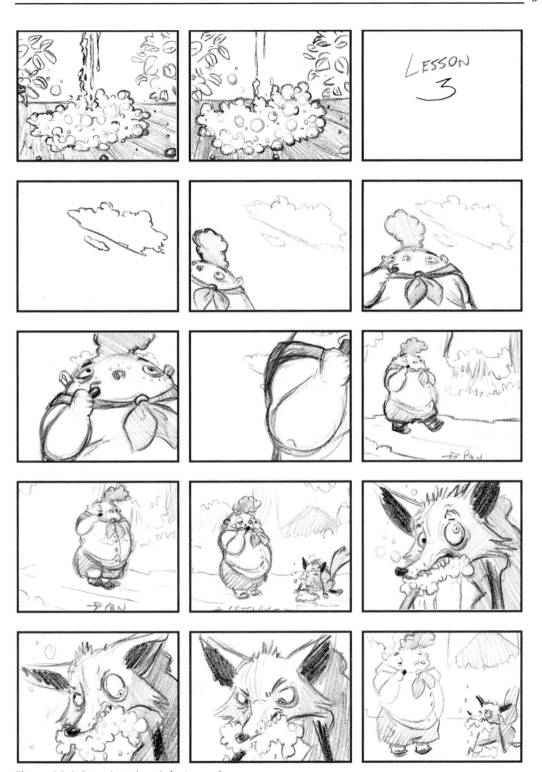

Figure 14-1 Revised storyboards for Lesson 3.

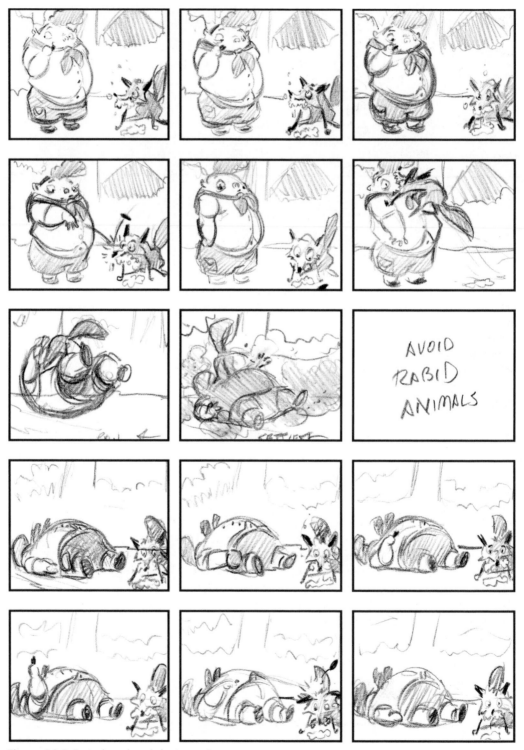

Figure 14-2 Revised storyboards for Lesson 3.

Chapter 15

Layouts

Layouts are the drawings of the backgrounds that the background painter will use. The design of the layouts comes either from the production illustrations that have captured the look and feel of the project, or from the storyboards, so that the layout works with the flow of the story (Figure 15-1).

In the layout phase the look of a scene is finalized, and each shot is made as dynamic and as helpful to the story as possible. Each shot should be composed with great skill and care, with the aim of focusing the audience on what the director has specified and creating the greatest visual impact possible.

Each shot also needs to properly follow the visual cues from the previous scene and lead into the following scene. For instance, one scene may show a character looking toward something, and the following scene may be his POV. The layout of the POV background should be from the proper height and perspective of the person we just saw. In a scene in which bugs and people are looking at each other, for example, the shots from the bug's POV would be a low camera angle looking up, and the shots from those of the people would be a high camera angle looking down (Figure 15-2).

Other visual layout issues to pay attention to are balance, negative space, motion, straight on shots, angled shots, and all the other rules of proper and exciting composition. Visually, the viewer's eye should be guided to the most important point in the shot, such as the lead character or a crucial prop (Figure 15-3). Once a layout is approved, the animators may use it to animate over. Animators only need a black and white line version of any background—in fact, it's much better that way. It is much harder to see important background details on an animation stand when the background is filled in with tone and color.

While the animators are working, the background painters will fill in and enhance the layout.

T.J., the co-director and lead animator, and R.B., our second animator, traded their original sketches of the backgrounds

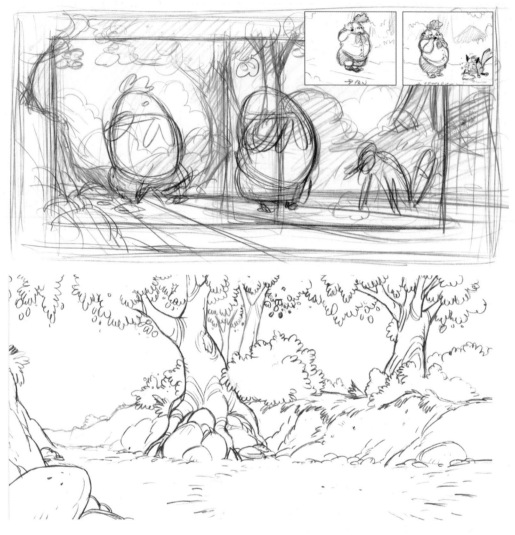

Figure 15-1 Storyboards, rough layout, and final layout of the panning scene. The background is wider than normal, allowing us to pan to the right with Timmy as he walks down the path. Layouts by T.J.

and kept going over one another's work. Each time they traded backgrounds, the layouts would get a little better.

Using the storyboards as a base, we designed the layouts to work with the action and be as visually interesting as possible. For example, we have a low-angle background of the sky that Timmy walks past as he walks toward the camera. We sketched the different positions of Timmy in the frame, and designed the clouds around his positions. In

Figure 15-2 Storyboards showing a man's POV looking down at a small bug and the bug's POV looking up at the man.

Figure 15-3 Rough layout from Mark Simon's short, *Scary Things*, by Hans Bacher. Notice the intensity of the image and how your eye is drawn around the image and down to the child.

Figure 15-4 you can see three versions of the development of the background. The first one is a rough of Timmy and the clouds, the second is the final blue-line layout, and the last is a contrast and tone mockup, done with a marker to assist the background painter.

We designed the main background to be much wider than the screen so that we could pan with Timmy as he walked and reveal the fox. Notice on the rough sketch how the positions of Timmy and the fox are roughed in. To give the scene some depth, we designed in a foreground element of rocks at camera left that Timmy would walk behind (Figure 15-5). The design was then finalized in blue pencil, scanned, and given to the background painter as a digital file. The

Figure 15-4 Rough position layout of Timmy and the clouds: the blue-line layout of the clouds and the contrast and tone of the background.

Figure 15-5 Lesson 3 pan background with a foreground element, the rock, shown in color.

Figure 15-6 Layout frame with Timmy and foreground rock.

final layout was drawn 12 fields high so that the animators could put it on their peg bars and animate over it for proper character positioning (Figure 15-6).

Layouts should not be rushed. The final look of any animation is dependent on a visually exciting layout.

Section C
Production

Chapter 16
Directing Dialogue

The most important part of a production is a good script. Next you have to have good acting. Without great voices, even the best animation will seem flat and uninteresting. (See Figure 16-1.)

Actors need to have the emotions of a scene explained to them. If you don't give an actor much information, they are less likely to give you much in return. Try having table readings with all the actors together. Table readings are early read-throughs of a script with all the actors, director, and producer sitting at a table. Read through the script to see how it sounds with actors, and take notes. This is a great time to make last-minute script changes so that it sounds more natural. Once the actors really get into their characters, they will often make suggestions as to what their character would or would not say, and those suggestions are usually very good ones.

All actors respond differently to direction, but none of them like being given a reading. In other words, don't demonstrate how they should say a line. They feel it's

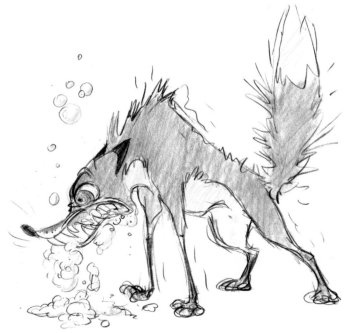

Figure 16-1 Early sketch of the fox character.

demeaning, and you are likely to get a very poor reading from them afterwards. Instead, give them direction by referring to other film or TV projects, relating a scene to real-life incidents, or anything you can think of to help them relate to the character's situation.

Actors should stand while delivering their lines to keep their energy up and help them project from their diaphragms (Figure 16-2). They should also be encouraged to act out the action during the session. You do not want low-energy actors unless the scene calls for it.

Audio sessions should also be fun. Try to avoid yelling at people during a session—it affects everyone who is involved. Sessions should also not go longer than 3 or 4 hours with each actor, with a number of breaks. Longer sessions are tiring and performances are likely to suffer, as well as being hard on someone's voice.

Just as big action never looks too big in animation, voices can also be much bigger and more animated in a cartoon than in live action. Cartoons benefit greatly from truly distinctive character voices.

Many independent animators supply their own voices. When you record yourself, it is helpful to have someone you trust give you notes during a recording. Your voice never quite sounds the same in a recording as it does in your head.

Figure 16-2 Producer/Director Mark Simon standing in the audio booth while delivering the fox's dialogue. Facilities provided by Sound"O"Rama.

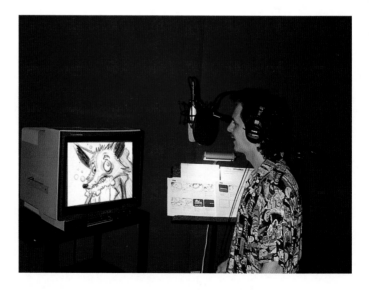

In *Timmy's Lessons in Nature*, I not only recorded the fox's speaking voice, I also did his vicious attack. For the attack I made a badger sort of sound and shook my head violently so that my jowls shook around. We recorded multiple takes of this—until I got a headache—and mixed them all together to get the huge attack sound heard in the animation.

In animation, actors don't have a lot to work with—there are no sets, no props, few, if any, other actors, and blank walls in front of them. It is very important for them to see their character and the storyboards. Once actors see what is happening in their scene, they can offer you much more.

Chapter 17
Audio Recording and Editing

Now the real fun begins. You've done all of your pre-production and you're ready to start production on your animation. If you have any dialogue, you will need to record it before you start animating.

The lines of dialogue need to be numbered for reference during recording and editing. Many scripts have each line of dialogue numbered for exact referencing during production. This may be overkill on small projects, but it is a tremendous help on big shows. (See Figure 17-1.)

Audio is always recorded before animation starts. This allows you to determine how long the scenes need to be and to plot, frame by frame, where the phonemes are so that you can sync your characters to their audio. Not all animations have dialogue, but they may still have special sounds to which the animation needs to be related, or you may want to have your characters move to the beat of music. In all these instances, the audio needs to come first.

When you are working with a project that has been funded, you can hire actors, rent an audio studio, record their voices, and have technicians edit the audio together for you. When you have no funding, you need to be inventive in how to produce your project with favors and cheap solutions. Let's start with the assumption of having money to hire the right people with the right equipment.

WORKING WITH FUNDING

There are two ways to find and hire voice talent:

(1) Use a voice-over talent agency, or

(2) Find actors yourself by asking friends, colleagues, or coaches at acting schools.

Talent agencies will supply you with tapes of people whose voices might suit your needs. They do the legwork for you and charge you a fee.

Whether you hire an actor yourself or through an agency, you need to have a clear understanding regarding terms of usage and payment. Are you paying for a buyout, which is a one-time fee for continued use of his or her voice from that session, or will there be residual payments? The standard in

Bug Off/Buzz Off "Blind Date" 5
5/21/99

STUPID SINGLE GUY
(Interrupting.) Did you say the color
for the new product was purple? (43)

JOE
(Testily.) Yes. (44)

STUPID SINGLE GUY
We tested purple in an independent
study last year and nobody liked it. (46)

BOSS
Then it's back to the drawing board
Joe. I hate purple and...NO promotion! (47)

Everyone else exits. Joe slumps down in his chair crying. He
turns to Stupid Single Guy, who's happily eating another
donut, and says through clenched teeth. (48)

JOE
I owe you one. (49)

Figure 17-1 Sample script page with lines of dialogue marked for reference. Script by Jeanne Pappas Simon.

animation is to purchase buyouts. Voice-over actors will perform as many as three different character voices in the same session for the same price as one voice, so to save time and money you may want each actor to portray a couple of characters.

Audio facilities charge by the hour for recording and editing (hourly rates vary from around $85 to over $150). They provide soundproof rooms that help create perfect recordings of your actors, and they should also have the ability to manipulate the voices to suit your needs. (See Figure 17-2.)

Most audio studios also give you and the actor the option of not being present during a session. This is often necessary when casting out-of-town actors. You can be connected to a studio by a phone line and give your direction and notes as the session is going on. A phone session is also helpful when an out-of-town client needs to participate in the session.

Figure 17-2 Stephen Bak recording and editing dialogue for an A&S Animation production at Sound"O"Rama.

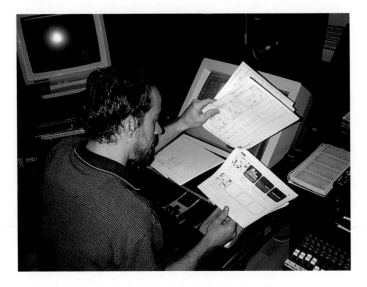

Whether you are present in person or by phone, you will be directing the talent to say the lines the way you need them. Sometimes you may record actors one at a time and edit them together later, and other times you may record them working together for a more natural rhythm and reaction.

The editors edit the dialogue audio together according to your notes, or slugging. Slugs are the segments of time between the lines of dialogue that are reserved for action. You need to remember to leave time for visual gags that happen in and around the audio. At our company we usually act out the actions and time them with a stopwatch so that we know how much room to leave between the lines of dialogue.

Once the edit is complete, the audio facility can give you a CD-ROM or Zip disk with the final digital audio, or e-mail it to you. You will need to tell the facility what audio format you want: .aif for Macintosh or .wav for PCs. You can then use it in your audio and video editing programs, and break it down into phonemes for your animation.

WORKING WITHOUT FUNDING

Finding actors willing to do voice-overs for free is fairly easy. Voice-overs don't take as long as acting in front of a camera: actors don't have to memorize their lines since they can read from a script. And as long as you're flexible, you can work around their schedules. If you don't know any

Figure 17-3 Sound-dampening in the corner of an office that is being used for recording. Notice that the actors will be facing the hanging blankets.

actors, ask around or go to the drama department of a local school. You can also try local theaters and comedy troupes. For short projects, you can often get voice-over actors to work for free, with the agreement that you will provide them with a tape that they can use to get future work.

Whether you have funding or not, record multiple takes of each line of dialogue. It always costs less to record more in the first place than to have another recording session. You often need to use portions of different takes. You may hear something in their acting while editing that you didn't hear while recording.

A number of smaller production studios set up their own little recording booths—or even recording corners—in their office. Find a quiet corner or small room and hang some sound-dampening materials in it to keep the recording from sounding tinny (Figure 17-3). You can use sound blankets, comforters, foam sheets, or anything else that is soft and will absorb sound. Place the microphone so that the actors are facing toward the sound-dampeners. Be sure to have a

Figure 17-4 DAT recorder for digital audio recording on tape. It will accept both analog and digital inputs, and the recording quality is as good as you can get.

stand for the actors to read their script from—you don't want the noisy shuffling of papers on your recording. Use a windscreen in front of the mike to keep down the sound of breath hitting the mike. If you don't have a windscreen, have the actors speak off to the side of the mike instead of directly at it.

Once your studio is prepped for recording, you can record to any device that will accept audio. The best results will be either recording to a DAT (digital audio tape; Figure 17-4) or directly onto your computer. Once the audio is recorded and you've chosen the best takes, you should clean the audio by removing any background noise that may have been recorded. We use Sound Forge for recording and Cool Edit Pro for removing unwanted noise. Years ago, we used to record room tone, or the general sounds in the recording area that had a slight hum; we then edited that tone over any gaps in the dialogue, so that the quality of the sound wouldn't change. Now, with digital audio recording, we ordinarily remove all background noises, so room tone is seldom necessary.

Different software programs work differently to remove background noise. In Cool Edit Pro, for example, you select a portion of the audio with no dialogue and sample it (Figure 17-5), then load this sample as your background noise profile. Then you select the entire audio file and have the software remove all elements that match the background noise profile (Figure 17-6).

Other popular audio programs are Sound Forge (Figure 17-7) and ProTools. ProTools also offers a free version of its program that may be downloaded from the Web at

Figure 17-5 The area highlighted in white is the noise in a silent portion of the recording. Selecting this sample allows you to eliminate that noise in the entire audio file.

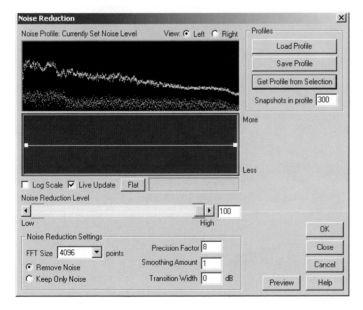

Figure 17-6 The background noise profile selected in Figure 17-5 is used here to remove noise from the audio.

www.digidesign.com/ptfree/. This is a fully functioning version, but it only works on a few operating systems. Since software changes so quickly there may be other freeware or shareware audio programs than these available at any time. It is always a good idea to search the Internet for free or affordable programs to use.

For quick recordings, you can even use the little computer mikes that come with most computer systems. The quality of

Figure 17-7 Sound Forge recording screen.

Figure 17-8 Placing two microphone foam blimps over an inexpensive microphone improves the recording quality.

these mikes is unbelievably good, considering their size and price and they don't pick up much background noise. We often use them for creating sound effects and recording quick dialogue. Placing two foam blimps (Figure 17-8) over the mike helps eliminate the "pops" from *P*s and exhales.

In many audio programs you can record numerous takes into a master file, clip the best take, and save that clip as your final file. There are many other audio programs that

Figure 17-9 Audio editing in Adobe Premiere.

allow you to record audio directly into your computer and edit it, such as ProTools, Cool Edit Pro, and Vegas Audio. Many nonlinear editors such as Adobe Premiere and Speed Razor also allow digital audio recording. Some animation programs such as CTP and Toonz also allow you to record into them.

Once all the voices are recorded, we edit them together to get the proper timing and reaction, while leaving room for action and gags. We use Adobe Premiere for editing our audio. There are also multitrack audio programs, such as ProTools, which many sound professionals use. Since we already own Premiere, it's our cheapest solution. Premiere offers up to 99 tracks of audio, and it allows you to adjust the audio level and speed of any clip on any track (Figure 17-9).

To determine the correct timing needed between dialogue for the action to take place (the process is known as slugging) we use stopwatches. We either act out an action in our heads, or act it out physically and time how long it takes. I usually do the same action a few times to make sure I've timed it properly. There are stopwatches that time by

seconds and frames, but we simply use a normal sports stopwatch, which is much less expensive and easier to find.

To perfect the timing, we often edit the audio and the storyboards together to make an animatic, which is also called a story reel or a leica reel (see Chapter 18, "Animatics"). An animatic allows us to see the rough action with the audio and finalize our audio timings.

After the audio track is complete, we break it into segments, scene by scene, and save them with the scene number as their name: for instance, Scene 1.wav and Scene 2.wav. The fox's line in Lesson 3 is titled Scene 4, Fox audio.wav. Name each file with the same naming format, and then they will be easier to sort through and edit with.

Chapter 18
Animatics

Once we have finalized our storyboards, we need to get a good feel for the flow of the story before we start animating. To do this we time the scenes and create an animatic, which is an animated video of the storyboards. Usually, making an animatic is as basic as using a nonlinear editing system and cutting the storyboard images together with the dialogue audio. Animatics can also get as fancy as productions want them to be, including moving elements, pans, zooms, and more. The enclosed CD-ROM has an animatic from *Timmy's Lessons in Nature*, Lesson 3.

Animatics can be produced with compositing and editing software programs singly or in combination. Your decision may be largely based on the software you use and how fancy you want your animatic to look.

For the most flexibility, use a compositing program like Adobe After Effects to scale and move your storyboard images (Figure 18-1). Scan each of your storyboards with a

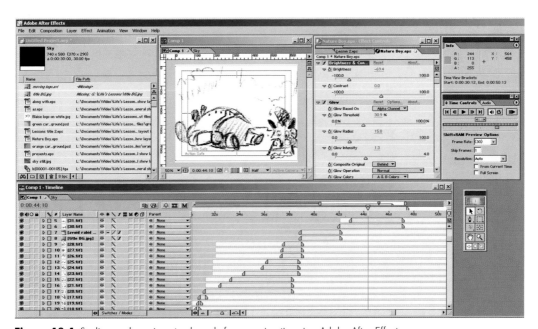

Figure 18-1 Scaling and moving storyboards for an animatic using Adobe After Effects.

resolution that is higher than what is required for broadcast. You want to have enough resolution to be able to zoom in and pan across your images. Time how long each panel should be on the screen, and include any appropriate camera moves and transitions. You should also cut in the basic dialogue tracks where needed to make sure your visual timings work.

You can also cut the storyboards together using an editing program like Adobe Premiere, Final Cut Pro, or AVID. Most editing programs, unlike compositing programs, do not allow you to make any camera moves. AVIDs, for instance, automatically resize any imported image to the size of the project output, such as 720 × 486.

Some of the newer programs, however, such as Adobe Premiere running on the Targa 3000 card, allow you not only to pan across and resize images, but also to edit in real time. A few of these software programs act as limited compositing programs (Figure 18-2).

We used a combination of Adobe After Effects and Adobe Premiere for our *Timmy's Lessons in Nature* animatics. We did all of our camera moves in After Effects. Since we had only one line of dialogue, audio timing was not a large concern. In fact, the dialogue scene was not even a part of our animatic, since we added that scene specifically for this book.

Once the compositing was done, we added some sound effects and background sounds to help the images flow

Figure 18-2 Timmy animatic in Premiere 6.0 RT edit suite.

together and give us a better feel for the final project. We added the audio in Premiere.

There are two main benefits derived from producing animatics. One, you can determine whether the shots work to tell the story the way you envisioned they would. You may find that you need to move, or remove, scenes so that the story makes more sense. Two, you are able to finalize the length of each scene.

Having done an animatic, we now know exactly how long each scene needs to be. Since animation is so expensive and time-consuming, we need to limit our animation to the exact length needed. We then take the final animatic and break down the length of each scene in terms of seconds and frames for the animators.

All feature animations work with animatics, as do many shorts and commercials. Animated television series will often produce animatics of the first few episodes to get a feel for the show. Even many live-action films, such as *Star Wars*, are produced with animatics first. Animatics help improve every animation. In the long run, they will save you time and money.

Chapter 19

Animation Breakdowns, Slugging, or Timing

Before animators begin animating, they need various pieces of information about each scene: its overall length, audio timings (lip sync or musical beats), a background, the storyboard panels, and a way to track who has the art. To convey this information every studio uses its own forms for breaking down scenes for their animators. We use two main forms with our animators. One is our Artist's Scene Form (Figure 19-1), which includes the scene's storyboards, the length of the scene, production notes, the scene number, the artist, and the date. The other form is the Dope Sheet (also known as a cue sheet and an x-sheet), which breaks the scene down into individual frames for tracking lip sync and provides the organization for every piece of art (Figure 19-2).

Slugging is the art of determining how long each action takes in between dialogue. It is fairly quick and easy to time the dialogue in a scene, but it takes longer—and requires more knowledge—to determine how much time is needed in between the dialogue for the action to take place.

During slugging, you figure out how long it takes for a character to jump a gorge or swing a bat. How long does it take to walk across a room? When a character falls down a hill, how long does that take?

Timings are quite easy when you have an animatic in your nonlinear edit system. To find the length of each scene, scrub (move the time line cursor along the project) along the animatic time line and write down the frame numbers of the first and last frames of each scene. Subtract the lower number from the upper number, then add 1, and you will have the length of the scene. (You need to add 1 in order to count the first frame.) For example, let's say you have a short scene that starts with frame 10 and ends on frame 17. $17 - 10 = 7$; $7 + 1$(the first frame) $= 8$. The scene is 8 frames long.

Editing programs also allow you to highlight a specific length of time on the time line. The Info box in the software will tell you how long the highlighted area is. In the example from Premiere, notice how Scene 1 is highlighted and the

Artist's Scene Form

assigned _____
deadline _____

Project *Lesson 3 - Avoid Rabid Animals*
Artist *Rosanna*
Scene *# 1* Sc. Length *4 sec. 4 frames*
Frames/Cels _____
BG _____
Character(s) *Timmy*

Notes:
- *Timmy will enter & exit frame.*
- *Keep the up-shot look.*
- *Timmy waddles side-to-side with quick, heavy steps.*
- *His hair should bob a bit*
- *Have Timmy look around without focusing.*
- *It should be clear he's chewing on a candy bar.*

Storyboards:

① *9 frame hold in beginning*

②

③

④

⑤

⑥ *20 frame hold at end*

X:\Spreadsheets\Animation Forms\Artist's Scene Form.wb3

Figure 19-1 Artist's Scene Form, which gives each of the artists all the important information they need for each scene they work on. Sample shown is from Lesson 3, Scene 1.

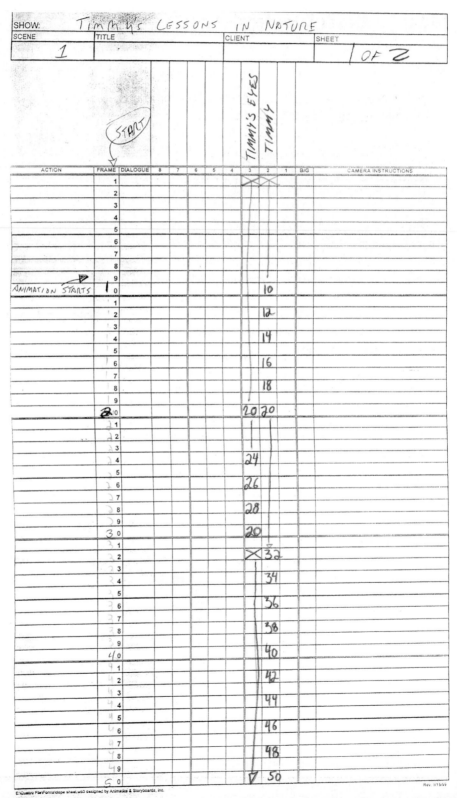

Figure 19-2 Dope sheet or x-sheet, which breaks the action and timing of a scene down into frames and layers of animation. Sample shown is from Lesson 3, Scene 1.

Figure 19-3 Adobe Premiere time line and Info box. Scene 1 is highlighted and its duration is automatically given.

Info box states the starting and ending frames and gives us the full duration of the sequence.

If there is no animatic, the slugging notes are made directly on a dope sheet. These notes will mark each of the major action key frames. Timings like this are more common when animation is subbed out (subcontracted) to other companies or other countries or when a less experienced animator is being used. Stopwatches are used to figure out how long the actions take. There are stopwatches available at animation supply stores that measure time in frames, but they are quite expensive. We use normal sports stopwatches.

Once each scene is timed and all the information is ready for your animators, they can get started.

Chapter 20
Audio Breakdowns

Breaking audio tracks down into syllables or phonemes frame by frame straight from audiotape used to be very time-consuming and required a lot of experience to do correctly. Some new software programs not only make it a lot faster for you to manually break down your audio, but they also can show you instantly how well your lip sync is working, which allows you to make quick changes until it's perfect.

There are some softwares that automatically break down the audio into phonemes. The problem with using these automatic softwares, however, is that they do not differentiate yelling from soft voices, or run-on voices (quick speaking where a mouth moves very little) from over-enunciated voices (where a mouth makes exaggerated movements). The automatic softwares are getting better, but many I've tested are not practical to use. Their output often took longer to decipher than it would have taken to break down the audio myself using softwares like Magpie. Also, the automatic phoneme output does not work the way animators do. Besides, when you do it yourself (with a software like Magpie), you get a better feel for the scene.

Before you determine lip sync, you need to break the audio into scenes. Using either a video or audio editing program, separate the main edited audio file into the individual scenes. Make sure that the first frame of scene 2 follows the last frame of scene 1, then all the audio files will edit back together perfectly. These individual audio files can then be used to determine the exact length of each scene for the dope sheets (x-sheets, cue sheets, or timing sheets), and to break them down into phonemes for lip sync.

We use two different programs for determining lip sync: Magpie (or Magpie Pro) and Flipbook (or Digicel Pro, the professional version of Flipbook), both of which have demos on the enclosed CD. Other digital ink and paint animation programs also have the ability to break audio into phonemes, such as Toonz and Animo (Figure 20-1).

The Magpie upgrade, which enables better printing of dope sheets and other options, is quite inexpensive. Magpie Pro offers many more options, including testing sync of facial

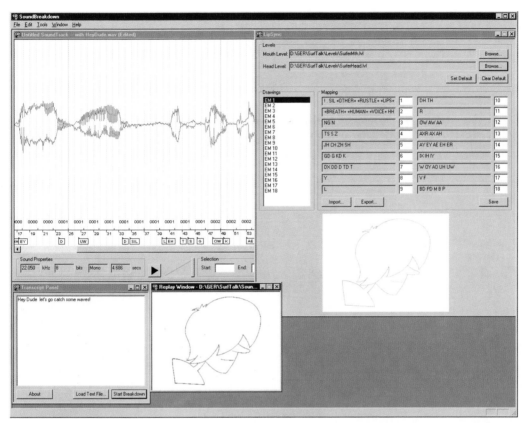

Figure 20-1 Animo sound breakdown window.

expressions other than just the mouth, such as eyes and brows (Figure 20-2).

The Magpie main working window is laid out well. On the left of the screen is a visual list of mouth positions for each letter and sound, across the top is the audio wave form, and on the right is the familiar dope sheet (Figure 20-3).

For the lip sync scene in Lesson 3, we import the wave file for Scene 6 (named Scene 6, Fox audio.wav) into Magpie. A copy of the audio file (renamed Fox_audio.wav) is included on the enclosed CD-ROM so you can try it yourself. But before we start working on any timings, we need to make sure the program is set at the proper number of frames per second (fps) and that the first frame is number 1, not number 0. The time code in Figure 20-4 shows 00:00:00.01. This stands for hours:minutes:seconds.frames.

As mentioned before, *Timmy's Lessons in Nature* are animated at 24 fps to work with our Fox_audio.wav sample.

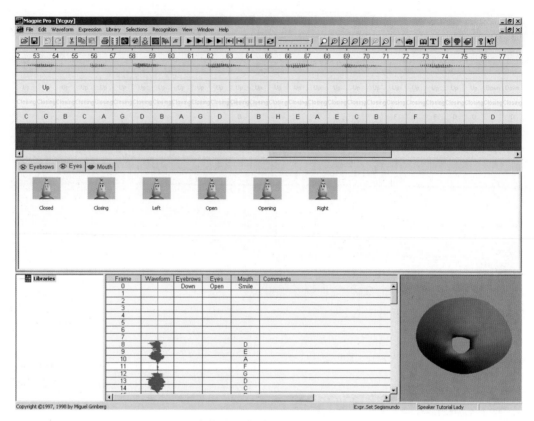

Figure 20-2 Magpie Pro main working window.

Pull down the Options menu and click on Change Frame Rate to make sure the program is set at 24 fps (Figure 20-5). The frame rate on your projects should be set to match the frame rate at which you are animating. If you break down your audio at a different frame rate than you are animating, the audio will not line up with your art.

Play back the audio a few times to get a feel for the actor's pacing and what is being said. In the Comments Line on Frame 1, type in the dialogue of the scene for the animator's reference. Then "scrub" (move through the time line) the audio by holding down the right mouse button. This allows you to hear the audio one frame at a time, forward or backward. For the first few frames, our character doesn't speak, so place a Closed Mouth symbol in Frame 1, otherwise nothing will be shown in the animated mouth window until the first phoneme is chosen. As you hear the sound of a letter, highlight that frame and double click on the mouth symbol that it represents. This places a reference letter of the phoneme in that frame and places a visual

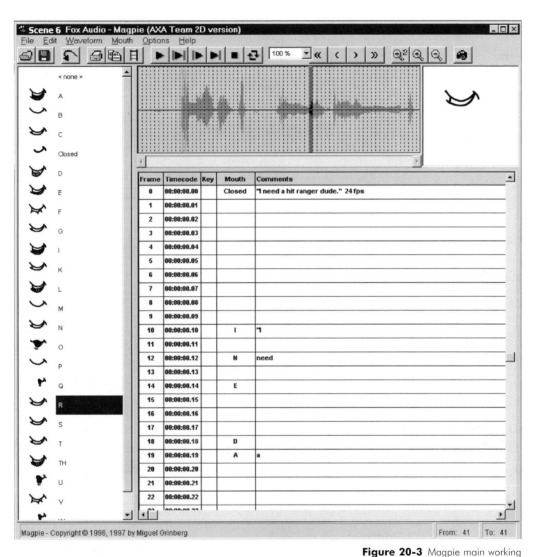

Figure 20-3 Magpie main working window. Sample shown is from Lesson 3, Scene 4.

mouth symbol in the top right corner window. As portions of the audio are marked, play it back and watch the animated mouth symbols say the words. This way, you can get instant feedback to see if the breakdowns are correct.

At the beginning of each new word, place the entire word in the comment line for easy reference by the animators. If the character is yelling or showing some other important expression, notate that as well. Some actions also need to happen on specific frames, so place action notes there too.

Figure 20-4 Starting frame should be set to Frame 1.

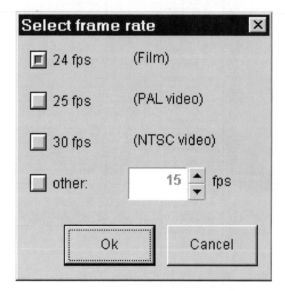

Some mouth positions of letters need to lead the actual sounds by a frame or two. For example, the letters M and H, among others, need to be "led" in order to look and sound correct when played back. Hard consonants, such as *k* and *p*, should also hold for at least 2 frames or they will pass by too quickly to be seen. Play with the frame placements until it looks and sounds perfect. Then print out the dope sheet and either give it directly to the animators or use it as a plan for writing your own dope sheets.

Figure 20-5 Frame rate should be set to 24 fps.

Flipbook, a part of the Digicel animation programs, also can be used to determine lip sync, but it works a little differently. Flipbook is a pencil test program that allows us to

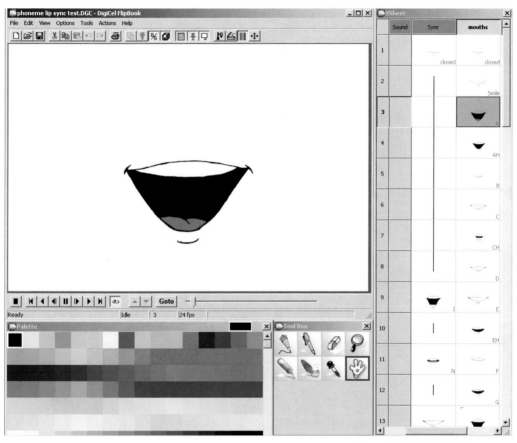

Figure 20-6 A full set of
phonemes in Digicel can be used
to break your audio tracks down.

quickly test the motion of our animation; it also allows us to
break down audio into phonemes.

Open a new file and import an audio file by right-clicking
on the Sound Layer. Then open or build your own library of
labeled mouth positions into a layer and turn off (hide) the
layer containing your mouth positions so you don't see the
original list of mouths during playback (Figure 20-6). Set the
file to loop and play the scene. As the audio plays over and
over in real time, copy the different mouth positions from the
hidden mouth layer into the matching frames on a visible
layer to match where each sound is. You can adjust the
timing of each mouth position in real time as the audio
plays until it looks and sounds just right. Once the lips
match the audio, copy the information onto your dope
sheet.

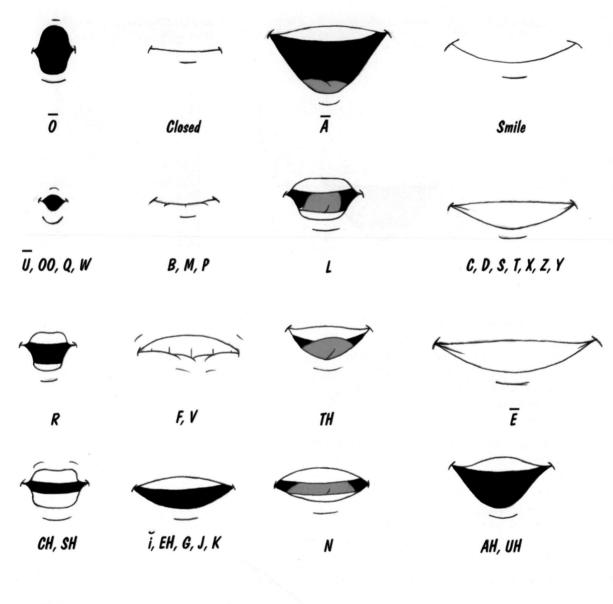

Figure 20-7 Sample of general phonemes.

Figure 20-8 Example of "anime" phonemes.

There are many different styles of phonemes that you can animate and test with. You may want to design your own phoneme icons to match your style of animation. There is a sampling of phonemes in Figure 20-7. Although this sample has 17 different mouth positions, most TV animation is accomplished with just 8 positions: Closed, O, A, C, i, TH, N, and L.

Japanese "anime" phonemes are different from those in western animation. They tend to have just 3 or 4 main mouth positions (closed, \overline{O}, normal open, and wide open), rather than the 8 to 10 positions in western style animation. Anime's mouth positions also tend to extend beyond the edge of a character's face. Lip syncing this style of animation is more like puppetry—you just have to match open and closed mouth positions to the audio (Figure 20-8).

With very little training, lip sync is now possible, fast, and fun.

Chapter 21
Assigning Production Work

Like all projects, Lesson 3 had a deadline. In order to meet the deadline we had to assign the work to a number of people. There were a number of steps to be taken to properly break down the production into work for different crew members. (See Figure 21-1.)

The first step was obvious. The background layouts go to the background painter, animation goes to the animators, compositing goes to the compositor, and so on.

The second step was to break down each area of production among as many people as necessary to complete the animation in the allotted time. Many independent projects rely heavily on just a few people due to budgetary constraints, and time constraints are less of an issue. Regardless of how many people are helping on a project, however, you need not only to spread out the work as much as possible, but also to schedule what happens first and when different crew members will need to work. The third step was to ensure that the work being handed out took advantage of both each person's available time and their talents.

The fourth step was to determine deadlines for all scenes. It's human nature to work toward deadlines—and to leave work without a deadline untouched for as long as possible. Even when projects have no outside deadlines, producers should give all artists deadlines to work toward.

Figure 21-1 Assistant animator Timmy, reporting for duty.

Since the bulk of the labor on Lesson 3 was in animation, and each animator was doing his own clean-up work, we had three animators splitting the workload. The least experienced animator had just one basic scene: Timmy walking up to and past the camera. R.B., our second animator, was very talented in animating funny animal expressions, so we gave the foaming fox scenes to him. This left the bulk of the animation to T.J., who would be working on the animation longer than the other two animators. This break down of the animation worked well in terms of scheduling, because we only had one scanning and ink and paint station, so we needed the work to come to us in stages. The shortest scene, a close-up of the rabid foam falling, came in first (Figure 21-2). While we scanned and

Figure 21-2 The falling foam was
the first scene completed.

painted this scene, the next scenes started to come in. By
the time we finished painting most of the scenes, T.J. was
finishing the animation on his last shots.

In order to track who was given which scenes and what was
expected of them, we filled out the form shown in Figure
21-3. Notice that each scene had its own page, which
noted who the artist was, how long the scene was, any
relevant production notes, and a copy of the storyboards.

Another form, shown in Figure 21-4, consolidated all the
scenes and listed who they were given to. The Project
Tracking Form in Figure 21-5 tracked the steps of production
that had been completed. These forms allowed the producer
to see the entire production at a glance. (Blank versions of
these forms may be found in Appendix 1, "Forms".)

Animation is a time-consuming process. In order to keep
great creative work flowing, the producer needs to motivate
everyone involved—constantly. The first form of motivation
is to have a time schedule or deadline. Another form of
motivation is to catch people doing great things and tell
them. Let your crew know how much you appreciate their
work. This is especially important if you are not paying them.
The final motivation is your own enthusiasm. The more
excited you are about the project, the more excited others
around you will be.

Artist's Scene Form

assigned _____
deadline _____

Project _LESSON 3 - AVOID RABID ANIMALS_
Artist _ROSANNA_
Scene _# 1_ Sc. Length _4 SEC. 4 FRAMES_
Frames/Cels _____
BG _____
Character(s) _TIMMY_

Notes:
- TIMMY WILL ENTER & EXIT FRAME.
- KEEP THE UP-SHOT LOOK.
- TIMMY WADDLES SIDE-TO-SIDE WITH QUICK, HEAVY STEPS.
- HIS HAIR SHOULD BOB A BIT
- HAVE TIMMY LOOK AROUND WITHOUT FOCUSING.
- IT SHOULD BE CLEAR HE'S CHEWING ON A CANDY BAR.

Storyboards:

X:\Spreadsheets\Animation Forms\Artist's Scene Form.wb3

Figure 21-3 Artist's Scene Form given to each artist with each scene.

WHO & WHAT

Date 1-27-2001

Project _LESSON 3 - AVOID RABID ANIMALS_

Artist	Scene #	Scene Description	Keys	Inbetweens	Clean-ups
R. U.	1	TIMMY WALKS THRU	———		——→
MARK	2	TITLE CARD	———		——→
R. B.	3	DROOL & FOAM	———		——→
MARK	4	TITLE CARD	———		——→
T. J.	5	TIMMY WALKS UP TO FOX	———		——→
R. B.	6	FOX CLOSE-UP	———		——→
T. J.	7	TIMMY THROWS CANDY	———		——→
MARK	8	TITLE CARD	———		——→
R. B.	9	TIMMY GRABS FOR ANOTHER CANDY BAR	———		——→
	10	CREDITS	———		——→

A&S Animation\forms\Who & What

Figure 21-4 Form Who & What for Lesson 3.

Figure 21-5 Project Tracking Form.

Chapter 22
Key Animation

The real fun begins when truly talented animators take a scene and make magic with it. Animators will often adjust the original timings of scenes while they are animating to take advantage of the inspiration they get while drawing. The better prepared each scene is, the easier any potential changes are. The only timing animators shouldn't change is the lip sync.

In key animation, the animators take the character sheets and start roughing in the actions of the characters (Figure 22-1). Rough animations allow animators to quickly capture the character's motions without worrying about the details of the character. While working, they place the background layouts under their animation to make sure the characters line up with the proper background elements.

Animators use either the top or bottom pegs when they animate. Each style has its value. Using the top peg allows you to draw without your hand hitting the pegs and tightening screw on the bottom. It also allows you to flip as many sheets as your pegs will hold (Figure 22-2). Many golden age (1940–1960s when most animation shorts were produced for theatrical distribution) animators could flip the drawings at the exact projection speed of 24 fps. Animating with the bottom pegs allows you roll the drawings while you work. This is helpful for keeping a good feel of the motion while you're working. However, you can only roll about 5 pages at a time (Figure 22-3).

As the animators finish roughing in the main key poses, they start tying down the drawings, or making them look more like the approved character design. They also add in the subtle animation touches such as follow-through, hair movement, subtle emotions, and more (Figure 22-4).

When just one animator is working on a scene, she will do all the drawings and possibly the clean-up herself. If there are other artists working on a scene, the main (also called supervising, lead, or key) animator may just draw the key poses showing the motion extremes. The animator will chart (Figures 22-5 and 22-6) where the inbetweens should go. This chart shows how many drawings need to be drawn

Figure 22-1 Rough animation of the fox's head talking to Timmy.

Figure 22-2 Example of flipping sheets. (Note: Normally the art is right-side up when flipping from the top peg, but we didn't have any scenes that were animated on the top pegs.)

Figure 22-3 Example of rolling pages.

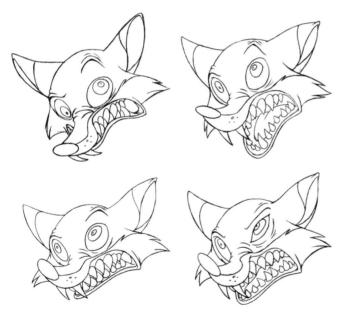

Figure 22-4 Tied down key poses of the fox. Animation by R.B.

between the keys and how close each drawing needs to be to the next or previous one.

The chart in Figure 22-5 shows that the key drawing is 52 and the next key drawing is 56. Drawing 54 will be the inbetween. Drawing 54, then, should be one-third of the

Figure 22-5 The animators will chart how close the inbetweens need to be to the keys.

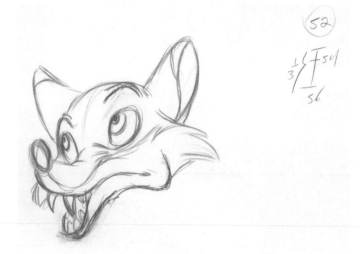

Figure 22-6 This is Timmy from an earlier lesson. The animator notates all the inbetweens from frame 74 thru 82, and that the hand is pretty much the only portion of Timmy that moves. Animation by T.J.

way between the keys. This is an example of "easing out" from a key frame. The closer the drawings are, the slower they seem to move. The farther apart drawings are, the faster they seem to move. Easing out means that the motion starts more slowly and picks up speed as it eases out of a key frame. "Easing in" means that a move slows down as it eases into a key frame.

SHOW: TIMMY'S LESSONS IN NATURE

SCENE	TITLE	CLIENT	SHEET
9	LESSON 2	H.C.	1 OF 3

Dates/Revisions

Import @ 8 field

ACTION	FRAME	DIALOGUE	8	7	6	5	4	3	2	1	B/G	CAMERA INSTRUCTIONS
	1			1	H.C.	1	H.C.					
	2											
	3			3								CYCLE OF FOX FROM OTHER SCENES!
	4											
	5			5								
	6											
	7			3								
	8											
	9			1								
	10											
	1			3								
	2											
	3			5	13							
	4											
	5			3								
	6											
	7			1	17							
	8											
	9			19								
	20											
	1			21	21							
	2											
	3			23								
	4											POCKET H.C. JUMPS TO ARM LEVEL
	5			25	25							DRAWINGS 25 - 73
	6											
	7			27								

START

TIMMY ATOM
TIMMY POCKET
TIMMY BELLY & SHIRT
TIMMY LEG & HERO H.C.
FOX

Figure 22-7 The dope sheet tracks each drawing for each frame. The levels are marked and named across the top, and the frames are marked down the left side.

In addition to charts, the animator may also make notes on the keys drawings as to what needs to be done and what parts of the drawing to pay more attention to. Each drawing also needs to be properly numbered.

When an animator fills out the dope sheet, he also needs to mark the drawings to match. When a character, or

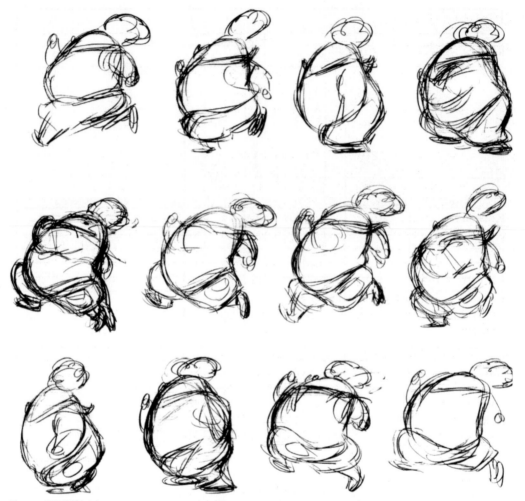

Figure 22-8 Rough animation of a Timmy run cycle. Notice how Timmy's hair bobs, and his large body squashes and stretches as he runs in this 12-drawing cycle. As rough as these drawings are, the character and motion are easy to see. You may see this rough sequence in motion on the CD-ROM: Rough Timmy Run.mov. Animation by R.B.

characters, are drawn in parts using more than one level of animation, knowing which drawings go on which level is very important to the compositors. The dope sheet (Figure 22-7) keeps all the art, levels, and timings organized for each scene.

A talented animator can take a good idea and make it great. People should always be encouraged to enhance projects where their talents are capable. Your project will only be better for it. A number of scenes in our Timmy series have benefitted from talented animators going beyond the storyboards.

Chapter 23

Rotoscoping

The art of rotoscoping consists of drawing over live action to produce your animation. The purpose of rotoscoping is either to animate a scene completely using a live-action reference, or to add animation to a live-action scene while tracking the movement of the camera and the live-action elements. More and more rotoscoping is done these days to produce mattes of elements, also known as rotomatting, within a live-action shot either to remove unwanted elements or to add special effects. For example, if we wanted to visually remove the legs from the character in Figure 23-1, we would pull a matte of his legs. The matte would consist of drawing an outline tightly around the outside of his legs. His legs are now the elements that we may remove or add effects to. In order to remove his legs, we would need a clean shot of the background without the character. The leg elements then would be replaced by portions of the clean background.

There are a number of different ways to rotoscope, and a few of them produce completely different results. Rotoscoping may be used to create a completely realistic motion, or as a test to study motion. Animators who shoot live-action footage and just use it for research are not actually rotoscoping; they are simply using live-action reference for inspiration.

When you are shooting footage for rotoscoping, set your film or video camera to a fast shutter speed. Accurate movement is what you are looking for, and fast movements with a slow shutter will be blurred.

Rotoscoping always starts with storyboarding and then filming live action of the shot you need. If you are shooting with film, you will need the frames scanned and saved as digital sequential files. If you are shooting with video, you will need to be able to capture the scene onto a computer or move a frame at a time with your video player. Some software allows you to rotoscope directly within the program. Figure 23-1 shows a video frame captured into Adobe Premiere and exported as a .TGA file.

The most basic way to rotoscope is to freeze-frame your video image on a monitor, tape a peg bar to your screen,

Figure 23-1
Video frame
of the author
acting up in
the woods.
Shot with a
Sony VX-1000
digital video
camera.

Figure 23-2
Tape a peg
bar to
the top of the
screen and
hang a
cel down from
it to keep
your art
aligned, then
trace your
image.

hang a cel or sheet of animation paper over the screen, and trace each frame on a separate cel (Figure 23-2). Make sure you don't move your head as you trace; if you do, the image you are tracing will shift positions, due to the thickness of the glass. When you rotoscope this way, you need to have perfect control over advancing the image frame-by-frame. And since many video players only hold a pause for up to 5 minutes, you need to work fast.

A much more accurate way to rotoscope is either to paint within a software package or print the frames you need and trace over them on a light table.

To rotoscope with software or to print the frames you need, you should first digitize your video footage. Digital cameras can connect to computers via their firewire connection. There are many video cards that will capture your analog footage through RCA, BNC, or S-Video connections. Once you've captured your video into your computer, you can export the video file from your editing or compositing program as individual sequential files. In other words, export the frames as .jpg or .tif extensions, such as roto-01.jpg, roto-02.jpg, and so on. NTSC video runs at 30 fps. To cut down your work, you can reduce the video to 15 fps. This will be the same as animating on 2 s (2 frames for every 1 drawing). You will find the short video sequence shown in this chapter exported as frames on the CD-ROM.

When adding an animated character to live action, it is always best to rotoscope every frame, or the animated character may seem to slide around over the live action.

Once the individual live-action frames are exported, you need to set up a template in a layout program such as CorelDraw or Adobe Illustrator. In the example from CorelDraw in Figure 23-3, we placed guidelines half an inch from the top and from the left. We then made two crosshairs and included a reference to the frame number on the bottom. Then we saved the form so that it never changes (set the program to "Snap to Guidelines"). Import each video frame into the form and have it snap into the corner of the guidelines. This places every frame in precisely the same position. The crosshairs will help you align all the frames when you tape the header peg strips to the printouts. Print each frame with its own frame number.

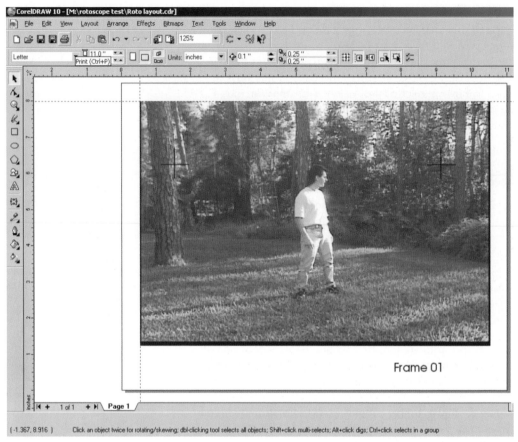

Figure 23-3 Rotoscope template in CorelDraw. The image snaps to the corner of the guidelines, and the crosshairs allow us to line up the images when taping on the animation header strips.

On your light box, place a blank form (with just the crosshairs) down and tape a peg strip to it. (Header peg strips are thin strips of paper with peg holes punched in them; these strips can be taped to any piece of paper.) The blank form is your template for all the other frames. Match the crosshairs of each frame to those of your template. The peg strips will now keep your animation paper and video reference properly aligned. Draw over your reference on new paper and you are rotoscoping. (See Figure 23-4.)

You can also rotoscope within a software program without printing anything. To rotoscope in Commotion Pro, you will need to open a composite the same size and length as your footage. Import your footage and a separate blank level. Make sure the blank level is on top and is set to "Transparent Background." When you have the blank level

Figure 23-4
Use the crosshairs to align your rotoscope prints to the peg bars.

selected, you can draw on it using any of the paint tools (Figure 23-5). When you want to see how your animation looks without the video reference, just turn off the video layer.

In Digicel it's even easier to rotoscope. Import your live-action footage into the background, then paint your images on any layer, using the background as reference. Painting your drawings is the same as filling any scanned image. You can use the drop fill or the brush and paint under the lines (Figure 23-6).

Rotoscoping is a great tool for having fun and learning motion (Figure 23-7). You can also design really interesting animations with it. Many music videos use this technique with a very loose brush stroke. The tools you use will be determined by your final style and what you feel most comfortable with.

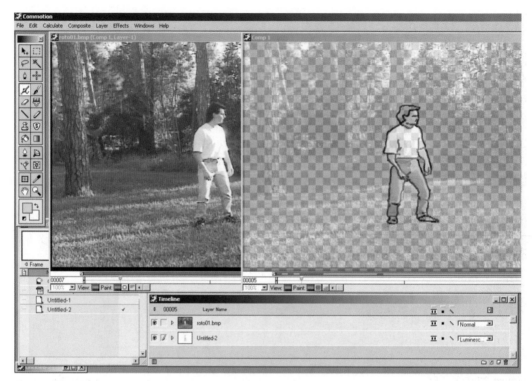

Figure 23-5 Rotoscoping within Commotion by drawing on a blank level on top of the video footage.

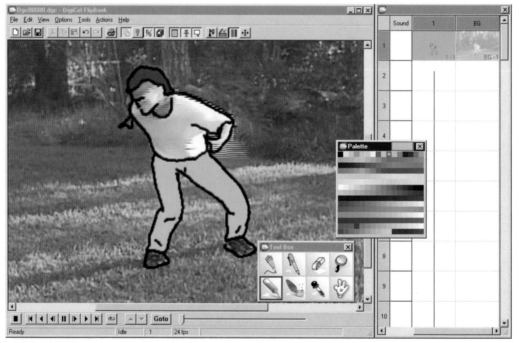

Figure 23-6 Rotoscoping in Digicel by importing the video footage to the background level and drawing directly in the program.

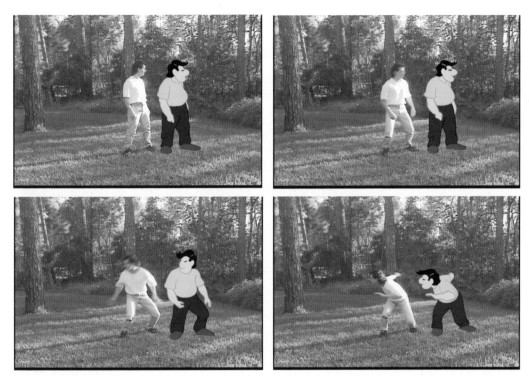

Figure 23-7 Sample images that have been rotoscoped and composited onto the live-action reference plates. The CD-ROM includes a complete rotoscope animation using this reference footage. Animation by Mark Simon.

Chapter 24

Effects Animation

Effects animation is a special art. Effects such as water, props, shadows, flames, and objects other than characters are usually animated separately from character animation.

Lesson 3 has two main pieces of effects animation. One is the foam spewing out of the fox's mouth, and the other is the dripping spit from Timmy's lollipop (Figure 24-1).

Effects are seldom the focus of a scene, so the key animator shouldn't worry about effects details when roughing out a scene; he should be concentrating on the action and acting. Effects can be added after the main animation is tied down.

The spit falling from Timmy's lollipop was animated after we were happy with Timmy's movements. It was animated on its own layer, which was composited on top of Timmy's layers.

Effects animation is a specialized field. It is often overlooked because the best effects animation is likely not to be noticed. When those effects are missing, however, the scenes often look flat in comparison (Figure 24-2).

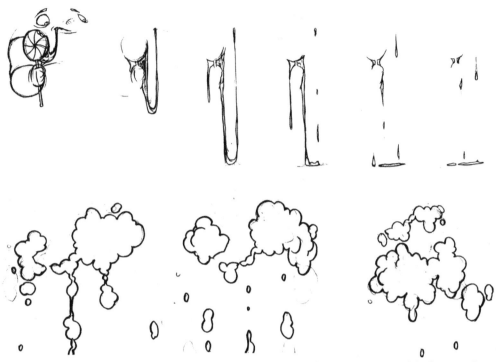

Figure 24-1 Effects animation of spit falling from Timmy's lollipop and foam spewing around the fox's mouth. Spit animation by T.J. and foam animation by R.B.

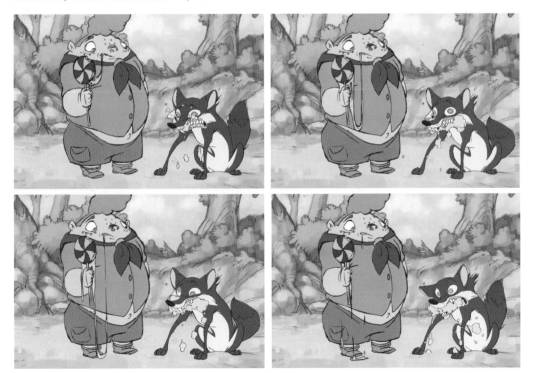

Figure 24-2 Stills from the final animation with the spit and foam effects animation added in.

Chapter 25
Pencil Tests

Pencil tests are quick samples of how the animation looks in motion as it's being drawn. Constant testing of scenes as they are being drawn helps the animator make timing and acting adjustments before the time-consuming and expensive process of finishing the animation. Pencil tests are also used for approvals before the animation goes through clean-up and painting.

There are three ways to run a pencil test: you can use a hardware device without a computer, scan images into a computer, or capture images with a video camera into a computer.

One of the fastest and easiest products to use is a stand-alone hardware unit called the Video Lunchbox Sync. Just plug a video camera into the Lunchbox Sync and hook the Lunchbox to a TV, and you have a pencil test system. The system works with only a few buttons. Changing timings, adding frames, and deleting frames is simple—and it won't tie up a computer or require learning or using new software. The Lunchbox in Figure 25-1 will hold over 6 minutes of animation.

We've used an older version of the Lunchbox in our studio for years (Figure 25-2). We built the copy stand to illuminate from above or from below. Our artists quickly test their animation as they work and make adjustments as they go.

Most cel animation software packages have pencil test modules (Figure 25-3). Unless you have an automatic feed on your scanner, the fastest way to capture your frames into this type of software is to use a video camera. Remember, though, that the highest resolution image you can get is by using a scanner. Scanned images also can have the highest contrast, making any light lines easier to see.

Many animators simply have a video camera pointed at their animation disc, and they use an inexpensive video capture card to grab the frames (Figure 25-4). Higher-end video capture cards, such as the Targa 3000 or the Media 100, allow a much higher-resolution video capture, real-time editing of your tests, and real-time output of your tests at uncompressed broadcast resolution.

Figure 25-1 Video Lunchbox Sync, stand-alone pencil test system, by Animation Toolworks.

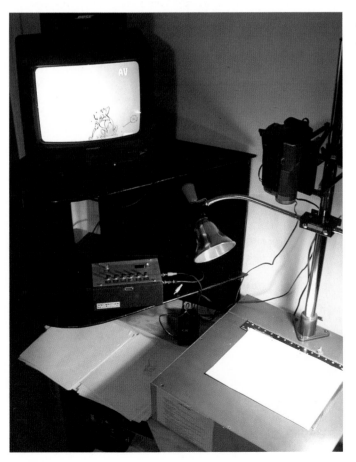

Figure 25-2 Older version of the Video Lunchbox in use at A&S Animation, Inc.

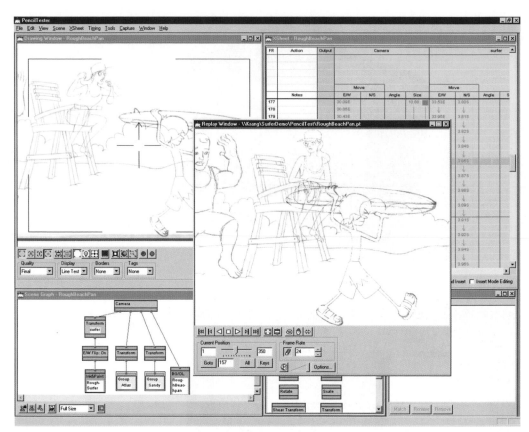

Figure 25-3 Animo pencil test
module.

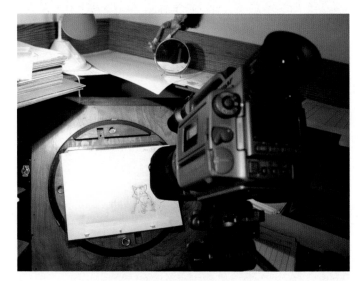

Figure 25-4 You may point a
video camera at your animation disc
for quick pencil tests.

Figure 25-5 USB camera hooked up to our laptop running a Digicel pencil test.

We also run pencil tests on a laptop computer using Digicel and a small PC camera with a USB plug (Figure 25-5). This is an extremely fast and flexible way to run pencil tests. Digicel allows drag-and-drop editing of frames, which means you can quickly adjust your timings without shooting new frames.

Computers can be so inexpensive these days that a software approach, even when it needs a dedicated computer, can be less expensive than other options. Pencil test software programs for PCs range in price from around $100 to around $1,000. A big benefit to using a software pencil test system is that once your timings are set, you can print a dope sheet for reference.

Chapter 26
Enhanced Animatics

An animatic is a work in progress until an animation project is finished. As scenes are pencil-tested and eventually inked and painted, they are edited into the original animatic (Figure 26-1). Each pencil test can either be exported from your animation software or captured from a video tape as a digital video file, then edited into the original animatic using a nonlinear editor. Notice in Figure 26-1 that we used Adobe Premiere to add the new footage.

The original storyboards in the animatic serve as a blueprint for the editor. As more scenes are animated and pencil tests replace the storyboards, you will get a better feel for the look and flow of your story. You may find during production that certain elements need to be adjusted as the animation takes shape. You may also find that a scene is not necessary, or that you need to add a new shot. It's always better and cheaper to make such adjustments prior to the final ink and paint.

Seeing the project build in the animatic is also a great motivator for the crew. On the enclosed CD-ROM you will find a second animatic that incorporates a few of the scenes in rough animation. We did change the timings of a few scenes during the key animation process, and it was all reflected in an up-to-date animatic.

During this phase, for example, we discovered that Timmy's candy bar didn't read as candy, so we changed his candy to a big lollipop. The change not only made the climax funnier and easier to understand, it also changed Timmy's opening scene (Figure 26-2). The scene where Timmy walks past the camera is now funnier because we added an action in which he takes a big bite out of the lollipop.

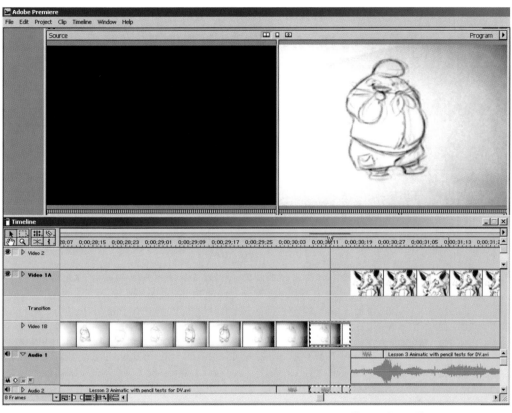

Figure 26-1 The new animatic time line shows pencil tests edited into the storyboards to get a better feel of the flow of the animation as the project progresses.

Figure 26-2 Timmy now holds a lollipop instead of a candy bar.

Chapter 27
Backgrounds

Backgrounds may be illustrated and completed in any number of styles using any number of tools. Many animators and studios use Photoshop or Painter for their backgrounds. Others may prefer actual paint, pastels, pencils, photos, or even computer-generated (CG) backgrounds (Figure 27-1).

When backgrounds are painted in a computer program, the layout drawings are usually scanned and used as templates for the final piece. Illustrations that are finished by hand are then scanned and, if needed, enhanced in the computer. Very large backgrounds are scanned in pieces and then stitched back together in a paint program such as Adobe Photoshop (Figure 27-2).

The backgrounds should be designed to enhance the flow of a project. Make sure that the look and color of the backgrounds work together in each scene. You may have a dark sequence in an alley that is predominantly red. Keep the same tonal values and color in all the backgrounds of that sequence. Color styling will improve the visual flow of a project. Many projects use color keys, which are rough boards of the main actions that allow you to view the project according to the evolution of color in your story (Figure 27-3).

Another important color issue to watch for is ensuring that your characters stand out. It is not a good idea to have a background that is the same color as your character's shirt or pants.

The layouts are given to the animators and the background artists. The animators plan their characters' positions based on the layouts. If any portion of the background image changes position during the painting process, it may completely disrupt what the character does in the scene; in addition, a character may no longer line up with the background. It would not be good for a character to jump onto a rock that is no longer in its original position because a painter moved it.

In *Timmy's Lessons in Nature*, we scanned the layout drawings at a higher resolution than we needed so that we would have room to push in, zoom in, on a scene if we wanted. (Please see Chapter 3, "DPI versus Pixels," for the

Figure 27-1 Samples of different styles of finished backgrounds. Clockwise from the top left: Photoshop painted file over a scanned layout from Lesson 3; color-manipulated photo for the preschool animation *Gina D's Good News*; computer-generated for an American Cancer Society commercial; marker art for the short *Scary Things*; photoshop painting with no scanned layout; and pastel art for the training video *Castle Selling Secrets*. All images copyright 2002, A&S Animation, Inc.; photo Raven Moon Entertainment, Inc.

Figure 27-2 Layout and finished background from Lesson 3. Layout by T.J. and painting by J.P.

chart in Figure 3-6 on determining the proper size and scanning resolution for your digital image.) We imported each layout into Painter or Photoshop, depending on the paint effects we needed. Our background painter used the layout to paint within (Figure 27-4).

When you are digitally painting backgrounds, it is a good idea to paint different sections and objects on separate layers. For instance, the ground may be on one layer, the foreground trees on another, and the sky on yet another. This technique is helpful in a number of circumstances, such

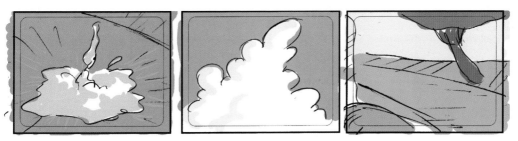

Figure 27-3 The color keys for Lesson 3.

Figure 27-4 The layouts for Lesson 3 were scanned into Adobe Photoshop. Foreground elements were painted on separate layers. A copy of the line art was multiplied and used as the top layer.

Figure 27-5 When a layer is selected, "Multiply" from the layer drop-down menu may be applied to remove the white behind the lines in a drawing.

as when changing the color of one section or making corrections without affecting the areas around the element of concern. The separate layers can also be used for foreground and background objects in multiplane shots.

We then took the layout drawing, changed the line color to indigo blue, and copied it onto a new layer over the painted background. By changing the layer mode to "Multiply," the white background disappeared and only the lines were left (Figure 27-5). This outline quality over the paintings gave our backgrounds a distinctive graphical look, even with a painted texture.

We save our backgrounds with layers as Adobe Photoshop files. When we import the files into Adobe After Effects for compositing, we can use the layers to allow our animated characters to easily pass behind foreground objects. The separate layers also provides us with more opportunities for utilizing effects such as glows, shadows, and color shifts during compositing.

When a scene needs a background to pan, certain considerations need to be addressed. If the pan is limited in length, the size of the layout must be wide enough to accommodate the camera move (Figure 27-6). However, if

Figure 27-6 The sample background is wide enough to pan down and to the right.

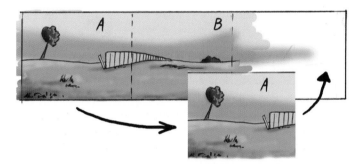

Figure 27-7 In order for a background to cycle, the left side, Section A, of the art needs to be duplicated to the right side.

the pan is so long that the background needs to be cycled, there are a few more things to do to it. Cycling a background means moving the camera across the same background multiple times as if it never ends, creating the illusion of one extremely long background.

Backgrounds that need to be cycled should be laid out at least 2 fields wide, or twice the width of the frame. The 12-field frame on the left side of the background has to be an exact match with the 12-field frame on the right side of the background (Figure 27-7).

In order to make the cycle seamless, digitally copy the left side of the background, at least one camera frame's width wide, and paste it onto the right side of the image. Use your painting software to hide the seam using the blend or cloning tools. In Figure 27-7, you will notice how your background is now broken into two sections, A and B. In

Figure 27-8 Section A has been pasted onto the right side of the background and blended in with Section B.

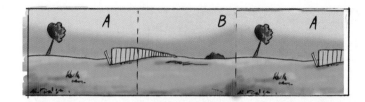

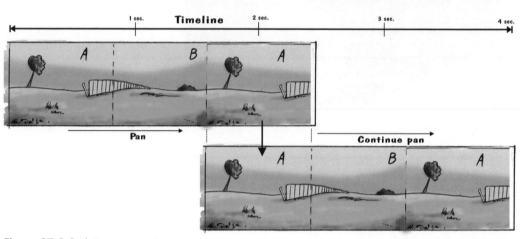

Figure 27-9 Each time a pan gets to the end of the artwork, reposition the art so that Section A on the left lines up with Section A on the right, and continue the same camera move.

Figure 27-8 we have taken Section A and pasted it onto the far side of Section B.

This background can now be cycled indefinitely. To properly cycle the background during compositing, pan from Section A on the left to Section A on the right. At any point where the entire camera frame is within Section A on the right, reposition the background so you once again have Section A on the left in the exact same position as it was on the right (Figure 27-9). If you continue panning the background at the same speed, and it will look like one continuous movement.

Chapter 28

Inbetweens

Once a scene has all of the key animation approved, it is time for the inbetweens. Inbetweens are simply all the drawings that are needed in between the key animation drawings. There may be as few as none or as many as 12 or more between each key.

On small projects, one animator will often do all of the animation, keys, inbetweens, and clean-ups. When speed and efficiency is needed, one animator will work on keys while another fills in the inbetweens and another does the cleanups.

An animator will mark on the keys where the inbetweens should be placed in regard to the keys; this is called charting (Figures 28-1 and 28-2). Not every inbetween should be drawn exactly halfway between one drawing and the next. Figure 28-2 shows the charted positions of the 3 inbetweens to be placed between key drawings 3 and 7. Figure 28-3 shows how the drawings would actually be drawn.

Proper charting allows the animation to move at an interesting pace and not always at one static speed. The farther apart two drawings are, the faster the character seems to move. The closer together the drawings are, the slower the character seems to move.

Figure 28-1 Key frame with animation chart showing relative position of inbetweens between the keys.

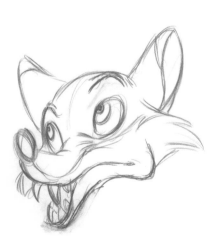

Limited animation means that either there are few inbetweens and the characters jump from key pose to key pose, or just a portion of the character moves, such as just their mouth or one arm. Animations such as *Yogi Bear* and most Flash animations make smart use of limited animation. Even in limited animation there are inbetweens—they may just be inbetweens of an arm, not the entire character (Figure 28-4).

Figure 28-2 Animation chart showing positions of inbetweens for falling ball.

Figure 28-3 Proper positions of an animated ball according to the previous chart.

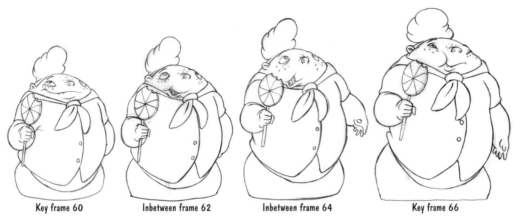

Key frame 60 Inbetween frame 62 Inbetween frame 64 Key frame 66

Figure 28-4 Keys and inbetweens on a Timmy walk cycle. Notice how the animator also added chewing into the inbetweens.

Chapter 29
Clean-Ups

Clean-ups are the final drawings that are to be scanned. A cleaned-up piece of animation will have closed lines around areas for painting in digital ink and paint. Any gaps in a line will cause the digital paint to spread throughout the drawing and will cause the painting process to take much longer. The lines also need to be consistent in both thickness and position from drawing to drawing. Any unnecessary change in a line will make the animation look jerky. That said, some styles of animation prefer to use the rough line quality of a more sketchy line. The most important thing is to have a consistent line quality.

Clean-up animation takes a steady hand and excellent drawing skills. There are many subtleties in many animations, and even a slight change from the animator's intent can change the look of a scene.

Many animation styles do not need a smooth line in clean-up. Squigglevision, as seen in shows like *Dr. Katz* and others, has a very squiggly line (Figure 29-1). With Timmy, we didn't want a perfectly smooth line, we wanted there to be some life to the line. We gave our artists sample line art to follow when cleaning up their scenes (Figure 29-2).

Clean-up artists also make sure that each cell is numbered properly. Large studios have checkers that go over every line to check for quality and closure, and they also make sure the drawing numbers match the dope sheets. Few independent productions can afford this, so the final check is done by the clean-up artist.

Our artists run the final art on the pencil tester for motion approval and inclusion in the animatic. They also use the pencil test to slowly scrub (move forward and backward through the video, frame by frame) between the drawings to see if anything is missing. It's very easy to leave out a freckle here and there, or to forget to include a shirt stripe on a character for one frame while animating. Missing elements are much easier to find when you run the animation in a pencil test (Figure 29-3).

Highlights and shadows that are drawn on the same level as the main character should be cleaned up with a red pencil. The red pencil line will scan black just as the other pencil

Figure 29-1 Dr. Katz used, and coined, the term Squigglevision, a wiggly line animation that kept the image alive on the screen even with limited animation. Image courtesy of Soup2Nuts. © Comedy Partners Copyright.

Figure 29-2 Sample image of Timmy that we gave our artists for matching the line quality.

lines, but the digital painter will use the red line on the original art to know what part of the art needs to be a shadow line. Many animators are used to drawing shadows as separate layers, which is not necessary much of the time. Ink and paint software can easily soften a shadow line within one drawing layer. Drawing the shadow on the same layer as the character saves time in scanning too (Figure 29-4).

Many animators also shade their art to show where shadows are. Even if the shading is in blue pencil, it can pose a

Figure 29-3 Digital artist Karl Haglund at A&S Animation, running a pencil test and checking for missing elements.

Figure 29-4 Red lines on the original art are scanned as black and used to differentiate between normal colors and shadows.

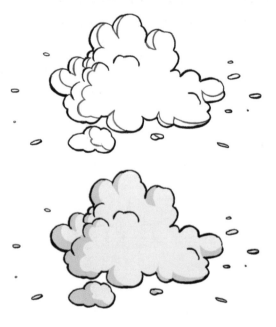

serious problem during scanning—the shading will show up in the scan and hinder the paint process. When animation frames are cleaned up on separate sheets of paper from the rough animation, however, this is not a problem as long as the clean-up artist does not repeat the shading (Figure 29-5).

Figure 29-5 Shaded art, even with blue pencil, can show up in scans (on the right), which makes digital ink and paint slow and tedious.

Some projects do clean up directly over the rough animation. If so, it is imperative that the original blue rough animation is light enough not to be seen in a scan and that there is no shading on the art. When the animator needs to show the shadow in these scenes, he should either use another rough sketch with notes on it or shade on a copy.

Clean-up animation is correct when it retains the feel of the original rough animation, has no line openings, and has no extraneous lines or shading that will be picked up in a scan.

Chapter 30
Scanning

The quality of your scans will make a huge difference in the final quality of your digital cels. The threshold, darkness, or contrast settings can either leave your lines with gaps if they are set too light, or blend your lines together into a large dark mess if they are set too dark. Experiment with your scanner to make sure the settings are as good as you can get them, and mark down and save your settings. Even different pencil leads and animation paper can make a difference in your scans (Figure 30-1).

Most animation software programs can scan your art as black-and-white images and then convert these images into *anti-aliased lines* or *vector lines*. The reasoning behind scanning the lines as black and white is so that the pencil lines all scan perfectly black and the lines end up having a very even tone.

As mentioned earlier, shadow lines are often drawn in red. Red will scan black, but the digital artists will be able to reference the original art to see what lines are drawn in red and are the shadow lines.

Light blue lines normally do not scan, but if your scanner settings are set quite dark, even your light blue lines are likely to show. It is always best to have your art as clean as possible so as to limit any extraneous lines that would then have to be erased digitally (Figure 30-2).

Programs such as Animo and Toonz allow you to customize scan settings to affect contrast and brightness and also offer tools for gap closing, image cleaning, and line width adjustment. You can even save settings according to individual artists to help make all their art look the same.

There are three different types of scanners that you are likely to use. One is a basic scanner, available at any office supply store, that only scans letter ($8\frac{1}{2}$" × 11") or legal ($8\frac{1}{2}$" × 14") sized paper. This type of scanner limits you to animating within an 8-field image. The second type of scanner is an oversized tabloid (11" × 17" or bigger) scanner (Figure 30-3). These are more expensive but will easily scan an entire 12- or 16-field sheet of animation paper. The final type of scanner is an autofeed scanner (Figure 30-4). These are incredibly fast. There are only a few

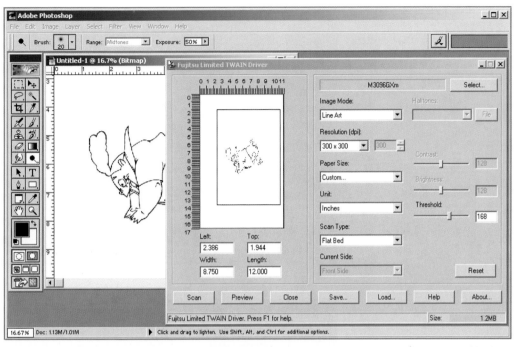

Figure 30-1 Timmy scanned in the Fujitsu 3096 GX large format scanner. Settings are set for Line Art, 300 DPI, and a threshold of 168.

Figure 30-2 Excessive extraneous lines can show up in scans, slowing down ink and paint. Scanner settings can be set to adjust for some lines, but cleaner art is a better answer.

Figure 30-3 Tabloid scanner with a peg bar taped to the scanner platen.

Figure 30-4 Oversized scanner with an ADF (Automatic Document Feeder). Pictured is the Fujitsu M3096 GX.

oversized autofeed scanners, but most studios would never be without them. Contact your digital ink and paint software companies for their recommendations as to what scanners work best with their software. This list is always being updated.

One scanner in our studio is the Fujitsu M3096 GX, shown in Figure 30-4. It is an oversized scanner with an automatic document feeder (ADF). Each scan takes less than 3

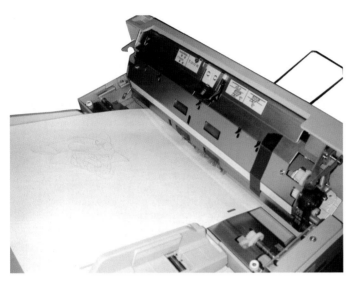

Figure 30-5 Black tape on a scanner in order to scan the animation paper peg holes when using the ADF.

seconds. This is one of the more popular scanners in animation studios. The ADF does not smear most pencil lines, but it can smear charcoal drawings. When using an ADF, it is best to have your animation software automatically line up the art using the paper's peg holes. (Scanners with no ADF use a peg bar to keep the art aligned.) You will have to place some black tape on the scanner, positioned behind the paper holes, so that the holes show up in the scan (Figure 30-5). If your animation timing varies from 1s or 2s, you may also want to place your drawing numbers within the scan area to assist you in placing the drawings on the correct frame in your ink and paint software.

We also use the Microtek ScanMaker 6400XL and 9600 tabloid scanners. We tape a peg bar onto one side and save our scanner settings in the software. Higher-end scanners allow you to customize scanner settings and save *marquee* areas for consistent scans. Marquee areas are portions of an image in your scanning software that will be scanned. They are normally outlined by a red dashed line. (See Figure 30-6.)

It is important that your peg bars don't move and that your marquees stay exactly the same. Any movement of either will keep your drawings from lining up properly. If you can save and lock your marquee settings, do it. Locking the marquee settings in your software keeps someone from accidentally

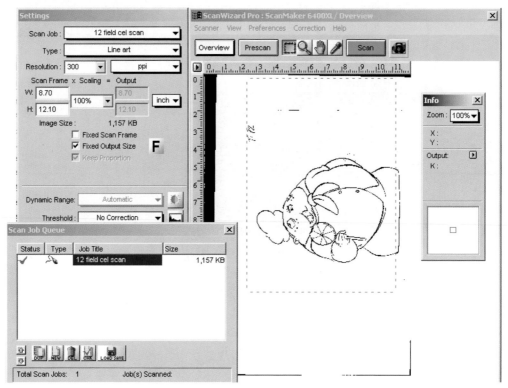

Figure 30-6 The scanning software interface shown, Microtek's Scanwizard Pro, allows you to save the settings such as position of the marquee, threshold, resolution, etc. Saved settings are important so that each scan is exactly the same.

moving your marquee or changing your settings. You should also mark, in pencil or pen, the outline of your peg bar on your scanner flatbed. Just in case the bar moves or you need to take it off, you can put it back in exactly the same position.

Autofeed scanners do not use *peg bars*, but most *digital ink and paint* software programs do not need peg bars. The software actually uses the scanned peg holes in the paper to line up the art, and then automatically crops out the holes.

There are two different ways to scan. One, you can scan the drawings, save the files, and then import them into your software packages; this is often done when your scanner and ink and paint software reside on different computers. Or, two, you can scan directly into your ink and paint software.

When saving the scanned files, take care to properly number each scan so that it will import in the right order. AXA and Digicel share file-naming properties, and many other

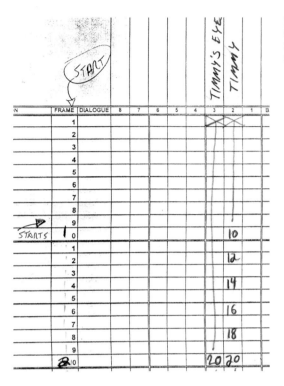

Figure 30-7 The first instance of the drawing matches its frame number, preventing the accidental misplacing of drawings.

software programs are virtually the same. The first drawing may be called L1F001 and the next L5F012. The "L" stands for Level and the "F" stands for Frame. The first drawing example file name, then, would stand for Level 1, Frame 1. The software will import these drawings and automatically place them in the proper positions in the dope sheet.

Numbering of drawings should always be with the frame number of their first instance in that scene. In other words if the drawing on level 2, frame 12 is repeated on level 2, frame 16, call the drawing L2F012. Then place the drawings' reference number (12) on frame 16 in the dope sheet (Figure 30-7). This tells your digital artists to copy the drawing from frame 12 and paste it into frame 16. Numbering in this way prevents a great number of potential dope sheet mistakes.

Programs such as Digicel and AXA will import file formats such as .bmp and .tif. Programs like Animo and Toonz only work with proprietary image formats. Fortunately, these programs come with conversion programs to convert your scans into the type of graphic image they use.

Figure 30-8 Digicel scan window that allows you to input the current frame and level to scan to and the number of hold frames. The frame number automatically advances as you scan.

Figure 30-9 Toonz scanning module with scan parameters and a predefined list of frames.

Figure 30-10 Animo scanning module.

When you are scanning directly into your software, you can set numbering defaults, such as the drawings being on 1s or 2s (Figure 30-8). A default set to 2s tells the software that every scan goes to every other frame, such as frames 1, 3, 5, and so on. Any drawing outside of that naming structure can be scanned into the proper position by paying attention and simply adjusting the settings in the scanner software.

Some programs, such as Animo and Toonz, allow you to set up your timing in a batch scan. You can predetermine what image will be scanned into which frame (Figures 30-9 and 30-10).

The larger format scanners are also nice for scanning large backgrounds. At A&S Animation, most of our backgrounds

Figure 30-11 Animo background scanning module, which allows you to scale, position, and splice together large backgrounds.

are drawn on tabloid paper, 11″ × 17″. Larger backgrounds can be scanned in sections and then composited back together in any paint program (Figure 30-11).

On the *Timmy's Lessons in Nature* series, we scanned directly into Digicel. Before we had the high-speed Fujitsu scanner, we used a scanner on a separate system, saved the files, and imported the images into Digicel on the ink and paint computer. We were able to save time on the slower scanner by using both of the two systems and having two people work at once.

Chapter 31
Digital Ink and Paint

Years ago our only option for painting animation drawings was to trace the drawings with ink onto clear plastic celluloid sheets, or cels. Then the colors were painted, one at a time, onto the back of each cel. The cels were then stacked on racks to dry and took up a great deal of space. As clear as the cels are, they could only be stacked to 6 or 7 levels due to a slightly increased loss of light and color with each layer (Figure 31-1).

Then digital ink and paint came along and offered us a quicker way to paint the drawings. We can now keep the quality of the pencil drawing in the final work, and we are no longer limited in how many levels we may *composite* (layers of art and effects stacked together to form one complete frame).

Digital ink and paint is the computerized version of finalizing animation art using scanning, instead of inking, for each pencil drawing, and digitally coloring instead of hand-painting each cel. With all the ink and paint programs now available we are able to drop fill (single-click paint an entire enclosed area) or use a digital paintbrush to fill colors into our characters. We can change the line color, fix problems in the original art, move and scale the layers of our animation, build a custom palette, and export the final art in a number of different video and sequential still image

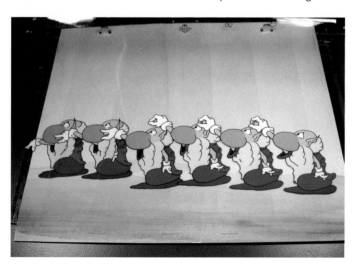

Figure 31-1 Notice that the lowest layer (left) of art is slightly darker than the top layer (right). This is due to the slight pigment in each cel. In the digital world, this loss of light is no longer an issue.

formats. They also all offer dope sheet interfaces for keeping track of scenes.

There are only a few major differences between the available ink and paint programs. The biggest differences may be found in the varying interfaces of each software, how user-friendly they are, project management features, camera and compositing capabilities, and whether artwork is kept as bitmap images or converted to vector images. (Vector images have much smaller file sizes and are resolution independent, can be scaled to any size with no loss of quality, but they can lose some of the subtlety of the original penciled line.)

The different processes within ink and paint software are broken into sections called modules. A number of the more expensive software programs allow you to purchase and install only certain modules, which helps keep the cost for a large production down. A person doing digital painting will probably not need camera or compositing modules, so only certain modules need to be purchased, and these can be spread out among many computers.

Each of the digital ink and paint programs labels its modules differently, but the main modules are usually pencil testing, scanning, ink and paint, camera, compositing, project managing, rendering, and others.

To start the ink and paint process, a number of parameters need to be set for each scene. Every ink and paint program allows you to adjust different parameters, some with very few options and others with a great many options. Different parameters may include

- How far you can zoom in on a scene.

- How many frames the scene is.

- How many levels of animation will be needed.

- How the dope sheet should be set up.

- What direction the scanned images need to be rotated.

- What color palettes to use.

- What the screen aspect ratio should be.

- How light or dark the scanned lines should look.

- And many other parameters. (See Figures 31-2 and 31-3.)

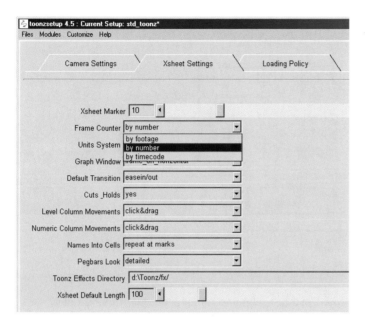

Figure 31-2 Parameter set-up window in Toonz allows you to adjust many settings for each scene.

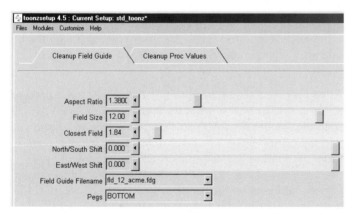

Figure 31-3 Another set-up window in Toonz that allows you to adjust the field size and positioning as well as how the software should automatically clean up the scanned art.

Once you have set up each scene, you may either scan the drawings directly into the program or import the scans you have already saved. If your drawings were numbered in the format the software reads, the imported images will end up in the proper frame and layer on the ink and paint dope sheet. For instance, a file named L3F005 will be imported onto Level 3, Frame 5. Even if your software doesn't understand this file format, the naming procedure keeps it clear to the operator where the image needs to go.

Figure 31-4 Digicel scanning interface with a "hold" set to 2 frames for each drawing.

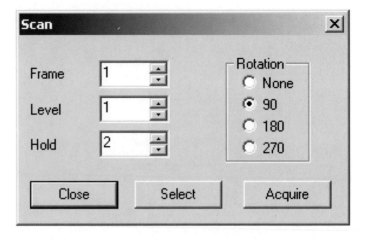

When you are scanning directly into the ink and paint program, you will have the opportunity to adjust all the settings, and preset how the art will be imported and to what level and frame. For example, you may set the software to automatically hold the artwork on 2s (one drawing for every 2 frames), as in Figure 31-4. You may always change the settings if your numbering changes at any time during a scene.

As you set up a scene, be sure to indicate when you need to zoom in and by how much. This informs the program to scan at a higher resolution so that by the time you zoom into the art you won't lose any quality. Every ink and paint program handles this information differently. In AXA, you need to change the input DPI settings for different zooms. In Digicel, you may set the scene to be 100% (12 field), 150% (for zooming in 3 fields tighter), 200%, 250%, or 300% for the largest zoom (Figure 31-5).

You have a couple of options when you scan images. You may scan them as black and white files that have aliasing (a stair-stepped effect on the effect on the edge of angled and curved lines), scan them as grey-tone files that retain the density of your original, or scan them as hand-colored images. Each method has its benefits.

In the case of pencil lines, for instance, which tend to vary in contrast, a black and white scan converts all the lines to a solid black. When importing these images the ink and paint

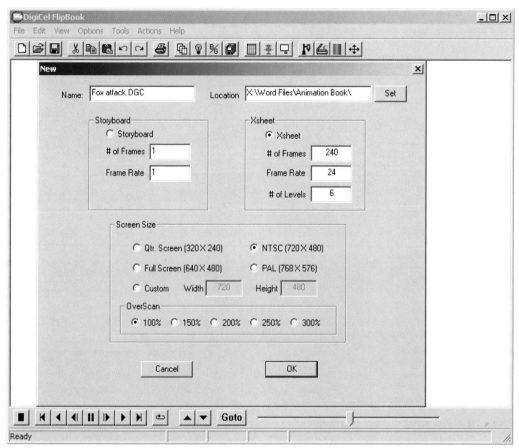

Figure 31-5 Digicel ink and paint set-up window.

program then processes them to give the lines an even, anti-aliased edge on both sides. The lines then have an even tone to them.

The grey-tone scans, on the other hand, have a livelier feel to them. The lights and darks of the pencil line are maintained. However, a lot of extraneous markings and smudges are also more likely to scan. Cleaning each image and painting thus takes much longer.

Once the artwork is in the program, you may copy and paste the cels that are repeated within each scene. The software will automatically update all copies of each piece of art when any one copy has changes made to it. In other words, if the drawing on frame 1 is repeated on frames 9 and 15, you only have to fix or paint frame 1 and the other frames are updated automatically. You may check your

Figure 31-6 Timmy's palette in Toonz.

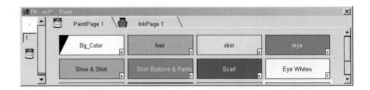

PROJECT: _Lessons_

CHARACTER: _Timmy in Scout outfit_

SCENE:

INK COLOR 58 / 25 / 18

FILE NAME - 'TIMMY.PAL'

Ink	Hair	Flesh	Freckle	Right eye	Shoe & Shirt	Shirt buttons Pants	red scarf	inside mouth	inside teeth				pockets
58	239	245	243	114	178	149	176	78	104				24
25	145	217	176	99	162	118	52	22	93				201
138	29	191	97	181	95	82	14	33	58				157

inside eyes	Lime color	nostrils	eyebrows	left eye	Shoe Sole	Socks	Scarf one	Tongue					
215	59	171	149	220	183	183	205	194					
205	59	150	94	240	150	178	195	31					
255	18	123	30	104	70	186	16	56					

Palette

Figure 31-7 We built a spreadsheet form that matched the shape of Digicel's palette for tracking the RGB number and palette position of every color.

revised scene any time by playing it within your software. Playing a black-and-white version of the scene is also often called a pencil test. This allows you to make sure your animation looks the way you want it to. If there are any problems with your timing, you may add frames or cut and paste your cels. The software Digicel even allows you to drag and drop your art from one frame to another while the animation runs so that you can see the differences as you work.

Painting your cels is one of the easier and more fun portions of the process. When you enter the painting portion of your program, you need to either develop a palette or open an existing one. Some programs allow you to label the colors, but many don't (Figure 31-6). If your program does not label the colors in your palette, you will need to keep track of it on a hard copy. In Figure 31-7 you will find a form we built in a spreadsheet program that allows us to keep track of where each color is in the palette, as well as mark the RGB values (the percentage of red, green, and blue) of each color. This is important in case we have a computer problem and lose our files and need to recreate them. You can also use your screen capture to save a shot of your palette for

reference. The "Print Screen" key on a PC keyboard allows you to grab a screen shot and paste in into a photo editor. On Macs running OS 9, click on Shift-Apple-3. For Macs running Mac OS X, you need to run a program called GRAB. It is well worth the extra time that it takes to make a copy of your palette, for you will use this reference far more than you expect.

Every object in your drawings needs to have its own palette choice, even if many of them are the same color. If you ever need to change the color of an object, you will only need to change that one color on the palette and the object will be automatically updated in the entire scene. If, on the other hand, you use the same palette choice for white socks and for the whites of eyes, and then you want to change the color of the socks to red, you will either end up with red eyes or you will have to repaint the socks in the entire scene. In my studio, we like to set up our palettes so that the first horizontal line in the palette for each character has his or her main colors, and the line underneath has his or her shadow colors. It speeds up painting when the shirt shadow color is directly beneath the main shirt color. You will spend less time looking for the proper color to use.

Here's another color tip: as you finish a complete cel, save it as a model. You can then use that model to quickly grab the colors for your character as you paint (Figure 31-8).

A quick time-saving tip is to paint only one color at a time as you move through a scene. Then choose a new color and go back through the scene. The fewer icons you click on during the process, the faster it will go.

And here's another tip: Choose your background color in your ink and paint module to be a bright color that is not the same as any color in your character. This will help you find holes in your paint. White does not work well since most characters have white in them.

As you paint each frame, you may find missing parts of a drawing, such as a button hole or a freckle. Instead of fixing the original art and rescanning, you can simply add the missing piece with your ink and paint module. Programs that have an onion-skin option make this very easy. Turn on the onion skin, a feature that allows you to see multiple cels that are increasingly more transparent with your current frame opaque and on top. Highlight the cels before and following

Figure 31-8 Character color model in Digicel. Like the palette, the model can be used to grab the paint colors.

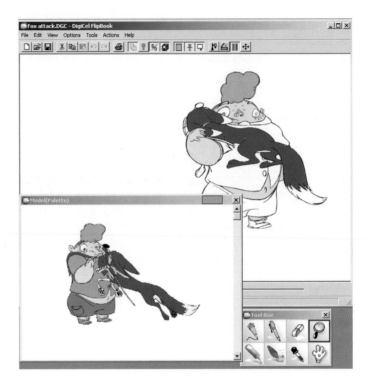

the cel you need to fix as well. Then draw in your missing element using the reference of the surrounding cels (Figures 31-9 and 31-10).

Many programs offer auto-fill, which can mean two different things, depending on the software. In some programs auto-fill fills the characters with one solid color for quick testing through an entire scene. In other programs auto-fill completely colors your characters with all of their colors in the proper place based on the first painted image. When your character makes big moves, this process does not work very well, but if your character is moving slowly, it can work. Be aware that it is sometimes harder to find an area that has been mistakenly colored than it is to paint it right by hand in the first place.

The ink line colors may be changed for an entire scene, or customized in each drawing. When you use the ink-line tool, only the pencil line color will be affected as you color over it. This is helpful, as it does not draw new lines or affect the fill paint (Figure 31-11).

Figure 31-9 Onion skin within Toonz. This allows you to see your current drawing over previous drawings as if it is on an animation disc.

Figure 31-10 Onion skin within Digicel.

Figure 31-11 Colored lines within Digicel. Coloring over lines in ink and paint programs does not affect the paint layer. Notice that the pen icon for coloring the lines is highlighted.

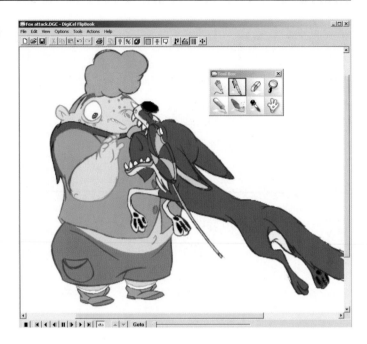

There are two ways to deal with shadows and highlights on characters. You can either draw them on the same layer as the character or draw them on a separate layer. When you use only one layer you simply fill in the shadow area and the separating line with the same color (Figure 31-12). Most programs also allow you to soften the shadow line.

The higher-end ink and paint programs also have the ability to close gaps. Settings can be such that gaps up to a certain size are automatically filled during image processing (which may be a problem in detailed scenes with many lines close together), or you may use a tool to encircle the opening so it will close with a perfectly matched line.

There are many settings to keep track of when you enter the digital ink and paint process. Between your scanner settings, import settings, palettes, export settings, dope sheets, production notes, and other features, the only way to keep it all straight is to use proper forms and vigilantly filling them out. Settings can easily be forgotten when time passes and multiple projects use different settings. See Appendix 1, "Forms," for a number of helpful sample forms.

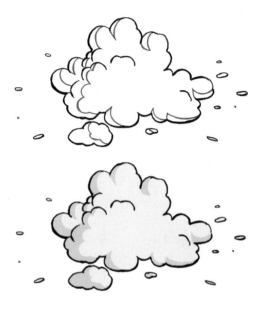

Figure 31-12 Original scan and colored cel with a shadow. The scan shows the shadow lines highlighted in red, the same way the original art would look. The scanner will scan the red line as black.

For *Timmy's Lessons in Nature* we used a combination of Digicel and AXA for our ink and paint. At one point, our scanning station and our ink and paint station were on different computers, so we scanned the cels to files, and then imported the files into the program. We always imported the files a little larger than we thought we needed; this gave us added flexibility in case we wanted to reframe or zoom in on a scene and not lose image quality. Now we scan directly into the ink and paint program using the high-speed Fujitsu scanner. Each character has its own palette and was drawn on its own layer.

Each scene folder, which is passed on to the animator, included the art, the dope sheet, and a form with all the scanning information. Keeping track of each scene's import and export settings is important, then when new and revised artwork is scanned into the scene, it will all line up perfectly. The animator places the final drawings in this folder for the digital artists to scan and use for reference during painting (Figure 31-13).

More and more ink and paint software programs are adding the ability to vectorize the scanned images for output to FLASH. This process makes the files much smaller and easier to use on the Internet.

Figure 31-13 Scene folder with art, scene form, dope sheet, and scan settings form.

Figure 31-14 CTP digital ink and paint program interface.

There are many other ink and paint programs available as well; many are listed in Appendix 4, "Software." We chose Digicel and AXA because the basic training time is less than an hour on each program, and we often employ different assistants to do the ink and paint (Figure 31-14).

Chapter 32

Composite and Export of Individual Layers

The only time you will need to export the individual layers of animation without backgrounds from your ink and paint program is when you will be compositing the layers of animation and backgrounds in a compositing program like After Effects or Commotion Pro. If you plan to do all your compositing in your ink and paint program, you should go on to Chapter 33, "Camera Moves and Special Effects."

I like compositing in Adobe After Effects for two reasons: all of the effects it gives me, and the way the it handles camera moves. To composite in a program like After Effects, you need to scale and separate your layers as needed within your ink and paint software. Other popular compositing programs include Shake, Commotion, Combustion, and Digital Fusion (Figure 32-1). After Effects is the most popular compositing program, according to its sales figures, so more people are familiar with it. This is helpful to small studios who may have a higher turnover and want to limit training time, since so many people know the program.

Any time you want a layer to move on its own or have effects applied only to it, it should be exported by itself. Likewise, when you want to rack focus (shift the focus from one layer to another, normally from foreground to background or vice versa) from one layer to another, they should be exported separately.

Before you export, make sure your image to export is set properly. When you plan for a zoom in a scene, the image you export should be larger than the final video frame size (Figure 32-2). Refer to Chapter 3, "DPI versus Pixels," for size charts regarding zooming.

When exporting layers of animation for compositing in another program, you will want to export your images as 32-bit sequential TGA (a common graphic file extension) files. Your files will be named something like Fox-001.tga, Fox-002.tga, and so on. You set the prefix, "Fox-," and your software adds the numbering. Keep each set of exports in its own directory, such as Scene 6, Fox.

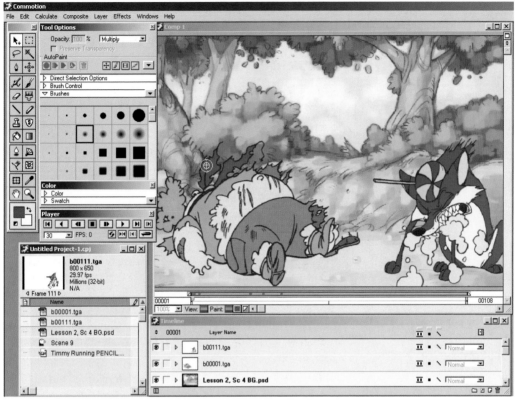

Figure 32-1 Commotion Pro compositing program interface.

When you export your images from your ink and paint program, you may export one file for each frame that includes all the levels of animation, or you may export varying groups of layers. You will have options of exporting 24-bit files of each frame (normally used when compositing the animation over the backgrounds within your ink and paint software), 32-bit files of each layer from each frame, or 32-bit files that composite multiple layers of each frame. Each program handles exporting in a different way with slightly different options (Figure 32-3).

The 32-bit files have transparent backgrounds, which allow you to easily composite them over backgrounds. Each image is made up of a combination of 3 channels (1 color per channel), and each channel is represented by 8 bits of information: 3 channels × 8 bits each = 24 bits. The last 8 bits come from the alpha channel, which represents the transparent area.

Figure 32-2 Notice the white outline boxes that extend beyond the borders of the video image. Those boxes are the outlines of the different elements in the frame that are bigger than the frame. This allows the camera to move on the image.

In Lesson 3 we reused the exported animation of the fox foaming at the mouth in two different scenes. Instead of re-rendering the animation each time, we used the same fox files for the close-up and the two-shot (Figure 32-4).

You will save yourself a lot of aggravation if you can keep all your images properly organized. Save your files in directories that are simply named, and name your scenes with sequential numbers. For instance, have a directory named Lesson 3, a subdirectory under that named Scene 5, and subdirectories under that named Character 1 Export and Character 2 Export. The last thing you want to do is have to search your drives for the right shots.

Figure 32-3 Digicel exporting window.

Figure 32-4 The fox animation in this close-up scene is the same animation shown in Figure 32-2 in the wide shot.

Chapter 33

Camera Moves and Special Effects

Once the animation cels are painted, effects and camera moves need to be added. To perform a camera move in 2D animation, the original art must be larger or wider than the final broadcast frame.

It is always best to composite your layers of animation onto your background in one large comp (composition) and then perform a camera move within that large composition. For instance, if you have a character walking along a path and you want a camera move to follow your character, composite the character on a large background first. Then, design your camera move following the character (Figure 33-1). This easily keeps your character tracked to the background. If you don't do this, you have to set the movement of your background and then track the movement of your character to match—and you have to do this with each element in the scene.

Each compositing program works a little differently, but each allows you to group or nest objects together. Ink and paint animation programs also offer camera moves. Some offer only linear or straight line moves, and others offer very sophisticated vector camera moves that allow bezier curves (curves that are adjustable with handles) and finer timing adjustments (Figures 33-2, 33-3, and 33-4). Camera moves may also include pushing in and pulling out of a scene or even rotating the camera.

Besides the hand-animated effects, such as rendered foam and spit, mentioned in Chapter 24, "Effects Animation," there are any number of compositing effects that you may want to add to a scene. You may want a foreground object to be out of focus, a character to spin around, a change in the color or brightness of a character, a sword to glow, or a character to disappear (Figure 33-5).

Whenever you want an object to be out of focus, or to make any other adjustments to it without affecting the other elements in a scene, make sure that you have it animated and composited on its own level, separate from the other elements. This allows you to add any number of effects to only that object or level.

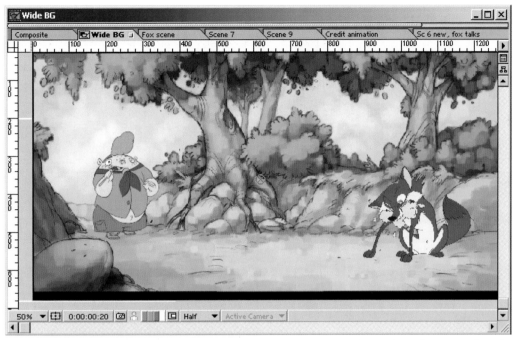

Figure 33-1 Composite of a wide frame with Timmy walking along a path. The camera move follows Timmy on the path to reveal the fox.

In Lesson 3 for instance, we wanted the silhouette of Timmy and the fox behind the smoke to lose color detail and get darker during the first attack (Figure 33-6). We animated and composited the smoke and Timmy on different layers. We painted the smoke with a partially transparent color (we also could have added the transparency in compositing) so that we could still see the attack. In After Effects we took Timmy's level of animation and added key frames on blur, contrast, and brightness at the beginning and at the end of the transition to go from full detail to little detail.

There are also more and more programs that offer multi-planing, the simulation of 3D movement in a 2D space. Programs such as Animo allow you to place your 2D layers in a 3D space, much like looking at a construction blueprint. In the plan view, you can design your camera move around and through your animation (Figure 33-7).

Compositing programs and some animation programs such as Animo and Toonz, also allow you to matte a portion of your background in such a way that your characters seem to pass behind background objects. A matte blocks a portion of an image from being seen. For example, if you have a

Figure 33-2 Animo screen shot of its Director module where camera moves are planned.

background of a forest and you want your character to pass behind a tree, you can place a matte on one of the trees and it will then block the view of your character, making it seem like your character passes behind it (Figure 33-8).

The abilities and interface of camera moves within animation programs are where the programs vary the most. Whereas all programs function using key frames, some programs do not provide visual representations of the key frame elements and the ability to move or manipulate them easily. Some programs allow you to simply determine the key frame positions of your animation, while others can show you the actual camera path and allow you to move it around interactively.

On my productions, we tend to use compositing programs for all of our camera moves. We use the animation

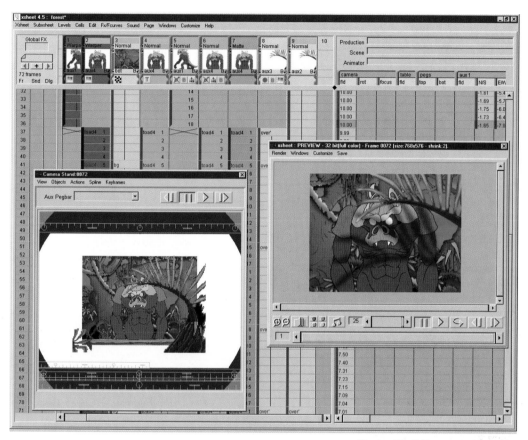

Figure 33-3 Toonz camera stand. Notice how a number of the elements are seen outside the frame. Only those portions inside the frame will be composited in the final image.

programs to layout our timings and paint our frames. Most of our effects and moves happen within After Effects. All of our new employees know After Effects, and since we are a small animation house, this approach limits our new employee's learning curve.

In Scene 5 Timmy walks up a path in the woods and stops next to a foaming rabid fox. The camera move is important because it allows us to reveal the fox during the scene. The background is quite wide to allow the virtual camera to pan across it with Timmy. (See Figure 33-1.)

In order to track the camera with Timmy as he walks across the background, we need to use After Effects to nest compositions, or place one complete composition within another (Figure 33-9). Notice the dashed line in the center

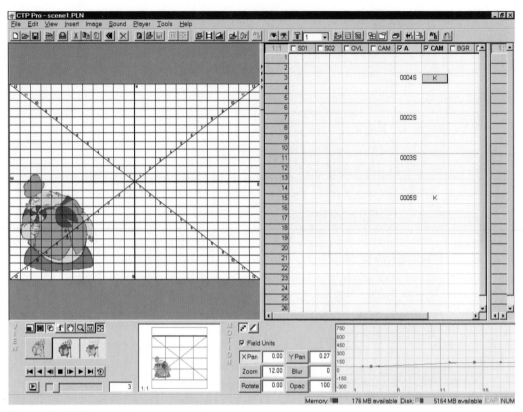

Figure 33-4 CTP scene planner.
Notice the effects you can place on
each level: X and Y pan, zoom, blur,
rotate, opacity, and others.

of the frame. That's the camera path through the wide
composition. We built one large composition that includes
the entire background, the fox, and Timmy walking on the
path. We then took the large composition and placed it
within a composition the size of our final rendered video file.
Then we moved the first composition under the camera to
follow Timmy. After Effects allows you to adjust the path of
your camera move as well as adjust the speed during any
part of the camera move.

There are almost limitless effects that you can add to your
animations. You can change the color balance, add glows,
add noise, rotate objects, add lens flares, change color tint,
add shadows, distort images, pull mattes, emboss, and
more. You are limited only by your software and the plug-ins
you have installed. Plug-ins are mini-software programs that
work within a larger program. For example, we use Knoll
Lens Flare as a plug-in for After Effects and other

Figure 33-5 After Effects effects list. Each main item listed has a number of effects within it. There are also many plug-ins available for After Effects that make the number of effects available almost limitless.

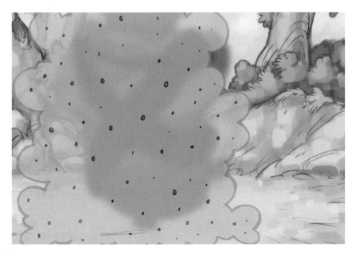

Figure 33-6 Frame from Lesson 3. The fox attacking Timmy and the smoke cloud were animated and exported separately. This allowed us to animate the transparency of the smoke that revealed part of the attack, without affecting any other art.

Figure 33-7 Multiplane feature in Animo. The thin vertical lines in the camera window represent the different 2D images in the scene, such as the curtains, elephant, and background seen in the image. The black angled lines represent the camera's view. As the camera moves past the 2D layers, they will seem to move as if in 3D space.

compositing programs. Knoll sells a plug-in for installing into After Effects that produces wonderful lens flares. Ink and paint programs allow color shift, blurs, rotations, and a number of other effects, but compositing programs have the largest set of options. Many productions mix and match effects and compositing options depending on which programs offer the best solutions to particular problems. You simply need to plan your animation to allow an easy separation of elements in order to add effects where needed.

Figure 33-8 Animo screen shot showing the original drawing of an octopus and how portions of that image can be matted to appear to go behind another character in the frame.

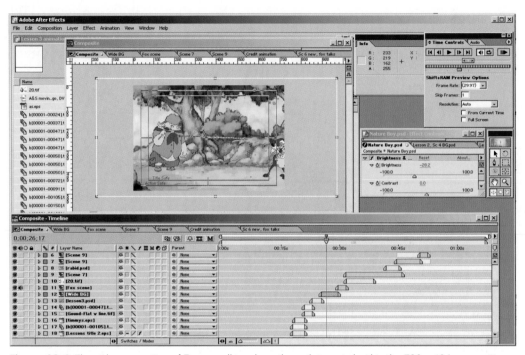

Figure 33-9 The wide composition of Timmy walking down the path is nested within the 720 x 486 composition for our final render.

Chapter 34
Final Image Composite

Once you have all of your elements compiled and you're happy with the camera moves and effects, it is time to render the scenes for use in your editing program. The closer to real-time audio and video playback you can work, the better your audio editing and your video timing will be.

How you render your scenes for editing depends on your editing system. We use the Targa 3000 video card with Premiere 6 RT for our final editing (Figure 34-1). The card edits real-time with full uncompressed video. Therefore we composite our scenes out of After Effects in full uncompressed video for the best image possible, and we could still edit with it easily (Figure 34-2). You will need to have your software export a video file using whatever video codec (compression/decompression software) your system calls for.

You may also render uncompressed sequential frames. Sequential frames won't play back real-time on edit suites, but they are compatible with most systems (Figure 34-3). The most popular formats for sequential images are 24-bit .tif and 24-bit .tga (Targa) files. You can carry these on CD-ROM to any post-production facility, and they can import the files, render them into a video format, and perform your final edit and output to tape.

Figure 34-1 Adobe Premiere 6.0 RT edit suite on the Targa 3000 video card.

Figure 34-2 After Effects Render Que. From the "Composition/Make Movie" window, you determine your output parameters in the Render Que. Notice we have the "Quality" and "Resolution" set to "Best" and "Full," respectively, to get the best image.

If you are compositing from your animation software, you will be compositing one scene at a time. Most ink and paint software programs also allow you to batch composite multiple scenes at once (Figure 34-4). You will edit all the scenes together with your audio in your editing program.

You should keep your exported composite uncompressed to retain the highest quality. Uncompressed sequential images, .tif, .tga, or .pict, are the most common to work with. Uncompressed video can be either a .mov or an .avi file. If you start with a compressed video file, you will lose even more quality when you have to compress it again to export your finished edit.

Setting your composite to number sequential frames properly is also important. Your sequential files should start with frame 0001, not 0000 or 0033. Many edit suites will not import sequential files that do not start with frame 1. It is also best to make sure your file naming structure does not exceed 8 letters and/or numbers. Macs that do not run Virtual PC, a program that, among other things, allows them to read the long Windows file names, will only read the 8 letters/numbers of the DOS equivalent of the long Windows file name. (There is still DOS code dealing with file names within the Windows environment.) Therefore, your naming

Name ▲	Size	Type	Modified
b00001.tga	84 KB	TGA File	2/7/2002 5:49 PM
b00002.tga	84 KB	TGA File	2/7/2002 5:49 PM
b00003.tga	84 KB	TGA File	2/7/2002 5:49 PM
b00004.tga	84 KB	TGA File	2/7/2002 5:49 PM
b00005.tga	85 KB	TGA File	2/7/2002 5:49 PM
b00006.tga	85 KB	TGA File	2/7/2002 5:49 PM
b00007.tga	88 KB	TGA File	2/7/2002 5:49 PM
b00008.tga	89 KB	TGA File	2/7/2002 5:49 PM
b00009.tga	89 KB	TGA File	2/7/2002 5:49 PM
b00010.tga	92 KB	TGA File	2/7/2002 5:49 PM
b00011.tga	92 KB	TGA File	2/7/2002 5:49 PM
b00012.tga	78 KB	TGA File	2/7/2002 5:49 PM
b00013.tga	78 KB	TGA File	2/7/2002 5:49 PM
b00014.tga	82 KB	TGA File	2/7/2002 5:49 PM
b00015.tga	82 KB	TGA File	2/7/2002 5:49 PM
b00016.tga	79 KB	TGA File	2/7/2002 5:49 PM
b00017.tga	79 KB	TGA File	2/7/2002 5:49 PM
b00018.tga	80 KB	TGA File	2/7/2002 5:49 PM
b00019.tga	80 KB	TGA File	2/7/2002 5:49 PM
b00020.tga	85 KB	TGA File	2/7/2002 5:49 PM
b00021.tga	85 KB	TGA File	2/7/2002 5:49 PM
b00022.tga	92 KB	TGA File	2/7/2002 5:49 PM

Figure 34-3 Partial directory list of files built as .tga uncompressed sequential images.

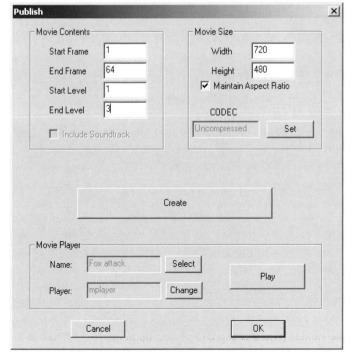

Figure 34-4 Exporting a video file from Digicel using their "Publish" window. Here you will set the frame size, length of the file, what levels of animation should be included, and the video codec to use.

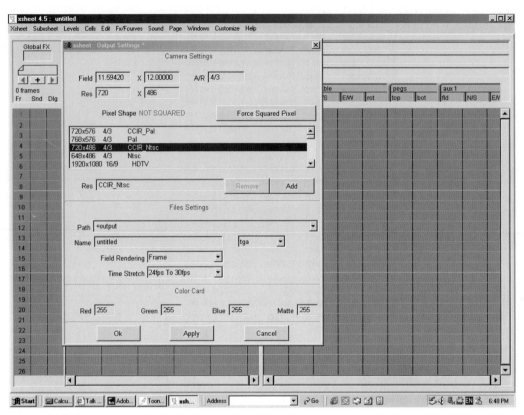

Figure 34-5 Toonz output settings for exporting video files. These settings are set within the x-sheet module.

structure should be XXXX0001. For example, our Timmy files could start with the file name TIMY0001.tga or sc3-0001.tga (Scene 3, frame 1). If you are compositing on a Macintosh, remember to add the three-letter **file extension**, .tga, or .tif. PCs will not import graphic files without the three-letter file extension.

If your compositing software does not number your files the way you need, you will have to rename them. Renaming hundreds of files by hand can be tedious, but there are great programs that will do it in an instant. For Macs, there is a shareware program called A Better Finder Rename. For PCs there is a freeware program called Rename It (Figure 34-6). Both are listed in Appendix 4, "Software," along with others.

If you animated to 24 fps and want to output your project for video or TV, you will need to get your footage to 30 fps. You can stretch your footage in your compositing program and

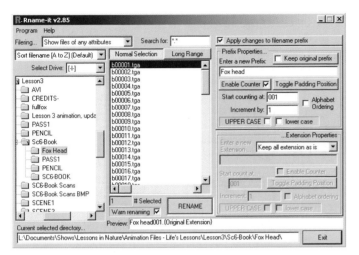

Figure 34-6 The program Rename It, and others, can be used to quickly rename groups of files that can be used with most computer systems.

Figure 34-7 After Effects time-stretch window. This can be set to 125% to stretch your 24 fps footage to 30 fps.

render 30 fps **sequential images**, render sequential images at 24 fps and stretch the time in your editing software (125%) (Figure 34-7), or render your scenes as .mov or .avi files and do a **3:2 pulldown**. A **3:2 pulldown**, or **telecine**, converts your footage into **fields** (upper and lower, or Field 1 and Field 2) and mixes the fields in a 3:2 pattern to stretch the length of the project (Figure 34-8). Field render may be set either to upper or lower field first

Figure 34-8 Render settings window in After Effects.

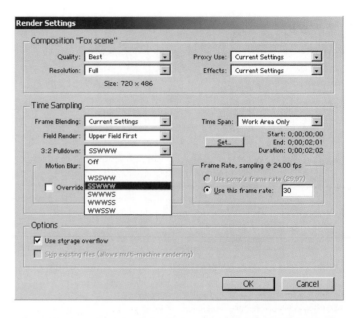

Figure 34-9 Time line of Lesson 3 in After Effects. Notice that some scenes had their own composition. Then all the scene compositions and other elements were compiled into one composition for the final composite/export.

(field prominence). Make sure all your elements are saved the same way, mixing field prominence will make portions of your edit look blurry. The 3:2 Pulldown options, listed with Ws and Ss (i.e., WSSWW), stand for Whole frame and Split frame. Split frames combine two frames around them to make a new frame, thus gaining the extra frames to stretch from 24 fps to 30 fps.

If you animated at 24 fps and you're going to film, or if you animated at 30 fps and you're going to video, export your sequential frames as they are, or export your digital movie file, .mov or .avi, as it is.

With Timmy, we built all of our camera moves in Adobe After Effects. Each scene has its own composition that compiles all that scene's elements. We also have one composition that includes all the scenes in order. This all-encompassing scene allows us to export one video file for the length of the project, saving us compositing and editing time (Figure 34-9). We stretched each series of composited animation files and exported sequential .tga images at 30 fps.

Section D
Post-Production

Section D
Postproduction

Chapter 35
Title Cards

Most projects have or need an opening sequence showing the title of the project. Often, as in *Timmy's Lessons in Nature*, the opening consists of a series of title cards or title sequences. These cards or sequences need to reflect the look and feel of the rest of the project. They can be simple text over black. They can be animated like the opening of each episode of *The Simpsons*. They can be anything you desire, but you should try to have them work with or enhance the rest of the production (Figure 35-1). In our Timmy shorts, we wanted the opening cards to have the colorful look of old educational shorts while introducing our main character, Timmy. We kept the cards as static pieces of art, with the exception of the squirrel on the main title page. Each image introducing Timmy is in character and helps prepare the audience for how goofy he is (Figure 35-2).

Most of the title cards were produced in Adobe Photoshop. The files were made to be 720 pixels × 540 pixels. The size of our video files is 720 × 486, but since NTSC D1 pixels are rectangular and Photoshop pixels are square, we had to adjust for the different shaped pixels in the size of our images. (See Chapter 3, "DPI versus Pixels," for more

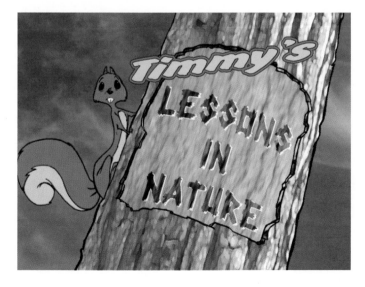

Figure 35-1 *Timmy's Lessons in Nature* opening title card with an animated squirrel.

information on resolution.) The animated title sequence was built in After Effects.

Vector programs such as CorelDraw and Adobe Illustrator do not work in pixels; they are resolution independent. When you use these programs to design your title cards, make sure your design is in the proper screen ratio for your presentation format (Figure 35-3).

Once your design is complete, export the image to any RGB file (the color mode of images for broadcast) type that your compositing or editing program can work with. We usually export either .tga or .tif files, which are uncompressed. Although .jpg files are much smaller compressed files and also work, you may see the compression in your final image.

All important imagery and text needs to be within the **safe areas** or **safe zones** (Figure 35-4). Television sets enlarge video and chop off part of the image. This is called **overscanning**. Every television cuts off a different amount of the entire image that is projected. Title safe is the area of

Figure 35-2 Graphic card introducing Timmy.

Figure 35-3 Ratios of different entertainment formats.

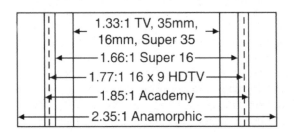

the frame where all text should be kept, and action safe represents the boundaries for any important graphic or motion. Compositing and editing programs allow you to view these boundaries as you work.

The timing of your title cards is also important. You need to make sure that the average viewer has enough time to read everything on the screen, but that the image doesn't stay up there so long that he gets tired of it. Like the rest of your project, you want the timing between your title cards to have the proper flow. Practice will help you determine what is the appropriate length of time to have any cards on the screen. You may want to use a stopwatch to time yourself reading each of your title cards.

Technology allows us to do amazing things with images these days. It is very tempting to design dazzling title cards that have a tremendous amount of layering and special effects. Many television programs have extremely complicated opening sequences that take a very long time to produce. But just because it is possible to do all these

Figure 35-4 Action Safe and Title Safe can be shown within After Effects. Notice that the text stays within Title Safe and the drawing stays within Action Safe.

things, doesn't mean that it's right for every project. You may find that small white text on a black background with a voiceover or theme music sets the proper tone for your project.

Our decision to have simple graphics for our opening titles works very well for the show stylistically—and they were very fast and easy to do. Photoshop was used to create the carved version of the title, Lesson 3 (Figure 35-5). The texture came from a tree trunk we took a photo of behind the studio.

Chapter 36
Credits

There are four basic ways to produce your credits: (1) they can be single graphic cards; (2) they can be produced within your edit suite; (3) they can be produced in an outside title program; or (4) they can be built in a compositing program.

If your show has only a few names that you need to credit, you can make some graphics cards and either set the timing in your editing program or in your compositing program. Otherwise, you will most likely want a rolling credit list.

Most edit suites allow you to make basic credit crawls. In Premiere, select the rolling title tool (Figure 36-1) and drag to the size you want your titles to be. Then type in the text. Select "Title/Roll Options" and choose the options you want. The speed of your text title crawl is dependent upon the length of time you have your title on the time line.

There are many different titling programs, from TitleDeko to Chyron to Inscriber to Boris Graffiti, that all give you many options. These programs generally offer you more text fonts, styles, and effects than those in editing programs (Figure 36-2).

TitleDeko is a popular program for still and rolling text. It works as a plug-in for Adobe Premiere and Avid. It has a tremendous number of prebuilt samples of fonts, styles, and formats, and it is fully customizable. The quality is also wonderful.

You may also build a large graphic file with your credits typed on it. You can import this file into your compositing program, or build the credits in your compositing program (Figure 36-3) and animate a camera move to have the text move by at the speed you wish.

Once you've completed your credit roll, export the video file for use within your edit suite (unless of course the credit roll was built within your edit program).

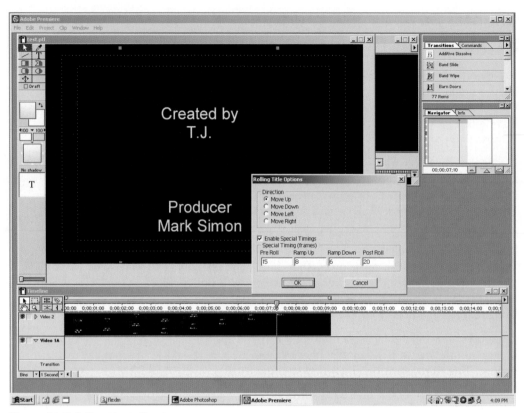

Figure 36-1 Rolling titles in Premiere.

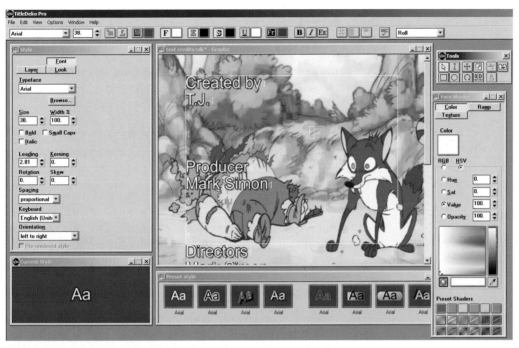

Figure 36-2 TitleDeko Pro interface running credits as a plug-in within Premiere.

Figure 36-3 A tall composition in After Effects with text on it may be animated to form a credit roll.

Chapter 37
Editing

Unlike live-action production where the editor has lots of footage to choose from when editing, animation has very little, if any, extra footage to edit. The shooting ratio of footage shot to final product for live action is anywhere from 3 : 1 to 15 : 1. In animation, that ratio is 1 : 1. You don't want to draw anything that won't end up on the screen. It takes too long and costs too much. In *Timmy's Lessons in Nature*, we used every frame of animation we drew in the final edit. (See Figure 37-1.)

You may find that you need to either lengthen or shorten a cycled sequence to make a scene feel right. Maybe a scene needs a longer hold at the end. Maybe a title card needs to be held longer. These elements may be easily adjusted in editing or compositing.

In our final editing of Lesson 3, we kept playing with how long Timmy looked away from the fox and how long the fox waited before attacking. We removed and added single frames until it felt just right. The length of a single frame sometimes makes a big difference.

You may also find that you need to rearrange the order of your scenes to have the story make more sense, or to heighten the drama. This happens more than you might think. Be open to rearranging scenes if necessary. Working with nonlinear editing systems makes this very easy and fast.

Since most cel animation is digitally painted and composited, you will most likely use a digital nonlinear editing program. Programs such as Adobe Premiere (the most popular due to its price and ease of use), Speed Razor, Incite, Avid, and others are all nonlinear programs.

During editing, you will compile all of your production elements, title cards, credits, footage, sound effects, music, dialogue, and more. If your project is to be broadcast, you should also have color bars and tone (a preset audio tone) at the beginning (to allow broadcasters to check color and audio levels) and a countdown leading up to the beginning of your piece. Many edit suites can put bars and tone onto your master tape during your final playback to tape (Figure 37-2).

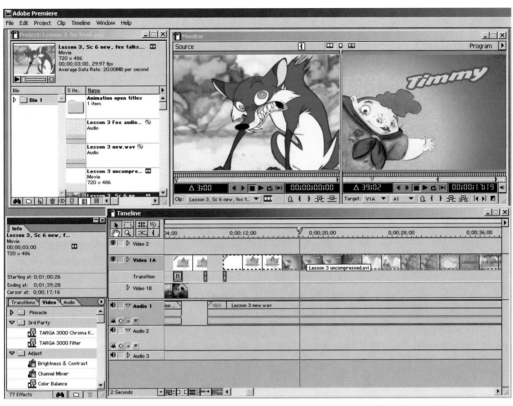

Figure 37-1 Adobe Premiere is a popular nonlinear editing tool that works very well on PCs and Macs.

Figure 37-2 Color bars.

If you plan to produce your audio in a program outside of your editing program, or if you have an outside house producing your audio, you will need all of the visual elements complete before the audio can be finished. The final audio needs to be timed to the final video length. Then you will take the finished audio file, most likely in .wav or .aif format, and drop it into your nonlinear editing program for final output. See Chapter 38, "Music and Sound Design," for more information.

In the Timmy series, we edited the audio within our edit suite on two episodes and at an outside audio house on the third episode, which is shown in this book. When you edit the sound in your edit program, you will use many levels of overlapping audio for the dialogue, effects, and music. Most programs will allow you to expand your audio levels to at least 99 levels. As you layer in your audio files, you will need to balance the levels of each so the dialogue is easy to understand and none of the audio is distorted.

One of the first signs of low-budget animation is bad lip sync. You always hope that your animation is perfectly synced to the audio, but dialogue often has to be re-recorded. Take great care to match the sync of the new audio to the animation; it will be worth your time.

In most animation, you will not need to worry about adjusting the color levels of your scenes, as the digital animation files should be perfect. However, if you are mixing any live action or stop-motion footage, you may find that you need color adjustment. Color shifts in video footage happens most often when the camera was not properly balanced to white for each scene, or the automatic settings in the camera changed due to fluctuating lighting conditions. Once a camera is white balanced in a location, the automatic features should be turned off.

Editing programs offer filmmakers many different styles of transitions, from the basic cuts and dissolves, to fancy blinds opening, page turns, rotating cubes, and too many others. The best transitions to use are simple cuts and dissolves. Fancy transitions often look cheap and usually make projects look like training films and not high-quality entertainment. Watch your favorite films and TV shows and you will notice only cuts and dissolves (Figure 37-3).

Once your edit is complete, make sure to back up your files and you are ready to output to tape or film.

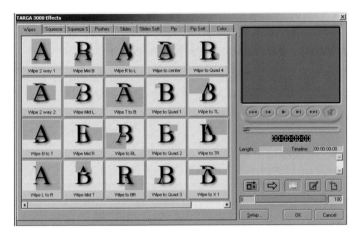

Figure 37-3 The number of available transitions grows every year, yet cuts and dissolves are still the best storytelling transitions.

Chapter 38
Music and Sound Design

Music and sound effects are the final touches that give your project life. The right music can help your animation flow, and sound effects can give your work a solid feeling that adds to the illusion of life (Figure 38-1).

If you are lucky enough either to afford an outside audio house or to make a deal with one to provide you with music and sound effects, they will need the final edit of your animation to work with. Try to make sure that you don't give an audio house a video file that does not have a locked edit, or the work they do might be a waste of time. Any timing changes you make in the video will throw off the audio timings. Check with the audio facility as to the format in which they would like to receive your video. They may ask you to provide them with a low-resolution .mov file or a simple VHS tape to work with. They will in turn provide you with an audio file that you drop into your edit suite.

On the third episode of *Timmy's Lessons in Nature*, we had an Orlando music and sound design company, Sound"O"Rama, produce the music and sound effects (Figure 38-2). We provided Sound"O"Rama with a 320 × 240 dpi .mov file of the final edit. They came up with a few samples of music for us based on the style of music we asked for. They then produced a custom music track that supported the action in our short. They added all the sound effects, from the chirping of the squirrel in the opening credits, to the vicious attack of the rabid fox. During the audio production I would go to the studio and make notes as to what sounds I liked and what sounds needed to be enhanced. Once their work was done, they provided us with a stereo .wav file that we dropped into our Premiere edit suite (Figure 38-3).

On the first two episodes of *Timmy's Lessons in Nature* we produced all the music and sound effects in-house. We used a program called SmartSound to build the music. SmartSound also has a professional version that allows you many more options when building a music score, including importing the video. Its software builds music according to the length of time you specify, the style of music you want, and a number of other options. The quality of the music is

Figure 38-1 Audio wave file for Lesson 3.

Figure 38-2 Steven Bak, sitting, and K.C. Ladnier standing, working on the sound effects for Lesson 3.

wonderful, and it's very easy to use. A sample of SmartSound is on the enclosed CD-ROM (Figure 38-4).

Another music production software is Acid. With Acid, you not only determine what type of music you want, you actually build the different levels of instruments until you're happy. Acid is often used for the Internet and for presentations where music loops are needed. A sample of Acid is also included on the CD (Figure 38-5).

Figure 38-3 ProTools screen capture from Lesson 3. Sound"O"Rama produced the sound effects and audio sweetening. ProTools would play the animation video file along with the audio.

Figure 38-4 SmartSound. A quick, high-quality, semi-custom music software.

Figure 38-5 Acid. A high-quality music composition and looping program.

Lesson 3 had professionally produced original music. Kays Al-Atrakchi of Sound"O"Rama wrote and composed the music using the music composing software, Digital Performer. We would sit down together and watch the animation while listening to his music. I made comments on the feelings I wanted to portray and where I felt the important beats were, and he also made suggestions as to what he thought would work best. He adjusted his music to rise and fall along with the action. Using Digital Performer, Kays would lay in all the instruments one at a time using his piano keyboard. The software captured the music and allowed him to edit the music in any way he wanted. He then exported the music as a digital file to be edited in with the other sound effects (Figures 38-6 and 38-7).

We either found the sound effects that we used on the sound effects library CDs owned by our studio, or had them custom-made. There are many sound effects libraries available for purchase. You can also find a number of free

Figure 38-6 Kays Al-Atrakchi of Sound"O"Rama composing the original score for Lesson 3.

Figure 38-7 Digital Performer music composition screen from a commercial. Music by Sound"O"Rama and production by A&S Animation, Inc.

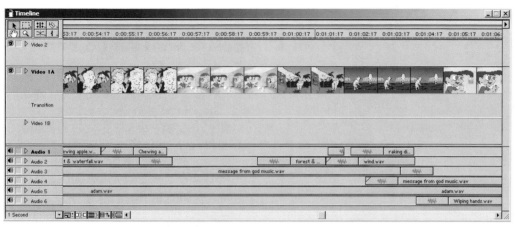

Figure 38-8 Six levels of audio were used in Adobe Premiere for the production of *A Message From God*.

sound effects on the Internet. For animation, one of the most popular libraries is the Hanna Barbera Sound Effects library of four CDs from Sound Ideas, www.sound-ideas.com. Each library also comes with a database that allows you to search for sound descriptions, and the results show you where to find the sounds. There are also a number of sites on the Web that offer free or inexpensive sound effects such as www.sfx_gallery.co.uk, www.hollywoodedge.com, www.hulabear.com, http://wavcentral.com, www.sounddogs.com, www.a1freesoundeffects.com/computer.html, www.soundfx.com. You can do a search for "sound effects" or "free sound effects" on the Web and find hundreds more.

Making custom sound effects is fun and a challenge. For instance, we needed the sound of a large juicy plop. We used the insides of a watermelon, added pudding and other disgusting things, and dropped it on different surfaces until we got the sound we were looking for. Regardless of how you record effects, you will need to digitize them. Make sure you name and properly file them so that you don't forget what you have and so that you can use them again on future projects. This way you build your own library of sounds.

In Premiere we placed the music on one level and added the audio on a number of other levels (Figure 38-8). We then go through the entire project and adjust the audio levels.

Once the audio is complete, we are ready to output the file to tape or to film.

Chapter 39

Final Composite with Audio and Output to Tape or Film

You've finished your project. All the animation is complete, the music is perfect, and all the sound effects are in. You do your final composite only to realize that one frame wasn't painted properly, or there's a problem with the audio. Don't worry, that only happens a few times on every project.

In *Timmy's Lessons in Nature*, *Lesson 3*, we had already built our master tape when we realized there was a single horizontal line in one frame that had not been erased from a bad scan. Somehow that line made it through every step of production and we never saw it. We went back, fixed the line, re-exported that frame, re-exported the affected scene, and built a new master tape in our edit suite. Oh well. Always plan on needing more time than you think it will take you (Figure 39-1).

But your project is now done. More decisions need to be made. In what format are you going to output your short? Will it be on tape or on film? Do you have the equipment, or do you need to get the files to a post-production facility? How should you handle the audio?

If you are going to master to tape, try to master to Digibeta, D1, DV, Beta SP, or SVHS, in that order. For video playback and for video dubbing, make sure that you render to tape at 30 fps. More and more people are mastering to Mini DV. The image is compressed, but it is also digital and works very well. If a client or festival wants a BetaSP tape, you can take your DV master to a duplication house and have them make copies in whatever format you wish for a nominal fee (Figure 39-2).

The best quality will be if you can output from a computer in real-time straight to a master tape. If you have your own equipment, that will be easy. If you don't, you will need to find a post-production house and talk to the engineer to find out the file formats you can output that are compatible with their system.

Generally, to take a project to a post-facility you should output your finished piece as sequential .tga or .tif files. It is best to have the files rendered to the pixel size of the format

Figure 39-1 One tiny line on one frame made it through until our master recording before it was caught.

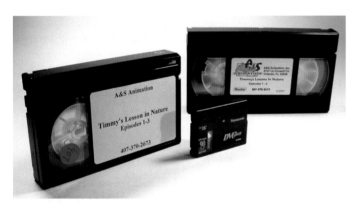

Figure 39-2 Master tape formats. From the left are BetaSP, Mini DV, and SVHS.

you wish to master to—NTSC, NTSC D1, DV, and so. However, if you master to 640 × 480 and the edit suite uses 720 × 486, the editing software will stretch the image automatically. Make sure your sequential files start with frame 0001, not 0000 or 0033, as some edit suites will only import sequences that start with 0001. Also, try to keep your file names to a total of 8 letters and numbers, such as TEMP0001.tga. Macintosh systems that don't have PC reading software will only read the first 8 letters of a PC file. If you are exporting from a Macintosh, make sure to include the 3-letter file extension, .tga or .tif, since PCs will not open files without am extension.

You should also take the audio file as an .aiff or .wav format that either starts with frame 1 or has exactly 2 seconds of

lead time before the first frame in your project. Have your audio files both as a stereo file and as separate left and right channel files. Some edit systems need the channels separated to import them properly.

Always use your master tape to make dubs at a duplication house. It will be faster and cost less than outputting multiple copies at a post-production facility. Duplication facilities will almost always be less expensive for dubs than post-houses.

When taking a digital project to film, you have many options. All digital to film transfer facilities have different specifications and costs. Make sure you talk to them before you send them your work to make sure you are sending your project in the ideal format for their facility. (See Appendix 2 for a list of digital to film transfer facilities.)

The ideal resolution for film projects is called 2K, or approximately 2,000 lines of resolution. The actual file size may depend on the aspect ratio, the facility, and what you are capable of rendering. Most facilities can accommodate virtually any size file. One facility may suggest an Academy 35 mm frame size of 975 by 1805 pixels. Another may want 1106 by 2048 pixels. High-definition files work great when transferred to film. Digital file delivery should be sequential images such as .tif or .tga or .pict, rather than .mov or .avi files. Render your sequential images at 24 fps, since that's the speed film runs. The files can be delivered on USB, SCSI, or firewire hard drive, DVD, CD-ROM, Exabyte, or any other format you and the facility share. Audio files should be delivered on DAT or DA 88, although some houses still prefer .aif or .wav files. The audio files or tape should have SMPTE timecode and a 2-pop for syncing (a beep at the 2-second mark prior to the first frame of the picture), and .aif and .wav files should line up with the sequential images frame 1 audio to frame 1 video.

It is also possible to "upres" (take a lower resolution image and make a higher resolution image) from tape to film. Again, facilities can handle just about any format tape and transfer the image to film. The better the quality of the tape, the better the final product. It is always best to master to a digital format tape and avoid analog.

Other things to consider when mastering from tape to film is rendering to tape at 24 fps. If you render at 30 fps, the film transfer facility will have to do a reverse 3:2 pulldown,

because film runs at 24 fps, which will reduce quality and increase your cost. Another thing to consider is keeping the field dominance the same throughout the project and not varying the frame rate. The tape should have SMPTE time code, a 2-pop, color bars, and tone. If possible, all edits should also be done full-frame and not be broken into fields (in video, each frame is broken into two fields, each containing half of the image resolution). Don't worry if you can't provide all that; the facility can always help you.

Costs will vary depending on how you bring your project in and how long it is. Transferring to film is normally charged by the frame panel, and the rate could vary from $0.17 per frame to around $5 per frame. Once you have your negative, you will then also have the costs of film prints and, since film is so heavy, a large freight expense. There can also be extra costs to have your sound SRD, THX, DTS (varying surround sound technologies owned by different companies, such as LucasFilm and Dolby) or other forms of audio that carry licensing fees.

All facilities are helpful when you ask them questions regarding how to present materials to them. It makes their job easier when the customer has properly prepared when they bring a project in. The technologies are constantly changing, so you should never make assumptions when you are preparing your project's elements.

Section E
What Next?

Chapter 40
Copyright

Many people don't realize that once they complete a project, it is automatically protected by copyright. The current law, from 1978, states that a work of art is protected from the moment of its creation. Unless there are prior written contracts, such as a Work for Hire (contracted work where the contracting company owns all rights) or staff employment status that state other ownership of work, the creator owns the copyright of any piece he or she produces.

The copyright symbol, ©, does not need to appear on a work to protect it. The symbol will, however, protect your work from so-called innocent infringers who may claim they did not know the work was protected.

Registering a copyright with the United States Copyright Office does offer further protection. It establishes a date when a project was created. It also allows you to sue infringers for damages, not just the value of the work. You may contact the Copyright Office at 202-707-3000 or online at www.loc.gov/copyright (Figure 40-1).

Trademarks further protect work but can be very expensive. A trademark covers words, symbols, sounds, designs, or slogans, or combinations of words and designs that distinguish one good or service from another and are generally only used when that word, symbol, or design of whatever kind is used in commerce. The trademark protects a name or identity. You may trademark the look and/or name of a character or show you create.

The cost is $245 per trademark. There are 42 different classes of trademarks, such as telecommunications, tobacco, education, advertising, clothing, games, and more. Each class is a separate fee. You may call the Patent and Trademark Office at 1-800-PTO-9199 or online at www.uspto.gov for forms and more information (Figure 40-2).

Figure 40-1 Main page of the Copyright Office Website.

Figure 40-2 Main page of the Patent and Trademark Office Website.

Chapter 41
Festivals

There are a number of reasons to enter film and video festivals, some of which are discussed in the interviews presented later in this book. The festival circuit is a great outlet for animation that would not be seen otherwise. It allows fans and industry professionals to see who is doing what kind of work. Festivals also tend to strive for new creative grounds; they are a place for us to stretch our wings (Figure 41-1).

Winning festivals does more than give you certificates to hang on the wall. It gives you the opportunity to have your short works seen by the studios. As Linda Simensky of the Cartoon Network says, "For every festival that I go to, I probably find about one creator whom I end up doing something with somewhere along the line." Entering and attending festivals gives you the opportunity to get some publicity and to talk about your work. It can also give you the industry recognition that you might have a hard time getting otherwise. Festivals are also a great way to test market your ideas.

Figure 41-1 Opening night at Animated Encounters, Bristol International Animation Festival. *Timmy's Lessons in Nature*, Lessons 1 to 3, were official selections in the 2002 festival.

We entered *Timmy's Lessons in Nature* in a number of festivals and won a few, including Gold at the Worldfest Houston in 2001 and a Telly Award for animation in 2002. By September 2002, Timmy had won and been showcased in 19 festivals. There were also network executives who saw Timmy in some festivals on the East coast, such as the ASIFA-East Animation Festival where we won Excellence in Writing for Independent Films. These executives called us to talk about developing a series based on our characters (Figures 41-2 and 41-3).

Certain festivals can also qualify you for an Academy Award nomination. The Academy has a list of festivals that allow you to qualify for nomination if you win your category in animation. You may find this list online at www.oscars.org/73academyawards/rules.html. In case the page changes, you may go to www.oscars.org and search for nomination rules and the Short Films Awards Festival List.

Many festivals are allowing video for preview, but a few still accept only film if you are selected. Make sure you read the qualifications before you submit and pay the entry fee.

Figure 41-2 *Timmy's Lessons in Nature* won the Gold at Worldfest Houston.

Figure 41-3 Timmy wins a Telly Award in 2002.

A&S Animation, Inc. 2002

Entry fees range from $20 to $50 for most festivals with the average being $35 per category. Many overseas festivals do not charge a fee at all. Some festivals look for specific types of projects, so don't just send your work to every festival out there. To enter you usually have to send a VHS copy of your work along with payment, an entry form, stills, a bio of the director, and a short description of the work. Once the work is accepted, you will be asked to send a higher quality copy of the work, be it film, BetaSP, Digibeta, or other.

One other item to watch for is the rights a festival asks for when you enter. Make sure they only ask for "nonexclusive" rights. There are some festivals that state in fine print that by entering their festival, they retain all rights to your work. Don't make the mistake of giving up your rights just to be in a festival.

Figure 41-4 Chuck Jones with his wife Marian standing with Kathleen Haney and Hunter Todd, the head of the Worldfest Houston.

Figure 41-5 Opening reception at the California Sun International Animation Festival held at the Beverly Hills Museum of Television and Radio. *Timmy's Lessons in Nature*, Lessons 1 and 2, have been official selections in both the 2001 and 2002 festivals, respectively.

Some festivals offer to bring the winners to the festival to get their award, though most don't, and many allow the producers or directors to speak before or after their screening. Going to the festivals is also a great way to network with others in the field and make new industry contacts. Many network and studio executives go to festivals to find the latest talent. It is one of the few places where independents can mix and mingle with the heads of studios and the giants in their fields (Figure 41-4).

Producing the greatest or funniest animation doesn't do anyone any good if no one sees it. Having your work showcased in a festival allows people to see your work and allows you to get feedback from a large audience. And besides, it's really cool to see your work projected on a movie screen (Figure 41-5).

Chapter 42
Online

The newest frontier for animation is on the Internet. The dot.com boom may be over, but there is still a great deal of animation watched and needed on the Web. There are only a few major sites that profile animation now, compared to the many sites that did so in 1999, but a runaway Internet hit can happen from any site (Figure 42-1).

The movie 405, produced by Bruce Branit, became the most downloaded Internet movie of all time with over 4 million downloads. It became a success virtually overnight, and it did not start on a major Website. What it had going for it was great animation effects and a really good story. That success led to many commercial projects for Bruce (Figure 42-2).

Because anything is possible on the Net, many of the animations are of adult nature. The Net is one of the few avenues for adult animation.

As for any entertainment outlet, make sure you read the fine print when you submit to a site or sign a licensing deal with a site. The best deal for you and your project will be a "non-exclusive," meaning you can resell the piece whenever and wherever you want and you retain all rights. Many sites ask for all rights to a project, which would leave you with very little if it's a hit. However, a hit is a hit. Even if you have to give up most of your rights for your first project, any success of that project will help you profit in other areas and sell other shows for a better deal. People have to see your work to know how good you are (Figure 42-3).

As in any deal, you may negotiate what rights you are selling and which you are keeping. There is no such thing as a contract that can't be changed. If someone really wants a project, they will be willing to deal. Just remember, the more unknown you are, the harder it will be for you to make a great deal.

When you approach Websites to see if they are interested in licensing or showcasing your project, make sure you do your research. Don't offer an adult animation to a children's site. Approach sites that run the type of animation that you have. This advice may seem simple, but it is the one thing most sites say people pay little or no attention to.

ANIMATION · DEVELOPMENT
STORYBOARDS · COMMERCIALS

ABOUT US
COMPANY
PRINCIPALS
CREDITS
SAMPLES
GALLERY
MOTION CAPTURE
SHOWS
DEVELOPMENT
BOOKS
PRESS
AWARDS
JOBS
STORYBOARDS
CONTACT US

Never before in the history of cinema, has a collection so grand...um...never mind. We'll just let these images speak for themselves. This collection of images are from animated series, commercials and videos we have produced.

11wmov.mov
Lesson 1 Web QuickTime
1:11 200 x 150 5.8MB

11wdivxs.avi
Lesson 1 Web DiVX small
1:11 200 x 150 2.3MB

11wdivxb.avi
Lesson 1 Web DiVX big
1:11 320 x 240 3.6MB

Timmy's Lessons in Nature - Episode 1:
Avoid Snakes - Timmy uses a stick to say "howdy" to a rattler.

pregtwin.mov
My Wife is Pregnant
QuickTime
1:05 210 x 158 3.9MB

pregdivx.avi
My Wife is Pregnant DiVX
1:05 210 x 158 3 MB

My Wife is Pregnant - Episode 2:
Surprise! Twins are coming.

FLASH animation isn't the only format of animation on the Net, but it is the most common. Even very long FLASH animations will download quickly and have a very small file size. With high-speed modems becoming more common, it is easier and faster for movies to be downloaded and played. More people are more likely to download smaller

Figure 42-1 A&S Animation, Inc. Website showcasing a number of our animations, including the first Timmy lesson.

Figure 42-2 Website for the Web movie *405*, by Bruce Branit and Jeremy Hunt: www.405themovie.com.

Figure 42-3 Camp Chaos Website: www.CampChaos.com. Online animations and games.

FLASH

Figure 42-4 Timmy's Lessons in Nature, Lesson 1, in FLASH. Notice the different line quality in FLASH; it's much smoother due to it having vector lines instead of bitmap images used in the broadcast versions.

movie files. The benefit to streaming movies instead of FLASH is that you can have smoother motion and more effects in a movie. But shorter is better. Any movie over a few minutes may be too big to stream (Figure 42-4).

Chapter 43

Pitching to a Studio, Network, or Distributor

Animation is a bit different than other forms of television when it comes to pitching and selling a show. Since animation is so visual, it has to be sold with visuals. Many live-action shows, on the other hand, are sold with only a verbal pitch or a script.

Networks and studios are buying into the creators as much as they are the show concepts. It takes a long time and a lot of effort to produce a series, so the more energy and confidence you have during a pitch, the better. They need to feel confident that you will be able to do what it takes to make your show a success.

An animated short may be used to pitch a television series. Hit shows such as *The Simpsons, The Powerpuff Girls*, and others started as shorts. In fact, before committing to a series the Cartoon Network produces 7-minute shorts for shows they are interested in testing.

Matt Stone and Trey Parker produced the first *South Park* as a video Christmas card for a studio executive. It led to their deal with Comedy Central (Figure 43-1).

Full animation is not always needed. Often, presentations include only sketches of the characters in action—whatever it takes to present the look and convey the concept of the show (Figure 43-2). Pitches include everything between sketches and full animation. Linda Simensky of the Cartoon Network (see her interview in Chapter 48) says, "I like to see lots of drawings. I like to see drawings of characters doing all sorts of things, because the humor should be right there."

Timmy's Lessons in Nature, a series of shorts, is being used as a pitch for a half-hour series called *The Troop*. The shorts introduce our lead character Timmy and demonstrate the look of the show. A one-sheet and presentation package introduces the rest of the cast and explains the concept of the show (Figures 43-3, 43-4, and 43-5). When we pitch the half-hour series, we show the shorts and then verbally explain the half-hour version using sketches to introduce the supporting cast.

Figure 43-1 Matt Stone and Trey Parker speaking at NATPE 1999. Their early morning discussion covered their production process, thoughts about the show, and examples of their early work. Photo courtesy of NATPE.

Figure 43-2 Patton character sketch from *The Troop*, a half-hour version of *Timmy's Lessons in Nature*.

When we pitch *The Troop,* we talk about how we would like to see the shorts with Timmy air as **interstitials** (shorts that are aired between other shows) while the series is in production, which could take over a year before the first half-hour airs. This allows the audience to become familiar with the character, building brand awareness. The networks have liked this idea. Nickelodeon has been doing that very thing with *Jimmy Neutron.* They were showing *Jimmy*

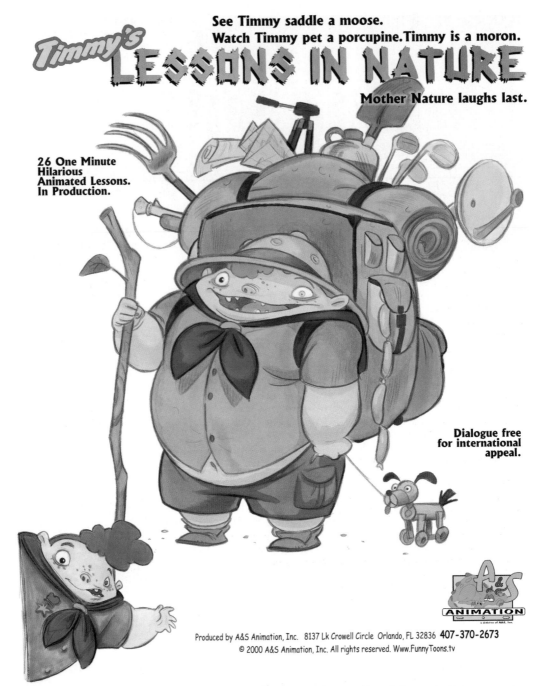

Figure 43-3 The face of the one-sheet promotional information package on *Timmy's Lessons in Nature,* a great leave-behind for meetings with executives that quickly gives them an idea about your show.

LESSONS TO BE LEARNED

1. Avoid Snakes. Timmy uses a stick to say "howdy" to a rattler.
2. Avoid Rabid Animals. Timmy gets chummy with a rabid fox.
3. Avoid Skunks. It's bottoms up when Timmy researches skunks.
4. Avoid Dark Holes. Nature Boy prods around in a hole that fights back.
5. Avoid Dark Holes. Timmy sticks his head into the hollow of a tree and finds out that killer bees can fly out your butt.
6. Don't Feed the Animals. A grizzly bear and Timmy share a Ho-Ho.
7. Don't Feed the Animals. Timmy is the Happy Meal on the field mouse menu.
8. Avoid Wasp Nests. Much to Timmy's surprise an allergy to wasp stings really does mean you can blow up to
 3 times your size.
9. Beware of Animals With Their Young. Nature Boy learns that a mother's love equals a Cujo attack on anyone who gets too
 friendly with her babies.
10. No Flash Photography. Nature boy gets batty.
11. Keep A Safe Distance. Timmy invades a buffalo's comfort zone.
12. Beware of Babies. Timmy learns the painful difference between bobcats and house cats.
13. Wild Animals Are Not For Riding. Timmy saddles a moose.
14. Make Noise While Hiking. Timmy learns why animals don't throw surprise parties.
15. No Running In The Herd. Not even Nature Boy's Nike's can keep pace with the caribou.
16. Wild Animals Are Not Good Pets. Nature Boy finds out why gators aren't called Spot.
17. Do Not Scare Animals. With one smooch of a porcupine, Timmy wins the body piercing contest.
18. Don't Touch Baby Animals. Timmy finds out that cute, little chicks have big, bad mamas.
19. Look Before You Leap. Timmy learns that once in the air – don't look down.
20. Look Before You Leap. The "shallow water" sign isn't just a ploy to keep Timmy from swimming.
21. Don't Play With Fire. Nature Boy stares down the business end of a blow torch and gets toasted.
22. No Littering. A finicky bear fines Timmy two legs and an arm for littering.
23. Avoid unknown plants. Timmy eats mushrooms and sees pretty colors.
24. No Cow Tipping. Timmy learns he should run when the cow falls.
25. Avoid Fire Ants. Timmy finds out that the only thing worse than a fire ant bite is...well, nothing.
26. No Monkeying Around. Timmy becomes the chimps' best friend when he brings a lice lunch.

Produced by A&S Animation, Inc. 8137 Lk Crowell Circle Orlando, FL 32836 **407-370-2673**
© 2000 A&S Animation, Inc. All rights reserved. Www.FunnyToons.tv

Figure 43-4 The back of *Timmy's Lessons in Nature* one-sheet with further information on the series.

Neutron shorts prior to the launch of his feature animation, which led to a television series.

There are a few times when full animation is a detriment to a pitch. When the quality you are able to produce is lower than networks are used to, animation will not help. Some studios also like to be a part of the development process and are less likely to buy a project that is fully designed.

Your completed shorts also make great demos for longer shows or series. As long as your short tells a story, it can be used as a pilot. *Bob and Margaret* is another popular series that started as a short. (See Chapter 51, the interview with David Fine and Alison Snowden, creators of Bob and Margaret.)

There are industry events and conventions where you may present and pitch your ideas using your completed shorts as samples of your idea. Although everyone may have ideas, the presentation of finished work sets you apart from most. It proves that you are capable of completing a production and shows the quality of your concept.

NATPE, or the National Association of Television Programming Executives, is the main buying and selling convention in the United States. It happens every year in January and is normally held in either New Orleans or Las Vegas (Figure 43-6). You have to be a member of NATPE to attend. For every year that you go to this event, the more people you will meet and the better your connections in the industry will be. It takes persistence to properly get meetings and present your projects (Figure 43-7).

Another gathering for learning and presenting your children's entertainment ideas in the United States is the Kidscreen Summit, put on by the periodical *Kidscreen*. This is a much smaller gathering, but all of the main children's producers and distributors are there to listen and to teach.

The largest content buying and selling convention in Europe is MIP-TV. MIP (Marché International des Films et des Programmes por la TV, la Video, le Cable et le Satellite. In English: International Film and Video Program Market for TV, Video, Cable, and Satellite) takes place in March or April, and MIPCOM, the fall version of the show, takes place in October, both in the city of Cannes, France. The convention is not as flashy as its U.S. counterpart, but more productive business is done during the convention. It costs quite a bit

**30 minutes of animated ineptitude for pre-teens.
Starring Timmy, from the award winning shorts**
LESSONS IN NATURE

Always Be Perfect

CUZINS

Mix a moronic troop of Boy Rangers trying to survive an unforgiving Mother Nature, sabotage by a local, backwoods, bad-boy threesome, and humiliation by the beyond-perfect Girl Rangers and you get...

THE TROOP

ANIMATION

Produced by A&S Animation, Inc. 8137 Lk Crowell Circle Orlando, FL 32836 **407-370-2673 Contact: Mark Simon**
© 2000 A&S Animation, Inc. All rights reserved. www.LessonsInNature.tv

Figure 43-5 The front of the one-sheet for *The Troop*.

Figure 43-6 The convention floor at NATPE. Hundreds of television programming buyers and sellers.

Figure 43-7 Author Mark Simon planning his next round of meetings at NATPE in New Orleans in 1999. I normally have 20 to 30 meetings in 3 days regarding my shows at each NATPE.

more than attending NATPE, but with overseas co-productions and sales needed to cover the costs of production, the trip is worth it.

Many studios and distributors will not take pitches during these events, because they are too busy selling their own product. Even if you are not able to pitch at one of these events, you will have the opportunity to meet the right people, face to face. Meeting in person is always better than just hearing a voice over the phone.

Completed animation shorts do a lot for everyone involved. Many people will be able to add the work to their portfolios. Finished pieces prove that the production team can finish a project. Projects that win awards improve the value of each person's on-screen credit.

Animation studios do not normally take pitches for features from non-staffers. Animated pitches and shorts, for the most part, do not get made into features. Features are either developed in-house at a studio or deals are made from successful television series.

The final part of a pitch is confidence. Networks want to feel confident that you are capable of maintaining the quality of a series over the long haul. One short alone will not give them that confidence. Many shorts or a steady flow of quality projects along with a tremendous amount of energy and enthusiasm will help prove your creativity and your ability to constantly sustain creative work.

Chapter 44
Portfolio Piece

Every work of art and animation you produce should be better than your last. Your portfolio should be a constantly evolving work that you are always updating (Figure 44-1).

As you add new work to your portfolio, take out your lowest quality work. Your portfolio does not need to be very large. It is always best to show a few great pieces than a lot of mediocre ones.

Every animation project should produce a number of character design samples, key animation samples, inbetween samples, clean-ups, and layouts. Besides animation samples, you should also always be doing new life drawings. No portfolio is ever complete. It is always a work in progress.

Portfolios should include life drawings, quick sketches, people, animal, and object sketches (Figure 44-2). Quick sketches should capture the feeling of motion. Add samples of your rough and clean-up animation art along with any layouts or character designs that you may want to show. If you don't want to do character design or layouts, don't include them in your portfolio. If you want to do storyboards, include storyboard samples. This may seem self-evident, but easily half of the people who send me samples and say they want to do storyboards have not sent me any storyboard samples. If you want to do backgrounds, include backgrounds.

Your portfolio does not need to be fancy. Save your money. If you're talented, it will show in your work. And remember to mark your name and phone number clearly both inside and outside your portfolio, and to have a leave-behind: a sheet or two of printed samples with your contact information.

Never send a portfolio of originals. Try to send copies that companies can easily file. If they can't file your work, they can't keep samples to refer to later. Call and follow up a week or so after you send your work in, but don't expect that it's been seen yet; it takes a while.

A video portfolio of pencil tests and finished animation is called a demo reel. The composition of your demo reel is dependent upon your role in production that it is supporting.

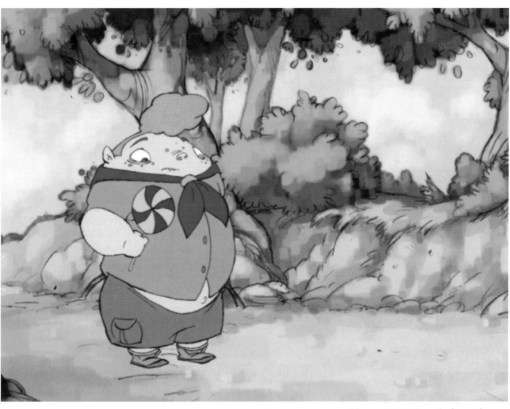

Figure 44-1 Sample frame from Lesson 3. The character art and the background are great portfolio pieces. The composite shows how well the two work together in a scene. Hard copy prints such as this are great in a portfolio, but don't neglect the sketches.

Figure 44-2 Life drawings by T.J. Notice how quick yet accurate the line work is, and how it captures the motion and balance of the subjects. We know in a glance that this is a great animator.

Figure 44-3 Very nice tied-down animation frame. It's not a clean-up, but it shows the quality of finished art: balance, character, and motion.

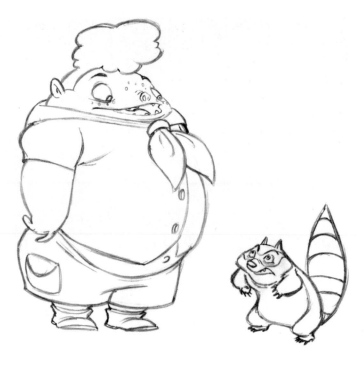

Figure 44-4 Character sketch of Blaze, a supporting character from our series, *The Troop*. This one sketch makes you want to laugh.

If you are a key animator, show great animation sequences. You don't need fancy editing and background music. That's not what you're selling. Use the original dialogue tracks and edit together 2 or 3 minutes of samples. You may even use pencil tests along with finished work. In fact, pencil tests for key, inbetween, and clean-up are essential to have on a reel. Pencil tests are the only way to see the true line quality (Figure 44-3).

Include a shot list with your demo reel explaining each shot and what you did on each. If you animated the swirling leaves in a scene and not the main character, make that clear. Also make sure that your name and number are on the face of the tape. Start and end your reel with your name.

Director and producer's reels should have complete scenes and complete short stories. Their demo reels need to show their ability to complete a project with style while telling a compelling story, and maybe making people laugh (Figure 44-4).

Many artists ask for their demo reels to be returned. This may be a mistake. Demo reels are your best calling card. If

a client is not able to hold onto it, they can't refer to it and call you later. They are inexpensive for you and best left behind.

Your resume should open the door, and your portfolio and reel should either keep it open or get you the job. You are advertising who you are and what you can do. Make sure you show each client what you can do for them.

Section F
Interviews

Chapter 45

Craig McCracken, Creator of *The Powerpuff Girls*

Craig McCracken is the creator, writer, and producer of the Emmy-winning animated series *The Powerpuff Girls* (Figure 45-1). His inspiration for the series came directly from *The Whoopass Girls*, a student film he created in his second year studying character animation at California Institute of the Arts (Cal Arts) in Valencia, California. His unusual superhero film was selected for the 1994 Festival of Animation. While at Cal Arts, McCracken wrote, directed, and produced eight student films, five of them featuring a character named No Neck Joe. McCracken's talent has been tapped by Hanna-

Figure 45-1 Craig McCracken and *The Powerpuff Girls*. Image courtesy of Cartoon Network. © 2002 Cartoon Network. All Rights Reserved.

Barbera and Cartoon Network. He worked as the art director for the four-time Emmy-nominated series *Dexter's Laboratory*, and he also served as art director on the first season of 2 *Stupid Dogs*.

MS: You produced your first shorts while you were in school?

CM: Yes, they were my freshman year student films at Cal Arts.

MS: Freshman year! How many pieces did you do?

CM: I did three little films my freshman year.

MS: All cel animation, I presume. How long were they?

CM: One was a minute, the other two were 30 seconds each, or something like that.

MS: Did you do them alone, or did you get help from other students?

CM: I did them by myself.

MS: Did the school provide all the hardware and software that you needed, or was it all hand drawn and painted?

CM: It was all hand drawn. Normally, your student films are just supposed to be pencil tests, which are just drawings on paper. I wanted to do something else, so I did mine in color. I didn't have time to ink and paint things traditionally on cels, so I did all the drawings. I cleaned them all up, then I cut them all out with an exacto-blade, spray-mounted them on onto cels, and then colored them with markers on cels. So those first *No Neck Joes* are kind of cel animation, but they're a cross between a pencil test and a finished color piece. I just didn't have time to sit there and Xerox everything to cels, and then have a crew of people ink and paint them.

MS: Were those first *No Neck Joes* the ones that first got into Spike & Mike? (The Touring Animation Festival.)

CM: Yeah. They came by at the end of the year after everybody had finished their films, and they just watched all the films. Then they approached me and said, "We really like these and would like to buy them, and we want to pay you to do two more over the summer. And I didn't have any summer work, so I was more than willing to do it. So I did two more, and there were a total of five, and then we put those into the festival.

MS: So how did being in Spike & Mike help your career?

CM: It was good in the sense that it was encouraging to be rewarded for doing your own thing. A lot of people at Cal Arts have as their main focus trying to do a good reel or a good test so they can get into Disney, so they can become an assistant and eventually an animator. I really didn't ever want to do that. I wanted to do my own ideas, my own jokes, my own type of films with my type of design. So I just did it at Cal Arts thinking nothing would come of it. The fact that Spike & Mike bought it and there got to be a small following, that was kind of encouraging to continue doing what I wanted to do.

MS: So when did you first come up with *The Whoopass Girls*?

CM: That was the summer of my freshman year. After I had finished the *No Necks*, I started thinking about what I was going to do the next year. I came up with *The Whoopass Girls* that summer, the summer of 1991.

MS: Now, did you also do those shorts completely on your own?

CM: Yeah, I did the first *Whoopass* short on my own. That year I had planned to do four films, but I got only one completed and one totally laid out. I storyboarded all four episodes, and then I laid out one of them, and I animated one of them. They were a lot longer than the *No Necks*. I just had this lofty ideas that I could get four films done.

MS: How long was the *Whoopass* short you finished?

CM: It was about three and a half minutes.

MS: That's a pretty long piece. So how did the Cartoon Network find the show?

CM: Because Spike & Mike had bought *No Neck Joe* the previous year, when they saw *Whoopass*, they were like, "We like that too. We'd like to buy that." They just bought the rights to show it. I still owned the characters and they had it inked and painted (Figure 45-2). That was playing in the regular festival. So I had this good presentation piece. I had my student film in color, and I could just take it around and show it to people. It's a better selling tool than just having a written bible of what your story is about. So I took it to Hanna-Barbera and said it was a show I wanted to make,

Figure 45-2 *The Powerpuff Girls.*

Figure 45-3 Cartoon Network logo.

and they watched it. They were like, "This is great. We have to do something with this." Right when I pitched that, they were just starting up the World Premiere Toons program, the original shorts, so it just fit right in there. They just started merging with Cartoon Network, and we were this big Turner family. That was in 1994. I pitched it in 1993 to Hanna-Barbera, and in 1994 we started producing our first short with the Cartoon Network (Figure 45-3).

MS: So do you consider that your first big break?

CM: Yeah, basically, because that was my first big professional thing. I mean the Spike & Mike shorts were films I was doing anyway for student projects that I just happened to get a little extra money for when I completed them. But this was my first work for hire—"we want you to produce this short for us, and we'll put it on T.V." That first *Powerpuff Girls* show was the big selling point.

MS: When I talked to Linda (Simensky, of Cartoon Network), in part of her interview she was talking about how Cartoon Network works as far as the kind of budgets they can give to people for their shorts. When you were given the budget, did

Figure 45-4 *Dexter's Lab.* Craig McCracken art directs on the series.

you go to an outside production house, or did you hire the artists yourself?

CM: We produced it at Hanna-Barbera, but for the main basic crew I had hired friends whom I'd gone to school with and whom I had been working with professionally for a short time.

MS: Like Genndy?

CM: Yeah, Genndy Tartakovsky, and Paul Rudish. The three of us did both *Dexter's* shorts [*Dexter's Laboratory*], and then we did both *Powerpuff* shorts [*The Powerpuff Girls*], kind of in tandem with each other. We would do *Powerpuff*, then we'd do *Dexter*, then we'd do another *Powerpuff*, then another *Dexter*. So the three of us did those four shorts together. We sent them to overseas studios to be animated as traditional television production. But the development, designing, storyboarding, and writing was done just by the three of us (Figure 45-4).

MS: When you first did the *Powerpuff* short it was awhile before it became a series. So what was happening while you were waiting?

CM: *Dexter's Laboratory*. Basically, we had those shorts at the same time. The Cartoon Network had tested those shorts and showed it to the kids, and *Powerpuff* tested off and on—some kids would hate it, and some kids would really like it. *Dexter's* was more even keel, and everybody liked it. Cartoon Network just felt that this was a safer bet for our

Figure 45-5 *The Powerpuff Girls* Villains of Abbey Road.

first series. They said they wanted to produce *Dexter's*, and I was the art director and one of the lead story guys. So we produced 52 half hours of that show. Then when we were getting near the end of it, the network approached again and said, "over the years a lot of people have been telling us how much they like *Powerpuff*, and we think it should be a show, and we want you guys to produce another series for us. Since we're so happy with *Dexter's* we feel *The Powerpuff Girls* are the next step." That was in 1997, when they gave us the green light to do the show. But I'd pretty much figured it was never going to happen (Figure 45-5).

MS: That's quite a while to wait, especially on your own creation.

CM: Yeah, when you pitch this in 1993, and they are saying, "We want this right now." The development executive who I had pitched it to was so excited about it that she immediately called me downstairs to talk to the president of Hanna-Barbera, and he was like, "Lets go for it." So in my mind the show was already green lit in 1993. And to not really ever start production on it until 1997, it was like a major thing. I had basically figured it was never going to happen. The rights at one point had even reverted back to me, and there was a period when I took it to every other studio in town, and they were all like, "We don't know about that because its affiliated with another network, and we

would rather have you do something else." Which was the best thing possible; the show would never have been the same if it had been done in another studio.

MS: I know Linda has been a really big supporter of yours all along.

CM: The weird thing is, when I was a student at Cal Arts working on *The Whoopass Girls*, one of my instructors was friends with Linda, and Linda happened to come by the school one afternoon. My instructor made me show her my student film, and it was just a work in process. Linda was working for Nickelodeon at the time, and she had seen it at Cal Arts, and she was pretty into it and really liked it.

MS: Wow! That's pretty cool the way it came around.

CM: Yeah, at the time she was at Nickelodeon and they had a different way of developing cartoons there, than at Cartoon Network.

MS: So the first short you did for Cartoon Network of *Powerpuff*, was it based on the board that you pitched?

CM: No, that was just a new idea. I didn't really pitch a board. I just had my student film, the one I had made at school, and a bible of what the show would be about. So I really didn't pitch a board. They just said, "OK, make a 7-minute short." So I came up with a whole new story (Figure 45-6).

MS: So how does it feel to have your own creation on every object made by man?

CM: It's amazing. When I was in Cal Arts a lot of people wanted to get into Disney and to be lead animators, and I wanted to have my own TV show. I didn't think that would be possible, but that would be the ultimate. It's amazing that it actually happened. A lot of it is that the Cartoon Network is such a great place to work. They encourage you to do your own thing. They trust your talents. They say, "OK, you know how to make cartoons, so you do it." And they let you learn on the job, develop yourself, and develop your skills.

MS: Is the series pretty much how you envisioned it, how you wanted it?

CM: It's better than I wanted it, and it keeps getting better every season. I've had the idea for ten years, and what it started out as and what it's become is a lot better than I

Figure 45-6 *The Powerpuff Girls.*

could have imagined. I've gotten better, the crew has gotten better, and I think the whole series has improved.

MS: Did you get mostly the same crew throughout the series?

CM: Yes, we had the same crew that produced *Dexter's Laboratory*. We had some new guys come on, obviously, but the majority of the crew was the same crew we used on *Dexter's*. I'm really thankful that we did *Dexter's* first, because we really learned a lot about cartoon making on *Dexter's*, that we could then apply it to *The Powerpuff Girls*. If I had been given the green light in 1994, I don't think the show would have been as good, because I wasn't as experienced.

MS: When you guys produce a series, do you do any of the key frames here or do the overseas houses work straight from boards?

CM: They go straight from boards. Then they send us a work print of the finished film. On the *Powerpuff* film we're working on now, they're sending us all the layouts back, and we're doing all the key frames here so we have a lot more control over it.

MS: What do you feel are the differences between directing a short, working on a series, and now doing a feature?

CM: Working on a short, because you're just working on one thing, is like you're doing it yourself, and it's all you. Every single drawing is yours, and everything you put into it is yours. When you're doing a show you're juggling many different facets of production at any given time. At one point you're having to deal with the story on a new episode, then you get an episode back from overseas, and then another show is assigned. So it's a different process. I don't get to draw every single drawing; a lot of it is delegating and approving stuff. I have to put all of my focus on storyboarding and fixing storyboards. I feel that's my forte. I feel that if the boards and story aren't that strong, it doesn't matter how good it looks, it's not going to work. So you have to balance television production a little differently than when you're doing your own film. The feature is a little like doing your own short—it's just a massive short—because we are able to go over every drawing, and we are able to control a lot more of those aspects. And I'm having a really

good time doing the movie because of that, because I can make sure everything looks perfect.

MS: When do you anticipate the movie coming out?

CM: They're saying July of 2002. We don't have a date yet, but that's what we're shooting for.

MS: So your production schedule is really short for a feature.

CM: It's really short for a feature. It's massive, too, and we're kind of scrambling to get everything done. We have never done anything this length before. So as soon as they said, "OK, make a feature," the crew and I went kind of overboard. We've wanted to do this forever, and now we're having to do it, and it's a lot of work to produce. It's turning out really well, and we're real happy with it.

MS: How is the way you're doing the production different for the feature than for the series, as far as the hold frames, for instance? And are you doing more drawings per second?

CM: From an animation standpoint it will be pretty similar. The television show is animated traditionally and is shot under camera, and then we get it back on film, and we call [retakes on that]. The way we're doing the movie is that we're going to composite the film digitally in the computer. So it will all still be hand-drawn, but all of those elements will be put into the computer. And it won't be shot on film at first—all the scenes will be built digitally. All of which means that we'll have more control with the effects that we can do, such as multiplaning. We can get a lot more depth and dimension out of every shot than we've been able to with only traditional camera stuff. We're doing that here in L.A. There are a lot more hands manipulating and tweaking and finessing every single shot. And once it's built in the computer, we'll output it to film. So that's a whole new process that we haven't really dealt with before. It gives us a lot more control than simply sending it overseas and getting film back.

MS: What's the best part of what you do?

CM: Just the fact that I get to come up with ideas and draw them and then they end up on TV. It's great to sit around in a room with people and invent something and produce it. There's the act of just making it, and then people get to enjoy it—that's what I like about it.

Figure 45-7 *The Powerpuff Girls.*

MS: So what's your next project when you wrap up the feature?

CM: They want more episodes of *The Powerpuff Girls*. I've still got more ideas, and I'm still excited about doing it. So I'm going to keep making it until I'm totally burnt out on it. I have other ideas I'd like to do, but I still feel that this one isn't finished yet. I 'd like to keep pursuing it, improving it. (See Figure 45-7.)

MS: What advice would you give to someone pitching a show?

CM: Basically, do your own thing. Try to come up with your own vision and your own perspective. I think that's what attracts a network, something unique and original—as opposed to something derivative of another show, like "This is my version of *The Powerpuff Girls*," or "This is my version of *Dexter's*." Try to come up with a new way of seeing

cartoons or entertainment, I think that's what the networks really respond to.

MS: There are a bunch of animators—I'm sure you met your fair share at school—who always want to produce their own piece. When animators are about to venture forth and do their own short, what advice would you give them?

CM: Not to get overzealous and overexcited. Realize the time frame you have, and realize what your capabilities are. Try to do something within the realm of possibilities. At Cal Arts I always tried to take on more than I could handle, then I didn't get as much done. Do something you can do, and do it right, as opposed to trying to do something huge and not getting it finished at all. A lot of people at Cal Arts come in their freshman year and try to make 4- or 5-minute films, and then they don't get anything done. Be one of the people who come up with a simple 1-minute idea, and then make that 1-minute idea really nice.

Chapter 46

Bill Plympton, Academy Award–Nominated Independent Animator

Bill Plympton was nominated for an Academy Award and is one of the most prolific independent animators working today. His style is unique and has garnered him a large following (Figure 46-1).

Bill was born in 1946 in Portland, Oregon. He credits Oregon's rainy climate for nurturing his drawing skills and imagination. His first attempt at animation in high school was accidentally shot upside-down, rendering it totally useless.

In 1968 he moved to New York City and began a year of study at the School of Visual Arts. He began illustrating for *The New York Times, Vogue, House Beautiful, The Village Voice, Screw,* and *Vanity Fair,* and cartooning for *Viva, Penthouse, Rolling Stone,* and *National Lampoon.* In 1975 he began a political strip, *Plympton,* in *The Soho Weekly News,* which by 1981 was syndicated by Universal Press to over 20 papers.

Figure 46-1 Bill Plympton. Photo by Linda Obuchoska.

His first independent short in 1988, *The Face*, garnered him an Oscar nomination for Best Animated Short Film. His first feature in 1992, *The Tune*, was the first animated feature drawn by one person. He has since animated over 26 short films and 4 animated features, written 2 live-action features, and 5 books.

MS: How did you get started in animation?

BP: It's an art form I loved immediately. I saw it at about 3 or 4 years old. I had always been drawing, and I always made plans to be an animator. However, technically, I found it very daunting to do exposure sheets, sounds, and camera. It was very difficult for me. Consequently, I became an illustrator. I got into animation late.

I got into animation by doing a film called *Boomtown* (1983) that was written by Joel Spiffer. He knew I was an animator, and we were buddies. He asked if I wanted to animate, and I said yeah. So I did the animation. Even though I didn't get paid, I got a lot of experience on how to make an animated film. I took the experience of making the film and later made my own film called *Your Face*. That film went on to win a lot of prizes and an Oscar nomination. And when it was showed in Annecy [the Annecy Animation Festival in Annecy, France], that's where it got picked up by MTV, Tourne' of Animation, Spike & Mike, and all that stuff. (See Figure 46-2.)

MS: How long was *Boomtown*?

BP: It was about 7 minutes long.

MS: And how long was *Your Face*?

BP: It was 3 minutes.

MS: I remember that—it's a great piece. How do you get people to work with you, especially since you were doing a lot of these before you had money to put into it? How were you getting people to assist you?

BP: I pay them. I don't pay them a lot of money, but fairly well. Most of them are students, art students and such, and not only do they get money, they get experience. They can put it on their resumes, and they learn a lot about how to do films. So it works out well for the student. I actually have a lot of people that call me up and say, "I'll work on your film for free," or "I'll pay you to work on your film." Its not a

problem getting people to work for me, it's a problem getting the right people who are really committed, who really love animation and who want to work on the film. (See Figure 46-3.)

MS: How do you fund your films now? Obviously some of your past projects have been selling and should be paying for part of it.

BP: A lot of things. My short films do well overseas.

MS: In what ways are they doing well?

BP: At the BBC, Canal Plus, and a lot of TV stations. The shorts play in theaters, and they win prizes and film festivals. Video, DVD, nontheatrical—there are many markets for these films overseas. And there are similar markets here, too, like video, DVD, cable TV, sometimes regular TV, like on *The Edge*, MTV, something like that. The money is very good simply because the cost of my films are so low. *Your Face* cost $3,000 to make, and it's made over $30,000 now. The shorts do very well, but my features don't do as well. I don't know why that is. I thought they'd make a lot of money. The cost is very low, at about $200,000 for a feature film. It's just whoever distributes the film, generally speaking; it's hard to get them to pay me the money that comes in. So I guess

Figure 46-3 Image from the short film, *25 Ways to Quit Smoking*. © 2002 Bill Plympton.

it's that there's more distance between me and the distribution, and its hard to get that money back. But there are other venues. I sell the originals. I bring out my own videos. I do merchandising, posters, books, etc.

MS: Yeah, like your last book, *Mutant Aliens* (Figure 46-4), which you came out with using the storyboards from the film.

BP: Right, that did very well.

MS: What about the Internet—any income from that?

BP: I make a lot of money from the Net. Atom Films bought a lot of my stuff for a very good price. I still sell my little FLASH animations for a lot of money.

MS: So are you doing some computer and digital ink and paint too, or is it all converted from your hand-drawn art?

BP: On FLASH. I just give the FLASH artists the drawings and the timing, and they will retrace the drawing on a Wacom tablet [a graphic stylus and tablet connected to the computer] and do the color themselves.

MS: Why haven't you gone over to any digital work?

Figure 46-4 Image from the
feature film *Mutant Aliens*. © 2001
Bill Plympton.

Figure 46-5 Image from the short
film, *Eat*. © 2002 Bill Plympton.

BP: Four reasons. One is that it's too expensive. I'd have
to hire a bunch of technicians. I'd have to buy a bunch of
machinery. Two, it's too slow. I can draw a minute of
animation in one day. If I do it on a computer it would really
slow me down. I can do a short film in a month. I did *Eat* in
a month (Figure 46-5).

So if I did it on a computer, it would take 6 months to get done, and I'd have to hire a bunch of people and work them overtime. Three, it's really expensive to transfer digital to film. If I want to show it at a movie theater, I have to show it on film, and just the transfer fees alone are more than my budget allows. Four, I don't like the look of digital ink and paint and computer animation. I like the look of hand-drawn. It's warmer and feels nicer. It's just a better image on the screen.

MS: Do you do all your own distribution?

BP: I will go to the major film festivals, especially Annecy or Sundance or Cannes. That's where all the distributors will go to see the film, and they see the audience's response, and they'll buy it. Now however, fortunately, I don't have to do that, like I did in the beginning. Now whenever I finish a film I have an agent who will be happy to see it and buy it. I have TV stations who are waiting in line to buy my new films, site unseen. Which is pretty scary—I have sold some really bad films. But it's "a Bill Plympton film," so they'll pay top dollar for it, simply because it has my name on it. So right now it's a pretty easy way to sell shorts. Features are another thing.

MS: Do you try to keep your shorts to a certain length, or do they come out however they come out?

BP: Generally speaking, I like to keep them under 10 minutes. I've never done a short over 10 minutes. I think the proper length is 3 to 7 minutes if you want to sell it. It's easier to program a film of that length.

MS: So the first piece you did on your own got nominated for an Academy Award. What was that like?

BP: It was great. First of all, I didn't really understand what the Academy was all about. I'd see it on TV, and I had friends who did it, but I had never really experienced it. And once you experience it, it really changes your life. People start calling you the Oscar-nominated Bill Plympton. You're seen by billions of people around the world. That film becomes an icon of your career. The experience of being there and seeing all these celebrities, being celebrated like that, it really changes your life and your perspective.

MS: It's really cool. Everyone aspires to do that, and you do it.

Figure 46-6 Image from the feature film, *Mutant Aliens*. © 2000 Bill Plympton.

Is your studio where you live, or is it near by? How do you work?

BP: The studio is in my apartment, unfortunately. Which makes it really difficult to live there, because I have boxes of drawings everywhere. I have light boxes everywhere. I have videos, books, and all that story stuff there, and it really gets in the way. Right now I'm looking for a studio to move to, and then I'll just live where I am now.

MS: During production of your features, how do you stay focused during the entire process, since you do all of the animation?

BP: Well, it's easy to stay focused, that's not the problem. I wake up in the morning envisioning the scenes I have to draw that day. You really get obsessed. You love the characters. You love the story. You love the drawing and the look. So losing my interest is not a problem. The problem is finishing the film on time and trying to get it sold. That's the hard part. (See Figure 46-6.)

MS: What recommendations do you have for independent producers and up-and-comers who want to do their own pieces?

BP: A couple of things: One is, do the films for the festival circuits, something for Annecy. Keep it 3 to 5 minutes long.

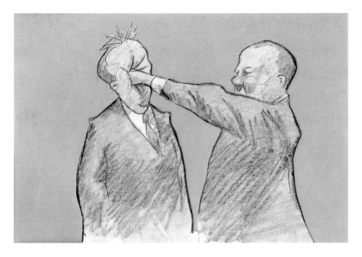

Figure 46-7 Image from the short film, *Push Comes to Shove*. © 1991 Bill Plympton.

Keep it short. Make it cheap. Try to do it for $1,000 to $2,000 a minute. Make it *funny*. People want to see funny films. Go to the festival circuits and make a deal. Also I recommend for young students, who are just out of art schools, to go to a big studio and work there as whatever— as an inbetweener, as a clean-up artist. Work there for 5 or 6 years. Get some money in the bank, and get some work experience. Make some contacts. Make a good portfolio. And then if you really have that itch to be independent, you can leave. You should have enough money to work for a year. That gives you time enough, hopefully, to make some money from your work. (See Figure 46-7.)

Chapter 47

Craig "Spike" Decker of Spike & Mike's Sick & Twisted Festival of Animation

Craig "Spike" Decker founded Mellow Manor Productions in 1977 with Mike Gribble, and they became the infamous "Spike & Mike." Through their company they produce *Spike & Mike's Classic Festival of Animation* and *Spike & Mike's Sick & Twisted Festival of Animation* (Figure 47-1).

Mellow Manor is named after the famed Victorian house in Riverside, California, where Spike, Mike, and many others lived in a communal setting. This was an "Animal House" before National Lampoon made theirs famous. Although Mike Gribble passed away in August of 1994, Spike continues to produce shows with the highest standards of artistic and subversive excellence.

The original mission of Mellow Manor Productions was to promote underground bands with retro animated shorts. In the early 1970s, Spike & Mike began promoting the local Southern California band, "Sterno and the Flames," a band in which Spike sang bass vocals. Later, they presented special shows, such as all-night horror-thons, an evening of *Star Trek* bloopers, and midnight rock and roll films such as *Jimmy Plays Berkeley* and *Quadraphenia*. They would also present full-length films such as *Slaughterhouse 5* and *King of Hearts*. At those shows, they would open with *Betty Boop* and *Superman* animated shorts. They also picked up other shorts that became cult favorites, such as *Bambi Meets Godzilla* by Marv Newland. The demand to see the shorts soon eclipsed the popularity of the band and other films. Spike & Mike knew they were onto an unfilled niche and began promoting animated shorts full-time.

Spike & Mike premiered works in the *Classic Festival of Animation* by Tim Burton (director of *Batman*, "Vincent"), John Lasseter (director of *Toy Story 1* and *2*, "Tin Toy"), Bill Plympton (MTV–popularized animator of the feature animations *I Married a Strange Person* and *Nose Hair* and *How to Make Love to a Woman*), Nick Park (creator of *Wallace & Gromit* in the Oscar-winner *A Close Shave*, Oscar-winner *Wrong Trousers*, and Oscar-nominee *A Grand*

Figure 47-1 Spike & Mike. Founders of *Spike & Mike's Sick & Twisted Festival of Animation*.

Figure 47-2 Image from *Timmy's Lessons in Nature,* Lesson 2. The first 3 Lessons are in the 2001 touring edition of *Spike & Mike's Sick & Twisted Festival of Animation.* © 2001 A&S Animation, Inc.

Day Out), Will Vinton (creator of the California Raisins commercials, *The PJs* and *Gary and Mike*, "Closed Mondays"), David Fine and Alison Snowden (creators of Comedy Central's *Bob and Margaret* and Oscar-winner *Bob's Birthday*), and many others.

The *Sick & Twisted Festival* began in 1990 as a home for animated pieces that are simply too revolting or adult in nature for their prestigious and tasteful Classic show. *Sick & Twisted* is the birthplace of *Beavis and Butt-head* (Mike Judge, creator of *King of the Hill*)—Spike & Mike produced the first two *Beavis and Butt-head* shorts long before the characters debuted on MTV.

The *Spike & Mike Festival of Animation* bought the rights to run three episodes of *Timmy's Lessons in Nature,* including Lesson 3 in this book. These shorts premiered in movie theaters in the summer of 2001, along with a number of animated shorts by other independent animators (Figure 47-2).

MS: Which animations that you discovered are you most proud of?

S: Obviously, *Beavis and Butt-head*, because they became icons, sort of animation history and American cultural history. And I would probably say *Wallace & Gromit.*

MS: Yeah, those were great. So were you the first to distribute *Wallace & Gromit* in the United States?

S: Sure was. Both on video and theatrical. We picked those for exhibition. We sort of produced and co-created the first two episodes of *Beavis and Butt-head*.

MS: How did you come across *Beavis and Butt-head*?

S: Mike Judge was a student, and he sent me a letter, which I still have, asking if we could help him make some films. He had a little short—I think it was called *Office Space*. I was producing a lot of films for *Sick & Twisted*, and I saw some element in that, the little bit of sarcasm, and I just proceeded based on that one little element that I saw in a very simple film that he had done earlier.

MS: *Beavis and Butt-head* set the pace for so many other sarcastic and really edgy animations.

S: Yeah, I've always liked parodies and satirical pieces using animation.

MS: When an animator comes to you and asks for your help on producing a project, what do they normally send you?

S: Generally, we get a student film or a pencil test, and we go from there. I used to do it off of storyboards, but I would have to have a relationship with somebody to do that anymore. I don't know how many films we have done production on. We put up funding. I just do it based on what I see or from talking to them, if they can pitch a good storyboard.

MS: What rights do you want in exchange for funding part of or the entire production?

S: It used to be, when we first started doing it, that we were more liberal in leaving rights for the animator. After getting screwed so many times, I'm now to the point where if I'm going to produce it, or co-create it, or put the money into it and believe in it before some huge corporate giant does, then I want a piece of the action—not having gotten a piece of the action or recognition for too many years, too many times. It's not right, and it's not fair. I now own quite a few character rights on films that we have done. We at least have to have shared rights now to go the whole nine yards like we did in the early days with *Beavis and Butt-head*. We

Figure 47-3 *The Powerpuff Girls* by Craig McCracken. © 2002 Cartoon Network.

also did the first episode of *The Powerpuff Girls*, which was called *Whoopass Stew* at the time, which was kind of cool. We did all the production on that, the ink and painting and everything (Figure 47-3).

MS: Obviously some of the animators you discovered have succeeded extraordinarily well.

S: Yeah. A lot of them have. Aardman [producers of *Wallace & Gromit*] certainly. John Lasseter. A lot of them. It's amazing how I look back and I see this stuff. And then I see their work come up ten years later, and it is all over the media how some major company has just discovered this product or this animator or these characters, and it's weird. We were running it a decade ago.

MS: For people who aren't familiar with your different festivals, the *Classic Festival of Animation* and *Sick & Twisted*, tell us how they are distributed.

S: We do a theatrical run that tours throughout North America. It is stronger on the West Coast than the East Coast, but we do play throughout the U.S. and parts of

Canada. In the past year and a half we started playing some international festivals. We played in Dublin and we played the Cannes Film Festival. I just got back from the Annecy Animation Festival, which is the biggest animation festival that takes place once a year in June in Annecy, France. We screened *Sick & Twisted* [the compilation of shorts] for the first time there in this huge outdoor arena in a park with this giant 40-foot screen and 3,000 French kids. It was pretty cool, they really dug it. We did a screening over at Aardman at their studio. I always knew and had this feeling that the different countries and the Euro kids would be down with the show. Sure enough, we were turning them away by the hundreds, selling out every show we did in Annecy. They not only like it in the U.S., but in France and Holland and England or wherever.

MS: That's the great thing about animation

S: And the *Sick & Twisted Festival*, they've never seen anything quite like the concept before. It's pretty cool to get out there in other countries like that.

MS: So how else are these pieces distributed besides theatrically?

S: We do video and DVD distribution. We are always working on further cable or broadcast rights. We also have a book coming up with Abrams Publishing. We're doing a sort of history of what we've done over the years. It's pretty cool. We are just always looking for ways to get out there. We did the Korn tour with the rock and roll band Korn. It was the Family Values tour, and they changed the name to the Sick & Twisted tour. We toured all over America with Korn. I put together a custom show that was 45 minutes long, and they put up these giant screens and they projected our animation. We essentially followed the first band, and they named the tour after us.

MS: When was that shown, during the concert?

S: It was shown after the opening band and before Korn came on.

MS: Oh great, great idea.

S: Yeah it was. It was better than having 45 minutes of dead time or watching guys move a bunch of equipment around. Korn really digs the show, and like a lot of groups here in California, they grew up going to the show, so they thought

Figure 47-4 Tiffany and Summer from *Hut Sluts*. © Mellow Manor Productions.

it would be a cool idea—which it was. If somebody's film gets shown on the Korn tour, not a bad showing in an arena with 30,000 kids.

MS: No kidding. Besides the pieces that have been financial successes, which are your personal favorites?

S: I like Tiffany and Summer. They're two girl characters we have. We did one short called *Hut Sluts* and one called *Swing Sluts*. I think they have incredible potential to be a series with the right writers attached. So I like Tiffany and Summer a lot (Figure 47-4). And then I like, in the *Classic Festival*, the non–*Sick & Twisted* show, a film called *Screenplay*. It's like puppet animation, and it's just a masterpiece of work. It is like perfection. I like Don Hertzfeld's stuff that's coming up, with *Rejected* and *All The More*, and things like that.

MS: What do you look for, when you choose shorts that you are going to distribute?

S: I look for, number one, humor—always the number one ingredient. I look for story accessibility. In that order. It's hard to get somebody with timing, story, and humor. And then, even more than the quality of animation, I look at their technique. Because Don Hertzfeld does very low-budget animated stick people, and Matt [Stone] and Trey [Parker]

proved that you could do it with cutout characters and minimal animation with *Spirit of Christmas*. The same with *Beavis and Butt-head*. So much of it is in the timing, the story, and the humor. It helps if you can get a good character design, like in *Wallace & Gromit*. Nick [Park]'s great, and they've got great character development. And then you have the ability to tell a story, as John Lasseter did with *Toy Story*. Those are the ingredients in making it accessible. So, those would be the things that I've learned after thousands of films and 25 years.

MS: Wow, it's amazing that it has been 25 years already.

S: Yes, and 10 years on *Sick & Twisted*.

MS: When you pick up a finished piece for distribution, what rights are you looking for?

S: If it is finished, we always get a minimum of video, DVD, and theatrical. If it is something that we can afford or something that is really hot, then we try to pick up some cable rights and that sort of thing. Some of it we buy according to what rights we are using at the time. I'm not going to buy European rights just to have them sit on a shelf. I don't have money like that.

MS: And you try to keep those non-exclusive if you're not funding the project, right?

S: Yeah, we do a lot of non-exclusives. If it's something that's really hot, then we'll try to get exclusive. If it is something we produce, it is going to be exclusive.

MS: When animators make a distribution contract with you, how do they need to deliver their finished product to you?

S: In a perfect world, we'd like to get 35 mm access. Ideally, a 35 mm negative. If not, we have taken a lot of films and taken them from video to blow up to 35 mm. I've gone from Super 8 to 35 mm, and gotten 16 mm to 35, and we've done tape to 35 mm. So we have done it all in that regard. But ideally, we would like to get 35 mm negative access. If not, we have to go in and convert from tape to film until the day comes that they have the digital projection that will go from a very heavy 35 mm cannon to a high-resolution digital projection—which is there, but the theaters are not paying for it.

MS: Right. Very few of them are.

S: It would be nice too if the studios, as wealthy as some of them are, invested or gave the theaters an incentive to buy the new projectors, so that they could present the quality of their art form in the best manner that they possibly could.

MS: Are you finding that most of the pieces that you are getting are still on film, or are most of them digital and straight to tape?

S: Digital. It's so funny. I look back in the early days, the pre-Pixar days even, with early computer animation just little exercises like *Andre* and *Wally B.* and these things and the early days of *Luxo Jr.* with computer. It's just amazing that there was a time when we made a big deal out of it at the show, or people would come just to go, "Oh my God, this was done on a computer," or "this was generated with a computer." It is pretty wild. So we get a lot more of the computer-generated films. We get a lot more films than we used to, which is good. Although I don't prefer computer animation. I mean, nothing ever matches traditional, old school, great, hand-rendered animation like early Max Fleischer *Betty Boops* and things like that. Those are masterpieces. Each drawing is a masterpiece unto itself.

MS: But you look at all different forms, such as stop motion, for inclusion in your festival, don't you?

S: Definitely, we have everything—clay, puppets, stop motion, cutouts, animation done with pieces of candy, stick figure drawings, pencils, everything.

MS: How often are you looking at shorts?

S: All the time. I'll go to the mailbox today and there will be a something from God knows where. It is pretty interesting to think back on the days when you opened up an envelope and it was the first episode of a certain film that has now become legendary, or the first Pixar short, and you're looking at it at that moment, sort of knowing that it is going to go huge. It's just like the first time I saw *Rugrats* as a short and put it in my show, I think in '89, and I'm looking at a video of it.

MS: So, *Rugrats* is another one of your discoveries?

S: Yup. I think it was '89.

MS: Wow.

S: I just saw it and saw the value of it, especially in the Classic show, having family accessibility and charm.

MS: Was *Bambi Meets Godzilla* one of yours?

S: Uh huh.

MS: That stands out as probably the most classic animated short of all time to me.

S: Yeah, definitely. I think Marv [Newland] did it when he was 18 years old or something as a student project. Marv's a good guy, a good friend. We still show it. The title is such a catchy play on words, and people are amused by it. Everybody knows Godzilla and everybody knows Bambi. It still holds up as pretty funny.

MS: What are your thoughts on the current state of the animation industry?

S: I was glad to see the success of *Shrek*. Kat Miller just called me, and she did a lot of the production on *James and the Giant Peach* and *Nightmare Before Christmas*. It is funny that she just called, because there is an example of the current state. I mean, look at the quality of animation and character design on those films. I've been on their sets up in San Francisco. I like that sort of thing [stop motion animation] much better than computer animation. I just didn't think that their stories were accessible enough, but the character design and the quality of animation were just like with *Aardman* and *Chicken Run*. I just like real 3D models and animation of characters and traditional animation better than computer-generated. That's the main thing that I'd like to see: something in the future that gets us back to traditional animation or models like that rather than using the computer. To me, it's like a handmade violin. It's like a Stradivarius violin as opposed to something that's massed produced. It's the texture and the quality of it. I'm hoping that goes on more.

MS: What do you feel about Saturday morning animation. There are no comedies at all on the networks right now [Fall 2001].

S: Most of it is just terrible stuff. It's just formula crap. All mass produced. It is all about the payday, and the simplicity of doing it, the quickness of doing it, and streamlined production.

MS: Through your festival, do you think that you have been able to predict the direction that animation successes would go?

S: Definitely, and we've picked so many and premiered so many. I could go on for 10 minutes about what we've done, and there are people right now that I know are going to be the next stars. But I don't like the Japanese stuff, and it's just that it has to get back to the characters and the humor and all of that. *South Park* was a good example.

MS: That's just so funny, constantly.

S: They have good writers. *The Simpsons* obviously do. I just want to get away from more of that mass produced slick look. The McDonald's of animations. Take this formula and put them everywhere. Lasseter has been one of the few people in computer animation that has really been in there to go create. Use computers, but create an interesting story with really interesting characters that have some depth and charm and human qualities.

MS: Do you think that animated shorts before feature films will ever have the popularity in movie theaters that they used to?

S: I think that they could, definitely. One thing that's cool about Pixar is that they have a policy now of making sure that they put a short before all their features. Like they did with *Gerri's Game*. They'll do it with *For the Birds* and *Luxo Jr.* And I think of our show, which is a 90-minute show. We might show 20 films that are more entertaining than one feature film with the same style of animation or the same story throughout, because there are many little miniature motion pictures in the 90 minutes. If there is something that you don't like in this film, you might like the next one. So I really think that our shows are more entertaining than the vast majority of feature films.

I always liked the application of animation toward Sick & Twisted. It's unlimited in what you can do with your imagination so it makes sense to play into that. Everybody always held it down or Disney held it down. It was always "Oh it's just for family fare" or "It's just for kids." That was something else that was kind of cool about *Shrek*—that it was not just for kids.

Figure 47-5 *Timmy's Lessons in Nature*, Lesson 1. © 2001 A&S Animation, Inc.

MS: We just saw it, and at the end the audience stood up and applauded.

S: Cool. Any kind of success like that is a great shot in the arm for animation in general.

MS: I have three animations in your 2001 edition of Sick & Twisted, *Timmy's Lessons in Nature*, Lessons 1–3. Lesson 3 is profiled in this book. Do you remember what it was that caught your attention when we sent them to you?

S: I liked the directness of it. The snake continuing to strike the kid in the face (Figure 47-5, Lesson 1). Just the directness of them. Right to the point. I just like that it is a goofy, goofy kid, and it's kind of against the family values of our society.

MS: Is anything too gross for *Sick & Twisted*?

S: Maybe *Sloach's Funhouse*. It is done in clay animation. A guy out of Chicago. It's really disgusting.

MS: [Chuckles]

S: It's really bad. I've seen people get up and leave.

MS: [Laughs] What do you recommend to aspiring animators?

S: I would tell them to look at the success of the people over the past 10 or 15 years, if that's what they're after. If

they're after true success, make a good living and get out there with their work commercially. Then look for just the basics of having a good story and making it accessible and—as elementary as it sounds—a beginning, a middle, and an end. I've looked at thousands of films that are great, great animation, and somebody spent hundreds and hundreds of hours on it, but they don't know when to stop. It's like three minutes too long, or they don't have their timing, or they don't know how to end it.

MS: Well, I know how and when to end it. Thanks for your time, Spike.

Chapter 48

Linda Simensky, Senior Vice President of Original Animation at Cartoon Network

Linda Simensky is senior vice president of original animation for Cartoon Network. In this capacity she oversees the development and production of all new Cartoon shorts as well as new original animated series, such as *The Powerpuff Girls*, *Samurai Jack*, *Courage the Cowardly Dog*, *Ed, Edd, and Eddy*, *Dexter's Laboratory*, *Johnny Bravo*, and *Harvey Birdman: Attorney at Law* (Figures 48-1 and 48-2). Simensky has also been involved in all aspects of programming and development for the network, including scheduling, acquisitions, program operations, and original programming and development.

Prior to joining Cartoon Network as director of programming in 1995, Simensky worked with Nickelodeon, where she most recently served as director of animation, searching for

Figure 48-1 Linda Simensky.

CARTOON NETWORK

Figure 48-2 Cartoon Network logo. © 2002 Cartoon Network.

new projects as well as seeking out new creators. Simensky had been with Nickelodeon since 1985, working in various positions within the programming and animation departments. In her career with Nickelodeon, Simensky worked on several pilots including "Rocko's Modern Life," which she helped to develop with the show's creator, and she also developed and produced many pilots for Nicktoons and Nick Jr.

Simensky is also involved with numerous committees and organizations that support animation. She is the past president of ASIFA-East (International Society of Animation), a position she held for 10 years, and the founder of the New York chapter of Women in Animation. She also lectures at numerous colleges and animation festivals across the country and has taught courses in animation at the School of Visual Arts in New York. Simensky was recently awarded the June Foray Award, a special honor from the Annie Awards (outstanding animation awards from ASIFA), which is given to an individual who has made a significant and benevolent impact on the art and industry of animation. She also received tribute recognition from Girls, Inc. for her role in developing *The Powerpuff Girls*, a television series that has advanced positive role models for young girls. Simensky holds a B.A. in Communications and History from the University of Pennsylvania and an M.A. in Media Ecology from New York University.

MS: What were the main steps in your career that got you into the position you're in now?

LS: I was always a big fan of animation, so I have to underscore everything with that. There was no animation being produced outside of L.A., and I lived in New York, but I was a big fan of animation and ended up working in children's programming at Nickelodeon. I was there as

animation got popular in the late 80s, and I was able to help start up the animation department. It helped that I was already there and everyone knew I was a big fan. So advancing as I have has had a lot to do with being at the right place at the right time, but also being able to see the potential of something. I worked on developing and finding pilots and producing pilots. I moved to Cartoon Network in 1995 as the director of programming, because I saw the potential at Cartoon Network. I knew that at some point they would be managing their own original shows. I helped set up the original animation department here.

MS: When you guys are looking for a new show, do you prefer to buy a fully developed series, or do you prefer working on the development with the creator?

LS: We work on the development from the concept with the creator. We very rarely buy fully animated things except for anime.

MS: Do you ever see shorts in festivals and want to develop them into a series?

LS: Absolutely, yes. A good example of that would be one guy in particular who had gone to RISD (Rhode Island School of Design). I had seen his student film up there and liked it. Then I saw it in a couple of festivals and liked it a little more each time, and eventually I worked with him on a short that aired this past summer. So yes, for every festival that I go to, I probably find about one creator whom I end up doing something with somewhere along the line.

MS: Do you feel festivals are the best place for independents to put there stuff out to be seen?

LS: I think so. Where else are they going to put it really? Unfortunately, TV is not the best format for the animated short. It's expensive to program a block like that, and most of the films are more for adults—and there are not very many places to program animated shorts for adults. So to me, festivals are the place where A, you get to screen it on a big screen, and B, you'll be with an audience that actually wants to see it.

MS: Do you use the Web for finding shorts?

LS: I have to be honest. Of the stuff made directly for the Web, the majority is not as good as what you might see in a

festival. I feel that my odds have been better at festivals, especially since the majority of things that I work on has to work for kids as well as adults and the majority of things on the Web really feel like they are only for adults.

MS: What kind of things are you and others at the network looking for in either pitch packages or shorts at festivals?

LS: The thing I really like is when something feels like it has been executed in a very interesting way. When it has a sensibility that feels different, that to me is interesting. Obviously, all the pieces need to be there. The design needs to be good, the basic idea needs to be good. There needs to be some humor in it. It needs to connect. Lots of people have good ideas, but not everybody has interest and sensibility.

MS: Do you want to see finished animations when people pitch to you?

LS: A lot of people think that they need to come and pitch to me with a finished board or a finished short, and that is completely not the case. Although if you're an animator, the chances are that you have done a film somewhere along the line. If it's an interesting piece of work, that's definitely going to help you.

MS: What do you like to see and what don't you want to see in pitch packages?

LS: I like to see lots of drawings. I like to see drawings of characters doing all sorts of things, because the humor should be right there.

MS: The drawings should be visual gags?

LS: Or just really interesting designs. It should make me want to see more. Writing is important, but it's not as easy to tell with writing if the show is a cartoon. It's much easier to see from drawings what it's going to be like. If the drawings are really generic it shows you that the project is going to be generic. The visual aspect of the show is very important. People flip around with the remote, and they stop on the things that look interesting. Or you look in the *TV Guide*, and if you see a picture that looks interesting, you check it out. Obviously, the pitch should look interesting and be designed.

MS: What's the best pitch that you've been given?

LS: I've been given a lot of good pitches, but I can't say that there's ever been one pitch that stands out as "The best pitch I ever got." Some of the best pitches that I've gotten haven't made the best shorts, or shows, and some of the best shows we've done weren't pitched in a particularly interesting way. I think a good pitch is written in such a way that you don't feel that it's contrived, but it still makes you laugh. A good pitch is not intentionally written so that you feel like someone only put jokes in it. It should have substance in it, but also seem funny and clever. I like pitches that are fun reads. The truth is that you can have a great idea for a show, but if you've written an incredibly tedious pitch with 25 pages of explanation, that's not fun for me to read. So I like a pitch that I just enjoy reading.

MS: Give us an idea of one of the worst pitches you've gotten.

LS: The thing that I can say about one of the worst pitches I've ever had—because I've had a lot of strange pitches—is that it's usually not just that the project is bad, it's that the project is bad and the creators are belligerent. You try to talk to them, and they deck you. Or they just don't want to hear it, and they tell you that you're wrong. I can think of a pitch once where the person came in and showed me something that I really didn't like. I tried to explain to him what we were looking for here, and he seemed pretty frustrated with my stupidity at that point. He thought that what he had was brilliant, that what I was looking for was stupid, and that I was just wrong. I launched into an explanation of what was wrong with the project that went on for so long that I was following him down the stairs. The guy who had pitched to me had shown himself to be a difficult person at the pitch stage. I certainly don't want to work with such a person, and his project was pretty awful on top of it. I think it's a very key point that getting together to do development is a little bit like dating, and you certainly don't want to come off like an asshole. There are certainly enough interesting creators out there that you don't have to work with jerks. I feel that the pitch is a good time to assess if this person is nuts. Sometimes they are. The worst pitches have been ones where the person walks out saying, "I'm going to make a phone call, and you will be doing this project," and I've had that happen. They're rarely simply bad because the

Figure 48-3 *Dexter's Lab.*

property is bad, or the creator's not good. It's usually a combination of the two plus that extra bit of spice.

MS: What are some of your favorite projects that you are really proud of?

LS: I've always been proud of a lot of the things I've worked on at Cartoon Network. One of the reasons I came to Cartoon Network was because I wanted to work on *Dexter's Lab* (Figure 48-3). After *The Powerpuff Girls* had not tested so well, a lot of people had given up on it. I was the first to really say, "I think we need to go back and reexamine this, because this creator, Craig McCracken, is really funny on *Dexter's Lab*, and I think we're making a mistake if we don't try to redevelop *The Powerpuff Girls*." My boss agreed with me, and then we had to convince everyone else at the network. I've always been proud that I stood up for *The Powerpuff Girls* (Figure 48-4). I've always been happy with shows like *Ed, Edd, and Eddy,* or *Courage the Cowardly Dog* (Figures 48-5 and 48-6), simply because they're unusual shows and the audience seems to really like them. Basically I've always been proud of virtually everything I've worked on. I was always proud of *Doug*. Although I thought another creator could have pushed it to be funnier, or that a creator in an alternate universe might have pushed it to be funnier. I always thought it was a sweet show and I was always proud of it.

Figure 48-4 *The Powerpuff Girls.*

MS: So you worked on *Doug* over at Nickelodeon?

LS: I worked on all the shows at Nick up through *Hey Arnold* and *Angry Beavers*. I was always happy with my involvement with *Hey Arnold,* because it was a nice experience. It was a fun show to work on. I really enjoyed working on *Samurai Jack* because it was such an unusual show, and the network left me alone with it (Figures 48-7 and 48-8). It was just me reading it with the people that worked on it. At that point I think I had developed a really good relationship with Genndy, the creator, so I was excited about that. But I'm always excited about the shows I'm working on. Obviously, the ones I'm most proud of are the ones people like the most. And it's not because they're hits. It's because we made something that people really like, and that makes me happy. My goal in going into animation was so I could be involved with making the kind of shows that people would love as much as I loved the shows when I was a kid. It's fun to do shows that people come up to you and say, "Oh, that's my favorite show ever." I feel like Wow! I fought for that show—glad I could help.

MS: Virtually every project I can think of that's on Cartoon Network is cel animation. Do you guys anticipate at any

Figure 48-5 *Ed, Edd, and Eddy.*

Figure 48-6 *Courage the Cowardly Dog.*

Figure 48-7 *Samurai Jack* logo.

Figure 48-8 *Samurai Jack.*

point putting on a CG (computer-generated) show, or do you stay away from that?

LS: I think [we would do one] if the right show came along. With CG and comedy—the kind of comedy that we do—you would have to have really, really amazing CG, and it would have to be affordable. Usually amazing and affordable don't come in the same sentence. It might be a while before we have a CG show. Some of our action stuff over the coming years will be CG, but as far as comedy, it's hard to say unless the right thing came along. We've experimented with alternative formats, and we're not opposed to that. We're open-minded. It just has to be the right project.

MS: How many original shorts do you and the network produce a year?

LS: We do anywhere from 8 to 12.

MS: How many of those turn into a series?

LS: Usually about 2, or 3. It varies. Every year is different.

MS: When the network decides to pick up a project, what are the general development steps you go through?

LS: Someone pitches the mini bible. That has a general idea of what the show is about: story ideas, character design, character description. If we like something, we option the property. Then we have the creator go back and maybe add a little bit to the bible, maybe tweak some things. We try not to pick up projects that need a lot of work because we don't usually like to change things. So we try to pick up things that come in seeming right for us. The creator then goes and tweaks the bible a little bit and maybe adds to it. Then the creator does an outline of a 7-minute short, does storyboards for the 7-minute short, and if it gets picked up to go to production, makes a 7-minute short, which airs.

Usually at that point you have some sense of whether it has a chance to go to series or not. When we air them, we take a temperature check around the network. We of course have our own opinions. Sometimes we focus group things with groups of kids, and we make a decision from there. A lot of times it has to do with the head of programming and his gut reaction. If it's a show that he thinks has a lot of potential, even if it doesn't test well or doesn't get particularly high ratings, it could potentially go to series just because he sees something there that he feels is going to make it work.

MS: When you green-light a 7-minute short, what is Cartoon Network supplying?

LS: We pay for it.

MS: Are you offering any post in-house or music in-house? Most independents don't have their own production houses.

LS: We have a studio in L.A., so people have worked out of L.A. People that don't have their own studio either find a studio to work with or just set up their own production. But they've got the money. We supply the money, and they produce it. In exchange for that money, though, if we go to series for that show we buy the rights from the creator. But

Figure 48-9 *Ed, Edd, and Eddy.*

we keep them involved. They get a deal that involves back-end and for services rendered, etceteras. Financially, it works for them. In exchange for all that we pay for everything that gets made. Even if you don't have access to post you have the money to pay for it. So it works out about the same (Figure 48-9).

MS: What kind of budgets do you have for a 7-minute short?

LS: They're competitive, usually somewhere between $200,000 and $225,000, sometimes more.

MS: What advice do you have for independents who are about to produce their own projects?

LS: Do it, that would be my advice. Get out there and make films. I think making a film is your calling card. Even if it's not exactly what a network is looking for, at least we can see that you're a filmmaker, that you know how to make a film, and that you have the wherewithal to make a film. In the event that you want to make a film, find a way to communicate your sensibility. Whether it's through writing or its through comics or its through drawings, just find a way to show what your sensibility is. And also, of course, go to festivals when you can. It's a great place to meet people, even if you don't have a film. You can see what other

Figure 48-10 *Samurai Jack.*

people are doing, and you can talk to people. Festivals are
a very casual and social environment where you can easily
meet people and not feel like you have to talk about
work. It's a good place to just meet people and have
conversations with them about anything (Figure 48-10).

Chapter 49

Rachelle Lewis, Director of Recruitment for Klasky Csupo

Rachelle Lewis oversees all the artist recruiting for Klasky Csupo. From television to feature film, home video to commercials, publishing to music, Klasky Csupo has become synonymous with state-of-the-art, cutting-edge animation (Figures 49-1 and 49-2).

Since they started the studio in a spare bedroom in 1982, graphic designer Arlene Klasky and animator Gabor Csupo, both passionate advocates of artistic experimentation, have built a company housing more than 300 employees. The studio's signature style embraces the wit and eccentricity of life through boldly imaginative uses of the animation arts. Winner of five Emmy Awards, two Cable Ace Awards, and numerous commercial, art, and production honors, Klasky Csupo has created hit television series including *The Simpsons*, *Rugrats* (along with Paul Germain),

Figure 49-1 Rachelle Lewis.

Figure 49-2 Klasky Csupo Inc. logo.

AAHHH!!! Real Monsters, Duckman, Santo Bugito, The Wild Thornberrys, Rocket Power, As Told by Ginger, and two *Edith Ann* specials. It is also the home for the UK's *Stressed Eric,* Class-Key Chew-Po Commercials, and the record labels Tone Casualties and Casual Tonalities, as well as Klasky Csupo Publishing.

Klasky Csupo initially distinguished itself with its work on logo designs, feature film trailers, TV show titles, promos, and spot IDs for a wide variety of clients, in the process earning a reputation as the industry's most imaginative and innovative studio. Building on its success, the studio opened its first facility in Hollywood in 1988 at the corner of Fountain and Highland Avenues. The studio soon grew to include six buildings that have become well known in Hollywood—in true Klasky Csupo style, the exterior walls of the buildings are decorated with large murals of its characters.

In 1999, however, due to Klasky Csupo's exponential growth and after an exhaustive regional search for an appropriate facility to consolidate its operations, the studio relocated to 6353 Sunset Boulevard. Committed to remaining in the district, Klasky Csupo chose a building on the corner of Vine Avenue in the heart of old Hollywood. With this move, the much-heralded "new" Hollywood now boasts one of the industry's major animation studios (Figure 49-3).

MS: What do you look for in portfolios for both animators and directors?

RL: Well, the bottom line is talent, obviously. For directors we look for strong composition and staging. We like directors who can see things with more of a "cinematic" sensibility. Acting is of course extremely important for directors as well.

MS: Klasky Csupo have a very specific look, do you worry about style?

Figure 49-3 Klasky Csupo building on Sunset Blvd. in Hollywood, California.

RL: In a portfolio we look for a wide range in styles, because at this studio not only is our style very different from other large studios, but the way we have our TV production model set up is different. You might be drawing on *Rugrats* on Monday and then drawing on *Rocket Power* the next week. Even though they're slightly similar, there are differences. In a portfolio you have to be able to show that you can draw in a wide range of styles, and that you can draw quickly and with a strong line (Figure 49-4).

MS: How would you describe the look of Klasky Csupo animation?

RL: I think it's quirky. I think it's very identifiable. I mean you can certainly turn on your TV, and if you're looking at something coming out of Klasky Csupo, you would know it right away. We're definitely heavily influenced by Eastern European artistic sensibilities. Obviously that influence comes from Gabor Csupo who's Hungarian, and we also have a lot of Eastern Europeans working at the studio. We love that kind of different style that they bring to the table.

MS: So what's the best way for someone to approach Klasky for work?

RL: The best way is through our recruitment department. Unlike other studios, we are not a corporate run studio. We're an artist studio. We don't have terribly strenuous rules about how often you can put your portfolio or reel in,

Figure 49-4 *Rugrats.* © 2002 Viacom International Inc. All Rights Reserved.

although we encourage people to submit no more than once every 6 months since that is a reasonable amount of time for an artist to show progress. You can submit your portfolio any day Monday through Friday, and we will take a look at it and give you some feedback. At least you'll be in the system. A lot of times people think, "Well great, I submitted my portfolio to a studio and nothing came of it," and they just give up, which is ridiculous. It's an ongoing process. If you're an artist, you're always growing. If you're doing your work and drawing every day, your portfolio will show that growth. If you're a beginner and you really want to be in this industry, you should be walking around with a sketch book. Drawing well is like playing a musical instrument—with practice you can always get better. And it is a lifelong craft.

MS: When people drop off portfolios, is there ever an in-person interview first, or is it just a drop-off.

RL: No, the first step is to drop off the portfolio. If we are interested in your work after checking out your portfolio, we

may meet with you at that point. Once or twice a week, depending on how busy we are, we look at the portfolios that have come in. We get anywhere from 200 to 400 portfolios a month. We take those portfolios and from them choose 20 to 30 of the best artists, the people that we feel would be a good fit with Klasky Csupo, and who can also bring something a little different and innovative to the table. Then we have a review board that meets once a month, and that basically is comprised of all of the producers and directors from every division of our studio: feature, television, Internet, commercial, and our record label. Someone comes over from each division and checks out the artists, even if we're not hiring at that time. It's just a way for everyone to keep in touch with the amazing art that is coming to our studio, and we receive incredible portfolios here.

MS: You look for more than just animators?

RL: Yes, we're looking for everybody. In television we look for strong storyboard artists, character designers, and background designers. We're famous at Klasky Csupo for growing our own talent. We promote heavily from within. Most of our directors came up from working as a board artist or a BG [background] designer or a character designer on television. And they understand how all those jobs work and how it all comes together, and they make great directors. Plus they know the Klasky style. They've been doing if for years, and they just know it. They can immediately see whether or not that board is right, how that's going to play out for a Klasky show. In feature we look for character layout, BG design, and BG layout. We love to hire animators to do character layout for us because of the way we produce our features. Our character layout artists are really doing a lot of animation. We love people that come from a strong animation/animator background.

MS: Are most of your artists freelance or staff?

RL: We hire a lot of freelance artists for our commercials division, but in TV most of our artists are staff. For features it's a different situation, because the artists have contracts, as is typical with feature productions. (See Figure 49-5.)

MS: So you do the keys in-house and ship the rest overseas?

RL: Yes. Our storyboard artists, and I know that I may seem prejudiced, but I think they are the strongest in the industry

because our boards for a 22-minute show are just fat [many more pages] compared to what other studios might ship. Also, our board artists are great storytellers and actors. They understand the punch line. They put a lot into the storyboard that is just totally coming out of their imagination. Sometimes it's something that isn't even mentioned in the script, but it adds a lot to the story. We record the voice first, and then board it out. Some studios board first then record the voice. I think we would lose so much if we worked that way. We have some amazing voice talent at this studio. I mean we have Tim Curry, this fantastic actor who brings so much to the script. Why in the world would we not record him first? He brings so much to a very simple line of dialogue. It just inspires the board artist to put even more acting and great poses, etc., into the scenes.

MS: We've run into situations where we were boarding on a project and we read a line with one intonation, but when the actor recorded later it was totally different. The same line could be either shy or cocky, and it needs to be boarded completely different for each reading.

RL: Absolutely, because boarding is all about the acting, the posing, and the staging. How can you possibly do that without the actors input? Good actors bring so much to the table with one simple tweaking of the way they're delivering the line that it can completely change the emotions of the scene.

MS: How important is education to you?

RL: It's important. With education I know that the person is going be able to communicate with other people. That they have done something that they have completed. That they play well with others. But talent really overrides education. I mean, we do have people working at the studio who have no formal art education but who are just huge natural talents who have come up through the system and just picked it up. The majority of people working here do come out of art schools. Certainly in my job 60% of what I do is developing relationships with art schools throughout North America and Europe so that I can bring in the best young artists. But every once in a while you see a portfolio of someone who has no professional training but has incredible talent, and needless to say I'm not going to discriminate against that artist because he or she doesn't have a college degree. That would be absurd.

MS: A college degree doesn't mean they're going to be any good.

RL: Well, we're talking about art, so there's a subjective element to what we consider "good" and "bad." Certainly, if I see that someone has graduated from an art school with a strong animation curriculum I'm going to assume that they have a higher level of understanding regarding the different aspects and disciplines of animation. However, just because someone graduates from a great art school does not necessarily mean they will be a great artist for Klasky Csupo and the projects we produce. Just because someone graduates with a law degree, that doesn't mean they're going to be a great attorney, either.

MS: Does having a really fancy portfolio or graphically well-designed resume make any difference?

RL: No, not to me. This is where if you had a panel of recruiters such as Frank Gladstone from DreamWorks, who's wonderful, or Tiffany from Disney, or Jay Francis from Film Roman, or anybody else, we would all have our own thing to say. Although there are aspects of a portfolio that pretty much every studio wants to see (for instance, everyone likes to see life drawing skills). However, because we are all different studios artistically, we look for different strengths in portfolios. For me, I could care less about a graphic design on a resume, or how beautiful the portfolio case is. For the

resume, the most important aspect is, is it easy to read? Does it tell me clearly where, when, and in what capacity you worked? Also, a lot of companies scan in resumes. For every resume we get we manually import all the information that we need and put that person into a database. I have heard other recruiters say, "please just give me plain white paper," because if it's textured paper or if there are tons of fonts with bolding and all this fancy stuff, especially if there is a graphic, it won't scan.

So the most important thing with a resume is clarity. Is it easy to read? Is it clear where you worked? What did you do, and when did you do it? With a portfolio it's very funny, sometimes we get people that bring in absolutely outrageously fancy big gigantic hand-painted boxes. Even though I understand that the artist's intent was to make the portfolio stand out, we look at every portfolio that comes in here anyway. We're not judging whether or not we're going to open up a portfolio by the looks of it. Some of the best portfolios I've seen look like they're about to fall apart. However, when I open them up they're well put together with all their life drawings together, and they're focused on how they're marketing themselves to the studio—that makes a difference. For instance, if I open up a portfolio and I see life drawings and amazing characters with turn-arounds and expressions, I know that this person wants to do character design and is very focused. On the other hand, if I open up a portfolio and see a little sketch of a character here, and the next page is a life drawing, and the next page is a BG, and the next page is something that looks like it belongs in a comic book, then I'm thinking, "What does this person want to do?"

I always tell artists, specifically students just starting out who don't really have the professional experience, that there are a lot of very experienced professionals on the street right now, and you don't have the luxury of just being able to present yourself as an all-around-artist. You have to present yourself as a character designer, or a storyboard artist, or a BG designer. Otherwise, there is just no way to compete with the other portfolios that we see.

MS: When you're looking at reels that people include with their portfolio, do you prefer to see pencil tests or a finished project?

RL: To be completely honest, and I can pretty much say this is universal for the other studios as well, we really don't look at reels unless the portfolio blows us away. I simply don't have the time. Of course I'm talking about 2D artists, obviously, not 3D. For 3D of course the reel is the piece to look at. For 2D artists I will only look at their reel if their book blows me away. I just do not have time to look at every single reel. If I see a portfolio that is really good and I do watch the reel, pencil tests are always nice to see—but you don't need four minutes of pencil tests! By the way, put your BEST work first on your reel. You have got to sell yourself in the first 30 seconds, because if it isn't there in the first 30 seconds, nobody is going to see it. So put your very best stuff up front on that reel, to really POW—this is my best work. Also, don't worry about the audio; nobody really listens to the cool, funky techno music that is playing in the background. We turn the audio down; we don't care about your audio ability or your taste in music. We're looking at you as an animator and what you can bring animation-wise.

MS: No one tells students this stuff.

RL: Nobody ever tells them this in school. However, at the World Animation Celebration, we organized numerous events, one of which was the following: we had all the major studios come in and give their 90-minute recruitment spiel. We had Jay Francis from Film Roman, who was up there speaking, "Okay, this is Film Roman and this is what we do. And if you want to get a gig at Film Roman this is what you need to send me; A, B, C, D, and E. Do not send me the following list A, B, C, D, and E." Then we had Frank Gladstone from DreamWorks, who gets up and says, "Hey, I'm Frank from DreamWorks. I want to see A, B, C, D, and E." We put this together, because as an industry why should we make it such a mythological search, to try to figure out what Disney wants, or try to figure out what Warner Brothers wants, or Klasky Csupo wants, etc. Let's just tell them, because as recruiters it just makes our life harder if people are sending us stuff in a confused state. I want them to know that at Klasky Csupo this is what I want to see and this is what I don't want to see. Send THIS to me and it will help your portfolio move through the system here, which in the end will get you seen by producers and directors and get you a job here.

MS: Give us your "dos and don'ts."

RL: For Klasky Csupo, do put in life drawings. That should always be the very first thing in your portfolio, if you are a beginner. If you have professional experience, put that professional experience first. Do put in quick sketches and contour exercises. That gives us a chance to see how you think as an artist. Because if you have that contour exercise where the pen never leaves the page, we can follow how you brought that life model onto the page, and see how you think as an artist. Don't put in any original pievec [oil paintings, originals of life drawings, etc.]. We've never lost a portfolio since I've been here, but you never know. These things are flying all over the studio, and even though we track them like hounds, you never know. You could end up losing all of your work, and that would be horrible. So never put originals in; always submit copies. Do focus on one area for which you want to present yourself.

If you think you'll be a good character designer at Klasky Csupo, only put in your character designs. Don't have a bunch of loose stuff flying around in your portfolio. The biggest don't, for me, is don't represent yourself as an artist who only draws in one style. Specifically I am talking to character designers. For instance, if I see one more big-breasted swordswoman, I'm going to kill somebody. Its OK if big-breasted swordswomen are your thing, but just put only one character of that style in your portfolio. Otherwise you're representing yourself as somebody who really only wants to draw that particular style. If your thing is anime, fantastic. But we may only have one or two anime jobs in our commercials division a year. But if you can draw anime and you can draw in other styles, I might consider you for a character design position on a TV crew. Do not only show one style, show a ride range of styles because you're showing your versatility as an artist. (See Figure 49-6.)

MS: Give me an idea of one of the worst presentations or portfolios you've seen.

RL: We get a few a month, but recently the worst that came in was, I kid you not, in a bakery bag, that had a half eaten croissant in the bottom. Actually the artist was quite good. I called him and said, "You have a lot of talent, but I have to ask you, what are you thinking? What are you doing? You don't deliver a portfolio to a studio in a bakery bag with a half-eaten nibblit in the bottom."

Stuff that is outrageously pornographic is bad. We have gotten some portfolios that have illustrated porn. And I'm not talking naked models, that's fine. I'm talking hardcore porn illustrations. I'm thinking, OK, gosh, I can really see you drawing Chucky on the *Rugrats*—Not! Just have a little common sense. If you send something to Klasky Csupo you can be a little crazy, because we're not so corporate, but still common sense is always necessary and sometimes very lacking.

MS: There are a lot of animators obviously who want to do their own thing. Whether it's to get attention for the work that they create, or potentially to get their own project. What

advice do you have for people about to do a project of their own.

RL: The first thing I'd say is obvious, and that's shop your piece to festivals. It's such an amazing way to have everybody in the industry see you. Also, put together a very strong treatment and pitch, and practice before you get in front of development execs. The more focused you are, the more chance you have of really getting your pitch across.

MS: So someone who produces his or her own thing and gets it shown at a festival—that could help them?

RL: Absolutely. If I'm at a festival and I see something that just blows me away, I'm obviously going to call that artist and say how incredible I think the piece was, and thank the artist for doing it. The next thing I would do is find out if the artist would ever consider doing something with a studio. If I think the artist would be right for visual development at Klasky Csupo, I will bring him or her in here and introduce the development team. By doing that the development team knows that this artist exists. And if a year later when we have something that is written and amazing they remember that artist, then I'll bring him or her in back for a second look.

MS: Most of what I see coming out of your studio is cel animation. What about CG projects and artists?

RL: I look at a lot of 3D/CG reels. We as a studio are presently about 90% 2D. We do have a 3D department in our Feature Division, and we often hire freelance 3D/CG people for commercials.

MS: Do you offer internships?

RL: We do have internships. We have internships three times a year. I cannot stress to students how golden an internship at a major studio is. If you have the words Nickelodeon or Film Roman or Disney or Warner Brothers or Klasky Csupo on your resume as an internship, that carries a lot of weight, because it's competitive to get internships. Our artistic internships last for ten weeks. They are paid, and we really utilize our interns. Our artist interns really draw. They're not going to be used to pick up dry-cleaning or tuna salad sandwiches for directors. We respect people as artists, and we would never do that. If you get an art internship here it is golden, and it's 10 weeks of more than you learned in 4 years of art school. If you're intelligent, you're open, and

Figure 49-7 Klasky Csupo studio.

you play well with others—don't have an attitude, just come in, be open, absorb—and if you do a great job, we may hire you. We have a very high rate of interns who once they graduate from school, we're on them. And that does happen here. We have hired people right out of school, putting them into character design positions on TV crews, because they did such a phenomenal job in their internship, and we know that they're great artists, and they're just cool people whom we would like to add to our team (Figure 49-7).

MS: Great. Do you offer ongoing training for your animators on staff?

RL: We do. We have a program that employees can take advantage of where they can take classes that are free to them. It's actually part of a state program here in California. We also have free life drawing classes here for all of our artists, which we feel is so incredibly important. Life drawing is the roots of the tree. It's a craft that is a lifelong process. Since we have grown as a studio in the last two years, we are putting together an even more extensive artist training program.

MS: What kind of advice would you like to give animators?

RL: For students I would say don't be disheartened by the state of the industry, because it's cyclical. If you look at the history of the industry, it always picks up. There is always a need for animation. People love animation in this country,

and it will always be here. It will always be a part of our culture. I'd also tell them, in a way, even though the industry is low right now, they're very lucky—because as opposed to 15 years ago, they have many more options. Fifteen years ago, if you were coming out of an art school with an animation degree, you maybe had 20 to 30 studios at the most within the United States and Canada to submit to. And if you didn't get a job at any of those 20 or 30 places, what were you going to do? Well, now we have DVDs and we have all these other opportunities. You can work on DVDs, you can work on video games, and there are so many more opportunities. The Internet, which is kind of taking a dive right now, is certainly by no stretch of the imagination gone. There is still a lot of work out there that you can get, and build yourself a professional resume, and build yourself up as an artist to re-approach the major studios with your portfolio. So that's the good news. For industry professionals who have found themselves on the street right now, I would say there are still jobs, and I think that the industry is definitely going to pick up within the next 12 months. I have faith, and I'm seeing little bits here and there, and I'm seeing it happen already. So I would say just have patience, and try to maintain and use this time to really work on your chops. No matter what you do, you can always get better. The other thing is to really know the studio you're marketing yourself to. Even as an industry professional you still need to

have that portfolio really tight, so that you're not saying, "Hey, I'm an artist, and I have all this experience, and what can you do with me?" Instead do the 5 minutes of research and find out what the studio is specifically looking for. It will just help me, the recruiter, sell you to the person in charge of actually hiring for that position, the producer. Do your 5 minutes of research. It will help tremendously. (See Figure 49-8.)

Chapter 50

Tom Sito, Co-Director of
Osmosis Jones

Tom Sito is a 26-year veteran of animated film production
(Figure 50-1).

His screen credits include the Disney classics *The Little
Mermaid, Beauty and the Beast, Aladdin, The Lion King,
Who Framed Roger Rabbit?, Pocahontas, Dinosaurs,* and
Fantasia 2000. Animation World Network (online periodical)
called Tom "one of the key players in the Disney Animation
Revival" (January 2001). In 1995 he left a Disney
directorship post to help set up the DreamWorks Animation
unit. He worked on *The Prince of Egypt, Antz, Shrek,* and
Spirit of the Cimmaron, he recruited and trained staff, and
he consulted on the animation direction on the film *Paulie:
A Parrots Tale.*

Tom also helped animate the title sequence of *City Slickers,*
the 1982 Emmy award–winning ABC special *Ziggy's Gift;*
directed 22 hours of Saturday morning television, including
Fat Albert, He Man and the Masters of the Universe, and
She-Ra, as well as numerous commercials. He just
completed Warner Bros. *Osmosis Jones,* co-directing
the animation with the Farrelly Brothers, directors of
Something About Mary, who were directing the live action
(Figure 50-2).

Figure 50-1 Tom Sito.

Figure 50-2 Animated characters from Warner Bros. Pictures' animated/live action comedy adventure, *Osmosis Jones*. Left to right: Drix, voiced by David Hyde Pierce; Tom Colonic, voiced by Ron Howard; The Chief, voiced by Joel Silver; Osmosis Jones, voiced by Chris Rock; Leah, voiced by Brandy Norwood; The Mayor, voiced by William Shatner; and Thrax, voiced by Laurence Fishburne. © 2001 Warner Bros.

Tom has produced short films, taught at the University of Southern California and California Institute of the Arts, and written numerous articles for *Animation Magazine* and Animation World Network's online magazine. He has lectured on animation at NYU, SVA, UCLA, AFI, Microsoft, Capilano College, Sheridan College in Canada, the Ecole Du Grand Gobelin in Paris, the Animar Festival in Palma Majorca, and the Yomiuri New Media Forum in Tokyo. He is completing his third term as president of the Motion Picture Screen Cartoonist's Union #839 and vice president of the International Animator's Society (ASIFA/Hollywood). He is a member of the Motion Picture Academy, the National Cartoonists Society and Hollywood Heritage. In 1998 he was named in *Animation Magazine*'s list of the 100 Most Important People in Animation.

MS: Give us an idea how you got started in animation and what moved you into directing?

TS: I'm kind of like an up-through-the-ranks type of guy. When I got out of college some of my first jobs were doing night-shifting in paint. Then I did inbetweening, and then assist. I was focusing on being an animator. I really wanted to be an animator, and then I became an animator. Then after a of couple years, I enjoyed stories so I moved to story. In fact, people always think that once you're in one category you're locked down, but you're not. You move within the system, and you try some other stuff. In fact, in the modern age, I think it's most important that you diversify your skill sense, that you try different things. Because different projects will have different demands.

I think I always liked working with story, and I've always liked working with people. One of the problems that hardly gets

addressed, in this kind of process, is that when you're directing, especially with a staff, you're like a general on a battlefield. And there are management skills involved because you are working with people. I was talking with Shamus Culhane, a mentor of mine, when I was first directing. I told him that with every job I had done in the business until then the responsibility was just me at the drawing boards and my drawings. I took responsibility for my art work. But when you direct or supervise, your performance is based on your ability to manipulate a dozen to several hundred people, just using your personality. You have no control. You don't have the pencil in your hand— it's their pencils, and they have to get done in time, and they have to do great stuff, but not divert to far from the main topic. You have to use your personality and basically not be a bastard.

Because the other problem is that there is a lot of turnaround in the business. On my story staff we had ex-studio heads and ex-directors. Banish the idea from your head that once you go in one direction you never fall back, because you probably will be doing story work or consulting on another film in the future. If you turn into a disciplinary martinet, one day you could be working for the person you were terrorizing. But on the other hand, you don't want to be a complete push-over and just let everyone do whatever they want, because then the film lacks focus. So it's a real balancing act, and requires a lot of people skills. More than you think.

MS: So what is the biggest differences between directing a small project and a feature like *Osmosis Jones* (Figure 50-3)?

Figure 50-3 The Chief, voiced by Joel Silver, and Osmosis Jones, voiced by Chris Rock. © 2001 Warner Bros.

TS: I think that with a smaller piece you're basically working with getting grants or getting funding from one particular source that's used to the idea that an independent filmmaker is going to have a very specific artistic vision. With large films, which are much more of a high-stakes gamble, there are a lot of cooks involved. A lot of people want to come in and play Walt Disney at your expense. They want to get their input in. So you want to make them feel like they're in power, but don't let them do too much damage. A friend used to say that Ralph Bakshi was always great in meetings in getting people to suggest things that he wanted to do all along, but he made it seem like it was their idea. He goes, "Oh yeah, of course!" In fact he was very good at that, in working the people in the meeting.

One problem with big films is that there's rarely even one producer any more. I mean Jeffrey Katzenberg is kind of a throwback to the David Selznick–Walt Disney school of the entrepreneurial producer who wants to be as creative as the filmmakers are. He wants to be very much hands on. Warner Bros. is the other way. They're like, "Here's the money. We've green lit the project. Let us know when the film is done." But when you're working in a mass market, you are subject to the pressures of the mass market—which includes pressure groups saying, "Are you being disrespectful to left-handed Vietnam veterans with AIDS?" Or whatever. We were working on one section of *Osmosis Jones* and then the Columbine shootings happened. A bunch of producers said, "Take all the guns out." So then *Monkey Bone* and *Titan A.E.* flopped, so they said, "We don't want this to be PG-13, we want it to be PG. Cut out all the curse words and go to heck, damn, and shucks, stuff like that"—which was pretty tough for the Farrellys and Chris Rock. But I've found that as a filmmaker as you work with the crew to get your vision through, you're also fending off the people above you who are worried about the project and assuring them that everything is OK. And again, this is no different than what Hitchcock or John Ford had to do; they had the same kind of pressures. In fact Hitchcock's famous quote, which always gives me a lot of comfort, was, "If we get even 50% of what we originally asked for, we'll still be ahead."

MS: So what do you think animation directors need to know?

TS: Well, I touched on people skills. I think the thing we learned on the Disney process in the 90s is to keep the process open and kinetic. When I started in the business, too many people would say, "Here is the script, and it's locked. Here's pre-production, and it's locked, and I don't care if there are plot holes you can drive a truck through, we don't have any more money for development. We're just going to go ahead and the animation is going to save it." Animation does not save anything. The look does not save anything. *Final Fantasy* is proof of that. I mean the audience is impressed by the look of the film for about a couple of minutes, and then they start watching the story. The beauty of a film like *Toy Story* is that halfway through the film you stop thinking, "I'm looking at a computer-generated image," and you want to know what happens to Woody and Buzz. That's superior storytelling. But if you cut quality, the audience will know. Not that they could put their finger on it. If you look at a film like *Raggedy Anne and Andy,* or a film like the first *Heavy Metal*, and you can see where they cut corners, it feels unsatisfying for some reason to the audience. Because *Raggedy Anne and Andy* started with these big complex scenes animated on 1s, and then at the end it looked like a Saturday morning cartoon because the budget had run out.

So you need to prioritize. What I would say is that, it's like you have a small army under you, and you have to achieve a goal. When I got to Warner's, we thought about what was called blitz screening tactics, like the German blitzkrieg— whenever they met resistance, they went around it. So I find a lot of times filmmakers lose their momentum, their inspiration, and stop dead fussing over a detail. We had a whole thing about Drix, his design, and work would stop because everyone was arguing over the design (Figure 50-4). What is the nature of Thrax as an illness—is he a flu virus or is he whatever? (Figure 50-5.) I kept pushing to go around, while this guy is fussing with that. Let's go past it, and we'll get back to it later. So don't let things impede your momentum; keep pushing forward. If something stalls, go past it and keep moving. Don't let anything come to a halt. The crew will fall into paralysis arguing over small details. You have to learn to prioritize important scenes. What always happens on these movies, like Piet [Kroon, co-director of *Osmosis Jones*] said, "There are really complex

Figure 50-4 Drix, voiced by David Hyde Pierce, and Osmosis Jones, voiced by Chris Rock. © 2001 Warner Bros.

Figure 50-5 Thrax, voiced by Laurence Fishburne, from *Osmosis Jones*. © 2001 Warner Bros.

and important shots that cost a lot of money and time. We have to go really fast at the end, but at the beginning of the production we spent six weeks with an alarm light that goes on and off." That's the kind of thing that you should have done in one day. You should of done it in half an hour, but instead it took six weeks. You have to prioritize what's not important. Don't get bogged down in details. Philosophically, I've had disagreements with a number of other directors. To me film is not details, film is moments. But it's not about the curl of the hair or the glint in the eye.

MS: You talked earlier about not being afraid to get rid of scenes that are not working.

TS: That's right. In the classic Disney process, even if a sequence is animated or storyboarded or even in color, if it's not working, you have to have no fear about throwing it out. Watching Robert Zemeckis working on *Who Framed Roger Rabbit?* he would throw out scenes in color and stuff, because he would say, "It's not funny. It's not in my movie." And it's painful, and it's frustrating, and you have to have a good bedside manor with the animator and tell him, "We

cut your scene, sorry." When you run a crew, you have dozens, if not hundreds, of creative people shoulder to shoulder who are all trying to work together and still maintain their integrity as artists. So you have a lot of forces pulling in many directions, and you want to make sure your vision goes through, again without being a complete psycho tyrant. But the thing is, the only work of art that counts is the can of film. Not this painting or that animated scene.

MS: What kind of experiences would be good for producers and directors? You said before that working up through the ranks and knowing story is important.

TS: I think the good thing about working up through the ranks is that you gain respect for everybody's position. Some folks come right out of college and get on a film and start directing. In the process of asserting their personal vision, they can be dismissive or condescending or disrespectful to the lower people. Those are the people that are really going to make your movie, and you want them to be as motivated as the artsy-fartsy top animator. You don't want to play elitism or factions, because the crew does take its hint from the person in charge. And if the director or the producer wants factions, then the studio will divide into factions against each other, and you want to set an example for them. I learned from Richard Williams and guys like Don Bluth and John Kricsfalusi, who are the same way—like the GI general. The director who is not afraid to roll up his sleeves and animate a scene or jump in there with the guys right along next to him. I would storyboard sequences, and we'd critique them just like anybody else's. So I think the crew respects that, and the crew likes to see that the director is one of us. That's one of the things about Walt Disney; in the end he was an artist like we were. He wasn't some guy from corporate who starches his drawers.

MS: Of all the different projects you've worked on over the years, what was your favorite project?

TS: *Osmosis Jones.* (See Figure 50-6.)

MS: It's great. In fact, a bunch of us were talking after seeing it about how—besides the style and look everything—it was a fun movie to watch. The flow between the live action and animation is the smoothest we've seen in a movie. You don't even notice it. It's just beautiful.

TS: That's wonderful to hear. We were very worried about that. We were worried the film was going to be schizophrenic, that you wouldn't get it. That you wouldn't really believe that you were going inside the body or outside. The first couple of preview screenings when everybody got it, it was such a weight off our shoulders. We agonized over these things, how to make the transitions slick. The film is all an illusion, and if you can see the technique then it's a failure. Tissa David, the great Hungarian animator, said, "If you're aware of the trick, like the animation is in a cycle, then it's a failure. If you're not aware of it, then it works." Like the famous dance cycle in *Charlie Brown's Christmas*. I think it's the most successful cycle in animation history. You can watch it for hours and never get bored. You just are watching it and watching it—and its been run every year since 1966—and you never get tired of it. It's so cool. So creating those kind of moments makes it worthwhile.

MS: Give us an anecdote about something that happened in *Osmosis Jones*, some funny moment.

TS: Piet and I would always be proud when we could out-gross the Farrelly brothers with something sicker. Because then we were like, "Wow, we did it!" At one point when Frank flat lines and you think he's dead, the doctor goes, "OK, that's it. I'm calling it." I originally rewrote the dialogue there and had Shane burst into tears, and the doctor goes, "That's it. I'm calling it." The way I wrote it, the doctors start going, "So what do you want to do for lunch?

Figure 50-7 Elena Franklin and Bill Murray in *Osmosis Jones*. © 2001 Warner Bros.

You want to do Chinese? Eh. I had Chinese the other day. You want pizza? Alright. I'll get pizza." I thought that was funny, and the Farrellys went, "No man. We have to go for emotions here. This is sad. We have to go for the high drama." And I went for the cheap laugh. They said "No, no," so they changed it back. But you know, it was fun.

Another thing that happened was in the opening sequence when Bill Murray was wrestling with the chimp. There were two male chimps, and as they would wrestle with Bill they would get uh . . . aroused, and so develop uh . . . let's say a little monkey-bone. Quite inappropriate for a PG film. We had to keep taking him into the trailer and read him baseball scores to calm him down. (See Figure 50-7.)

MS: You mean the monkey, not Bill Murray.

TS: No, not Bill Murray. The monkey. I guess he really liked Bill.

You try different jokes and you try gags to see what works. We always have the pressures from the studio censors. There are all these fears of Washington, because of Senator Joe Lieberman and his Hollywood-is-the-Devil Crusade, all the fuss for censorship and that Hollywood is out of control, blah blah. The general public might think that the major Hollywood studios are deaf to such entreaties, but the fact is they are very sensitive to public pressure and to what's being discussed in Washington. And the studios get especially anxious about anything that might be viewed by children. A

red flag goes up as soon as you say "children's programming." You can't argue with it. Many will debate free-expression versus censorship, but no one in his right mind will declare, "Yes, I'm for exploiting children!" Forget it. There's no defense. And despite all the animation Websites and fan club protestations about the adult audience for cartoons, most executives still consider animation to be primarily an entertainment for children. For example, at the end of the movie when Bill Murray's body is dying, the NNN News Anchors are panicking. At one point Dan Matter cries, "We're going to die! We're going to die!" and Piet Kroon wrote this hysterical line for Trudy. She coolly says: "When we come back, everyday kitchen implements that can improve your sex life." It's very funny. But a studio lawyer freaked, "You can't say that and keep it PG!" It's a joke. Come on, you hear worse stuff on TV nowadays on *The Simpsons* or *Will and Grace* during the "family hour." But they made us change it to, "Everyday household implements that can improve your golf swing." It's still not a bad line, but it's not as funny. It was a funnier line.

There's another piece of good advice for filmmakers. Trust your instinct. So many people are trained to ignore their instincts. I told you that line and you laughed; it works. Like Robert McKee says, you don't interpolate comedy, it's an instant judgement. If you laugh, it works. If you don't laugh, it doesn't work. I was at so many story meetings when we would bust everybody up, and they would say, "No, we can't do that. No. Can't do that," and somehow you justify not using it, which is foolish. I find that if you go with your gut, if it makes you laugh, then it's funny. Chuck Jones used to say the same thing: "If it made me laugh, it went into the picture." I think for some reason we overintellectualize. We overthink stuff. But for some reason people stop trusting their instincts. Your instinct is that if it's a funny joke, it works.

Another thing an old animator taught me was, "Never argue with a laugh. If you get a laugh, put it in. It works. Don't try to improve a laugh. Don't build a laugh, because you could beat it to death. It could get to 'it's not funny anymore.' You can overdo it." In *Osmosis* you'll see that it's a technique we did at Disney, which is that once you create a fantasy world, you layer in a lot of detail like a Rueben sandwich, because it makes people want to go back and look at it again and again. We've noticed in reviews that people have been saying, "I want to go back and see it again and see what I

Figure 50-8 *Osmosis Jones.*
© 2001 Warner Bros.

missed." And there are films like that. The second and third time you see it, you see more detail, and that's deliberate. That's what we did on *Beauty and the Beast*. We put in a lot of stuff because we knew people were going to come back and look at it over and over again. We hope that they'll do the same thing with *Osmosis Jones* (Figure 50-8).

Chapter 51

David Fine and Alison Snowden, Academy Award–Winning Producers of *Bob and Margaret*

Alison Snowden and David Fine have worked in London since 1989. They recently completed the 26th episode of their half-hour prime-time adult TV series, *Bob and Margaret*. The series is produced by Nelvana Limited and is based on their Oscar-winning short film *Bob's Birthday*. It is broadcast in America on the Comedy Central Network, in Canada on the Global Television Network, in the United Kingdom on Channel 4 and the Paramount Comedy Channel, and on other networks all over the world (Figures 51-1 and 51-2).

When he was 17 years old, David made a short animated film called *The Only Game in Town*. It was a plasticene animated film about a father and son relationship based around a poker game. He co-directed his film with the renowned documentary filmmaker Ron Mann, although this was before Ron was renowned. *The Only Game in Town* received a Canadian Academy Award nomination for best short film. David and Ron have also collaborated on other short films.

Alison Snowden, who is British, and David Fine, who is Canadian, both graduated from the National Film and Television School in Beaconsfield, England, in 1984, working in school in both live action and animation. Alison's short animated student film, *Second Class Mail* (1984), a film about mail-order love, won a number of international awards including best first film at Annecy and an Oscar nomination. At film school they worked alongside now-renowned animators Nick Park and Mark Baker.

After film school Alison and David moved to Canada, where they worked at the National Film Board. There they made *George and Rosemary* (1987), a short animated film about elderly romance. This film received an Oscar nomination, a Canadian Academy Award, first prize at the Zagreb Animation Festival, as well as a number of other awards. *In and Out* (1989), a wry film about life beyond the womb, won awards at the Berlin Film Festival, Athens, and a Canadian Academy Award nomination. Their work includes

Figure 51-1 Alison Snowden.

Figure 51-2 David Fine.

Figure 51-3 *Self Assessment.*
© David Fine and Alison Snowden.

a segment for the short erotic film *Pink Komkommer*, the script for the humorously macabre NFB (National Film Board of Canada) short animation *Deadly Deposits*, and various commercial works, including the award-winning Smarties Policeman ad and the current national U.K. campaign for the Inland Revenue featuring a tax inspector voiced by Sir Alec Guiness.

MS: David, you started working before you and Alison met. You did your first short while you were still in Canada, correct?

DF: Yeah, as a teenager I was making a lot of films— 16 mm, Super 8, all kinds of things. I did a couple of documentaries as well as animation.

MS: Were you focusing mostly on live action or animation at first?

DF: Both. I just liked filmmaking generally, and animation was a tool that allowed me to make a film on my own in my bedroom. It wasn't that I had this passion about animation, per se. I was more excited about filmmaking in general.

MS: I know that you co-directed *The Only Game in Town* and that you were nominated for a Canadian Academy Award. How did that affect your career?

DF: It did not have any sort of practical effects, like it suddenly led to this opportunity. But it was good for me

personally, because it was inspiring. It made me feel that this was a viable career because I seem to be having some success at it by way of this kind of nomination. So it helped me in that way.

MS: So the two of you ended up meeting in college in London.

DF: We went to the National Film School, just outside of London, and we met there.

MS: What drew both of you to that school?

DF: I was in Canada and wanted to go to a really good film school. At the time there were not fantastic film courses in Canada. There were some good ones, but I thought it would be interesting to do something outside of Toronto. So I looked at UCLA, and I looked at the Film School in London. UCLA was very crowded and very expensive. I thought it sounded like a zoo and very intimidating. I looked into the one in London, the National Film School, and it was much more specialized, and much smaller. It had much more equipment and a better budget allowance for students, so I applied for grants and thought it would be exciting to be in London. Alison, of course, was already English, so it didn't hold the same international interest.

MS: Alison, why did you decide to go there?

AS: I was studying for a degree of graphic design and wasn't really enjoying it, but you could choose to do some animations as one of the options, sort of on the side. I was really interested in that, the same as David. It was a form of filmmaking. I had always liked writing stories, and especially liked the writing aspect of it. This was a way of sort of making a cheap movie. Of course you didn't end up with any finished films and such, so I really wanted to go study film further. We didn't want to do animation. We put our names down as live-action directors, because we just really wanted to study live action. So we did that for three years, and then at the end we made an animated film. I actually think that was a really good idea, because we learned a lot more about animation filmmaking doing live action than we would have if we had just studied animation the whole time. We learned a lot about editing, timing, storyboarding, and everything, really. Just how to tell a story on film—which people have commented on, that our approach seems a bit

different than what people normally do when they only do animation.

MS: That's how I got started too, in live action. That's a really good point.

DF: Yeah, as Alison says, both of us were really interested in filmmaking and telling stories, and then using the medium to do that. A lot of animators come from a background of being really in love with the technique and the artistry, and then they think, "Oh no, what story can I tell using these pictures?"

AS: We were the opposite. We weren't trying to do nice pictures. We were more interested in the story. Another thing we learned was how to direct actors. Sometimes the voice tracks, can let down some animated films because the animators may know how to draw and how to animate, but they don't know how to direct actors. So I think live action was the best training we had for what we are doing.

MS: Well that's interesting, because now that I'm interviewing you, I have a feeling I recognize your voice.

AS: [Laughter] That's right. The actor we directed the most was me! For *Bob and Margaret*, anyway. It wasn't supposed to be me—we actually cast two different people in the main roles to start with. But we weren't really happy with them. We had a hard time finding a Margaret, because we would sort of describe her, and I suppose I was actually using her voice as I described her and what we wanted, but we could never get that sort of frailty. You know, a character that could really panic or seem a bit helpless. The nature of actors is that they are usually quite confident people. So they always sounded like they were acting being worried rather than actually being worried. We had a bit of a dilemma finding me as the lead. A friend of ours who is also an animation producer, Derek Lamb, suggested I do it. I thought I was game. We were so desperate at the time, I thought, "Yes! Goddammit, I'll have a go at it."

DF: I was a little resistant at the time because I thought, well, that's cheating—we need a "real" actress. But it really worked well, because Alison has this kind of naive quality about the performance, and it's not professional, and it comes out very naturalistic.

MS: It's such a strong character voice. It really works great with the character.

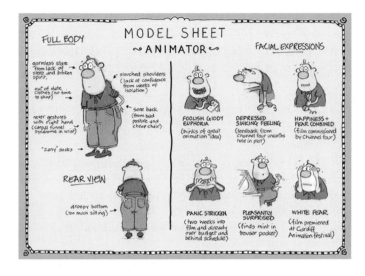

Figure 51-4 Model sheet of an animator by Alison Snowden. © Alison Snowden.

DF: Thanks, we thought it did as well. We were quite happy with it, and you know I have to say that I'm rather proud of Alison.

AS: The other good thing is that because we write the material, who could know it better how it should be delivered, really. We could write things knowing how I was going to perform it, which was good.

MS: Alison, was *Second Class Mail* your first student film, or just the one that got the most attention?

AS: It was my first complete student film. I experimented with animation in my graphics design course, but I never had much tuition, so I never came up with a finished film. We had a proper budget there at the National Film School, so yes, technically, that was my first completed film.

MS: And David, you worked on it as well?

DF: Yeah, I did. I co-wrote it with her, and helped her make it.

MS: What kind of animation was it, and did you work alone? What was your production process at school?

AS: In terms of the student film, we did everything. All the drawings, and all the rendering, coloring. You get the odd person to do a bit of the crayoning for you. I think we hired

someone just to do some crayoning, but basically we did all the animation. Particularly all the sound, because we wanted that to be a big feature of the film and the track. There is no dialogue, so we wanted it to be very particular with very exaggerated sounds for everything.

MS: Well, you had a lot of success with your first full piece since you got your first Academy Award nomination on that one.

AS: That's right. Obviously that's what led our way to stay in animation and working together. After that film, we got quite a lot of interest. The National Film Board contacted us to submit an idea to them, and that's how we got *George and Rosemary*. That was our next film, which is about an elderly couple.

MS: Was that kind of the launching for your animation company?

AS: No, not in that case, because at that point you go work for the National Film Board. Our company really arose with *Bob's Birthday*. We made that with Channel 4. They give you the whole budget, and then you form your own company and produce it yourself. So that is what really enabled us.

MS: Well, you two have obviously had a tremendous amount of success. Very few people have gotten as many Academy Award nominations for their animated shorts as you two have. What do you think separates your work from most other independents?

AS: I would say a bit of what we were talking about before. We come at it from a story writing point of view, more than just a visual sense.

DF: I think where we seem to have a lot of success is that we create characters and stories that touch people in a particular way, rather than it just being purely gag-based or visual. Although those things are there, we don't begin unless we have a story that we think means something to us—or have characters that mean something to us. So there is some real emotion and depth to the jokes. They have more resonance because they are about real things. And people seem to remark about that.

AS: Yeah, or at least the characters feel like they've got more depth. They are kind of sympathetic and irritated at the same time, because I don't really like characters that are just

outrageous and you don't really like. I'm not saying they never work, but for us, it would be hard to get under their skin in order to figure them out. We like a character that is usually some sort of underdog character, or a fairly sympathetic character.

MS: What led to the *Bob and Margaret* short and then to the subsequent series?

AS: The short film was really an idea that we submitted to Channel 4. They were the chief funder of short films at the time, so we submitted the idea for *Bob's Birthday*. They liked it, and we got to make the short. Then, because it was pretty successful, they were really happy with it. It was Channel 4's idea to make it into a series. They all wanted to embark into adult animation and turn it into a series, and they thought that this would be a good one to begin with. We found partners with Comedy Central and Global TV in Canada, so it was a co-production. That gave us a bigger budget and actually made it a much bigger series than was first intended. I think Channel 4 originally thought it would be more like 10-minute episodes or something, but it was made a much larger production because we were able to get other partners on board.

MS: Do you guys write all the episodes yourself, or how does the writing work on the series?

AS: In the first series I think we wrote about 12 [out of 13]—maybe even all of them. We'd split them up rather than write them together. We'd each come up with ideas and write them, and then sort of script edit each other. We were co-writing, but essentially each of us was sort of in charge of one story. If you came up with the original idea, then you were kind of the boss of that one. That was quite enjoyable. Then in the second series we couldn't keep up with it. We couldn't write the episodes and oversee the series the way we wanted to. So we had to get other writers on board, and that went quite well. We were script editors, and I think we had written a couple of episodes as well with other writers. And then by the fourth season we weren't writing any of them anymore. We were burnt out. [Laughter]

MS: Sounds like a lot of work to do.

AS: True. Actually, I wasn't allowed to write any more because it became a Canadian production. Only because of my British origin was I even allowed to do the voice. Then

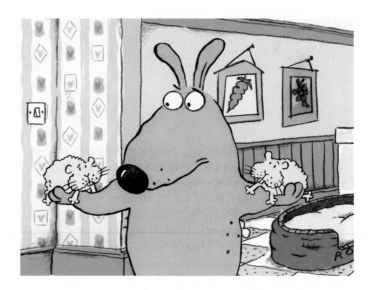

David wrote a couple of them, and we took more of the backseat. Once it moved to Canada, it all changed anyway.

MS: Is that series hand-painted, or is it digital now?

DF: It's digital painting, hand-animation, then composited in the computer.

MS: Is all the animation handled in Canada, or is all that taken overseas?

DF: All the animation and the layout is done overseas. The design packs and storyboards are done in Canada.

MS: Do you guys still do any of your own animation?

DF: No, we don't. Why bother?

AS: We don't do any on the series, which needs hundreds of people now. We would be just like a drop in the ocean. So that would be just like we were trying to show something.

MS: So how did you guys find the time to produce a series with a newborn baby around?

AS: Well, it was hard! [Laughs] It was hard because the minute she was put to bed, we were upstairs working until midnight. It was terrible, because babies wake up in the night all the time, so we were sort of sleepwalking through

most of it. But I think we had such an adrenaline rush because it was so exciting. We were scared.

MS: You described how you divide the work up on writing. How do you divide the work up on the rest of the show?

DF: Alison does pretty much all the character design work. Although, again on the series, there were people at the production company that assisted in that area in a big way. But in our individual filmmaking, Alison does that. I tended to do the voice direction, but even though I was doing it, Alison always had an opinion, and we were always consulting each other about it. And the same with the designs. Alison was doing it, but I'm looking at it and saying I think it should be a bit this and that, you know. So it's very collaborative, and in every other regard it's pretty 50-50.

AS: Yeah, I mean it's a big task with all the storyboards. I think Dave would take care of most of that, because we had the baby at that point and that's such a huge job [the baby].

DF: The storyboards for a show could be 400 pages, and it would take me a couple of days sometimes, depending on how many comments there were, to go through it in minute detail.

MS: So what about merchandising for *Bob and Margaret*? Do you have any kind of control over the quality or anything on those?

AS: I think we can influence it a little bit, but not a lot, really. It's not our responsibility, ultimately, because we sold the rights to the production company. I mean they send us things, and we make some comments, but that's it.

DF: But the thing is, we have the right to approve, and in theory we can say this isn't good or whatever. But you know, in the process you can only do that so long before people start to go, "You're being too picky." You just have to try and work with people who will get it, and then make small comments rather than fighting an uphill battle.

MS: So what do you think are the biggest differences between producing an independent piece and a TV series?

DF: Well the TV series is a hugely more collaborative process. I think for me the most exciting thing about a TV series is that you're dealing with a program that ultimately is seen by a much broader audience, and it becomes kind of

part of the mainstream, which is exciting. When you're dealing with a short, it's kind of a niche market. Having said that, certain films like *Bob's Birthday* did get quite a wide release. It had a theatrical release, and it's been shown on television a lot of times. We meet a lot of people who have seen it, and they are just "normal people."

AS: Another thing is that it took us like 2½ to 3 years to make a 10-minute film. You have to do it all by yourself because of the budget, and it's an awful long time to be on just one short idea. What was so exhilarating about the series is that we had 13 half hours that were being produced in a year. From a writing point of view, you could just explore all these different ideas so the characters really developed rather than just being one moment. That's on the plus side. I think if you only made series and you never made your own short film you might be frustrated, because you might want that control of being able to animate it and everything. But because we spent many years doing that, we sort of know what we can do, and we prefer to just get more stuff out, making it a little more accessible to everybody.

MS: How many episodes have been produced of *Bob and Margaret?*

AS: Fifty-two.

MS: I know when *Stressed Eric* came over from Britain, they made some voice changes so it would sell better in the United States. Did you guys make any changes for the U.S. market on *Bob and Margaret?*

AS: We didn't make any. We did have to put the obvious Canadian reference in there, I think, to satisfy Global TV, but nothing in terms of changing the content or any of the voices. We certainly were put under a lot of pressure to change them into Americans. It was what people seriously wanted us to do. They said, "Why can't we relocate them and make them into Americans?" But because the short had been so successful, we just didn't want to do that. We thought if we're going to do that we had better come up with a whole new series. But it's a series that Channel 4 wanted to make and we wanted to make, so we were pretty resolute about keeping them that way. It had been so popular in America anyway, the short film, that we believed that it would be fine.

MS: So what's your next project?

AS: Well, we've got some more series—hopefully one that we are moving forward with.

DF: We have a series called *Ricky Rockett*, which is a sort of an older kids show. He's a child movie star. That's a show we're talking about with Cartoon Network right now.

MS: Now is that something you were asked to come up with, or was that a pitch you came up with and started pitching around?

AS: It's an idea we've had for a long time. We had it when we first started just after we made *Bob's Birthday*. We were going to make it, but Channel 4 wanted us to make *Bob and Margaret*, so we put it aside. We just finished with *Bob and Margaret*, so now we've sort of come back to it.

MS: What do you put into one of your pitches?

AS: Well, a whole description of the series, the concept of it, and then character descriptions. Then I think we've got about six or eight outlines of episodes—and then, obviously, drawings of the characters.

DF: We're also working on a series with Aardman Animation.

MS: Is it going to be stop-motion?

DF: Yes, and it's based on the character Shawn the Sheep from *Close Shave*.

MS: Oh, great!

DF: You know the sheep character?

MS: Yes, I do.

DF: Well they [Aardman Animation] asked us to develop it and write it.

MS: Is their studio far from where you guys are based?

AS: A couple of hours, but we can do that from home. We're just writing it from here.

MS: Lately there has been a lot of talk about cel animation dying away because of the success of CG in features. What are your thoughts on that?

DF: I think that it's a popular issue right now because so many CG films have been successful, but I think that's [CG

success] going to continue to be the case, and traditional animation is going to be successful as well. But CG is just what's being used right now because people are very excited about the medium and the possibilities. There is a lot of energy being put into it, so I think that it will continue. But I don't think that anyone is worried that "Oh, will this be the death now for this type of technique," or whatever. At the end of the day it's about filmmaking and what's a good film and what's a good story and what are good characters.

AS: I think, though, that for movies CG does win out because movies are a whole different experience. You go to a cinema, and I think that the whole look of flat animation—even if it is amazingly drawn—doesn't capture the imagination quite as well. But the series is different. Tons of 2D animation has done really well in series because it's more like a cartoon strip animated. You're not expecting fantastic cinematography, you're just expecting a funny story.

MS: That's a really good point. I've never heard anyone describe it that way, and I think it's a really good point. So what advice do you two have for independents who are about to try and produce their own shorts.

AS: Well, things have changed from when we were trying to get money. We could just go to Channel 4, and they were great funders of short films. So that was always the thing to aim for. You could probably start with a council to grant small amounts, and then advance to trying to get our budget from Channel 4. I can't say I really know the route these days. There must be some alternative.

DF: I think the most important thing is to make films that you believe in and that come from your heart so that they have a truth and a dynamism. To me, one of the most inspiring animated films I've ever seen is *The Street* by Caroline Leaf [A 10-minute Canadian short, 1976, funded by the NFB. Produced from a short story by Mordecai Richler. Nominated for an Academy Award.], because it just opened up my eyes to the possibilities of animation in terms of it not being a Bugs Bunny cartoon, which I love as well. In terms of really being packed with emotion and drawn in not the most traditional animation style—a more stylized look—I just thought, gosh look what you can do with animation. It's like a painting that's come alive. It has a story that is really moving and funny and got me very

excited. More than anything else a lot of people will say, "I became an animator because I saw *Snow White*," or because of this or that Disney film. Those films I enjoyed immensely because of the entertainment value, but they really didn't get me going.

MS: One thing I see a lot of is that students try to produce their own piece, and they have very large plans, but they don't really understand how much time it takes to do the projects, so they try doing something that is far too long and that consequently never gets finished.

DF: Very true. But there is another side of the coin to that. A good friend of ours, whom we went to film school with, is Nick Park, and he started making *A Grand Day Out* at film school and did exactly what you said. He wrote a script, and he spent 4 or 5 years working on *A Grand Day Out*, and he realized that he'd only gotten about a quarter of the way through the story he intended to make. So somebody said, "What are you doing here?" The film school didn't afford animators the same sort of critique that they did live-action students, because they thought, "Oh, it's just cartoons. Isn't that delightful. Let them do their thing."

It was like he had spent all this time getting them [Wallace & Gromit] to the moon, and that was supposed to be the beginning of the story. The whole story was supposed to be what happened on the moon. Nick realized he had twenty minutes of film here and had been working on it for 5 years and only just got them to the moon. So he had to come up with a new kind of idea to finish the film off. So I guess that's a little anecdote to confirm what you're saying, really. What I'm saying is that that's a problem, and at least Nick managed to work with it and then have an incredibly successful career. It didn't kill him, but I think that would be a lesson that he would agree with.

MS: Yeah, but it's still 5 years of work.

So you guys have been able to take a short and turn it into a series. What advice would you have for those people who are negotiating a deal to turn one of their projects into a series?

DF: I think the most important thing would be to retain as much creative control as you can and make it really clear to

the people you are working with that that is how you intend to work. I think a lot of big companies are used to buying the rights to something and then letting them [the company] get on with it.

AS: Yeah, they just want your idea, and then they want you to move out of the picture.

DF: But you need to stay in the background so that they can pursue your production model, and you have to say it very up front—this is how we are going to work. We want to see everything, we want to have input in everything. It's an old tired story that everybody talks about, but it still has to be said, which is, the most successful shows are creator driven: *The Simpsons, King of the Hill*, all the really good stuff that you see has a strong creative source that controls it.

AS: Yeah, and the person with the idea is the person driving it. If you're just a hired director, you might be doing a good job, but it still doesn't feel like your baby. You know you're not going to put everything into it that you do when you know they're really your characters.

MS: Do you feel *Bob and Margaret* maintains the integrity that you originally designed?

DF: Yes.

AS: I think you're always going to lose something. I mean you're not going to get a 100% out of what you started with because you have to compromise. You know there is a time frame, and you've got to work with other people, and I think that you do have to give up some of that control. It's healthy to work as a team. You don't want to be so obsessed with it. It just won't happen if you treat it like that. No, we feel pretty happy with it. I think on the whole it gives off the same feel. I mean the short film has more detail in it because we were animating it ourselves and taking so much time over 10 minutes and noticing little details in the acting and moments and all that stuff that is hard to do anyway. But I think it captures quite a fair amount of that sort of thing.

MS: This one will make you think a little bit. What do you know now that you wish you had known when you started your professional careers?

DF: You're right. That's gonna make us think a little bit. . . . That Microsoft would take off. It was so stupid that we didn't buy anything.

AS: That animating on paper and then tracing onto cels is such a boring story, I don't even want to go into it. I think I must have spent years just scraping off paint and doing stuff that had nothing to do with being creative at all. It was just boring labor.

DF: But what would you have done if you had known that?

AS: I don't know. Just cried if I knew it was coming.

DF: I don't know, because I think that ultimately you have to go through certain things, and everything leads you places you didn't expect.

AS: I think we did sort of OK, anyway, despite our naivete. We were quite lucky when we made *Bob and Margaret*. It all happened so quickly that when we finished *Bob and Margaret* we just thought, "Oh, well, we'll get a series right away," and then, "Well, that's not how it happens." You've got to go pitch. We had the short film, so we already had a pilot, and we immediately had many people interested, whereas when you've got a new series you've got nothing. We thought, this is horrible, we were really lucky before, and we had never planned on it being made into a series, so we just made this short film not intending it to be a pilot at all. So I think we didn't know things, but we seemed to end up in the right place anyway, just by shear luck or coincidence or whatever.

MS: How long did it take between finishing *Bob's Birthday* and having the deal to go ahead with the series?

AS: Two or three years?

DF: Yeah, a long time. I think two years.

AS: It took a long time. Just making deals with people seemed to take forever. We had people interested fairly soon, but it just seemed like organizing the whole production took a long time.

MS: What were you doing in the meantime? Were you two producing commercials?

AS: I think we were writing scripts.

DF: And commercials.

AS: And commercials, yeah. That's right. We did lots of commercials, and Channel 4 gave us a development

budget, so we were actually writing quite a lot of scripts while we were waiting as well.

MS: Hopefully we won't have to wait too long for your next project. Thanks for your time.

Section G
Appendixes

Appendix 1
Forms*

There are so many elements of and software settings for an animated production that the only way to stay organized and communicate with other crew members is with the proper and consistent use of forms. The forms included here cover many aspects of production and may be copied from this book for your use. You may find the need to customize these forms for your own style of working or to work better with your software needs. New forms may be easily built in a spreadsheet program such as Microsoft Excel or Corel Quattro Pro, and storyboard forms can be easily built in CorelDraw and Adobe Illustrator.

There are a few different styles of storyboard forms. The styles with 3 panels per page are the basic forms most animation houses use. The 4:3 ration panels are for TV (Form 1) and the 16:9 ration panels are for film projects (Form 2). The sheet with 6 panels (Form 3) on it is often used for thumbnails to quickly layout a scene.

We use the Who and What Form (Form 4) to track who is animating, inbetweening, and cleaning up scenes on our projects. This is a quick glance form that will work on small projects.

We tape the Scene Approval Form (Form 5) to the inside of each scene folder. As the folder gets passed between artists and the production staff, all of the relevant information is listed and approved on this sheet. We tape the scene storyboards on the bottom of the form. If the animators revise their dope sheets, we write the date of the most recent version on the top left to ensure that everyone is working on the proper dope sheet. The animation levels section is used to layout the dope sheet levels.

The dope sheet can come in many flavors. Our dope sheet is made to easily number multiple sheets (Form 6). Each sheet has 50 frames on it. You will notice that every tenth frame starts with 0. We do this so that each sheet can be used for any sequence of numbers. The structure of the sheet also matches most animation softwares, making it very

*All forms mentioned in this appendix appear at the back of the book for ease of use.

clear and easy to use. The large box over each level is for naming the levels.

The Project Tracking Form (Form 7) is actually one wide form that we split onto two pages. We color in each box as that portion of the project is complete. This allows us to see at a glance where we are in production.

The Scene Form or Artist's Scene Form (Form 8) is taped to the inside of each scene folder. As each artist is handed a folder, this form, along with a dope sheet, gives them all the information they need to animate.

The Budget Form is 13 pages long (you will find this form in Chapter 12, Figure 12-1). When you fill in a budget, not every line needs to be used, but each line serves as a reminder of something you may not have included. The only way to improve your budgeting is to track actual costs through a project so that your next budget can be more accurate. The **Number** column is usually used if there is more than one episode in your project. If you had 5 animators working on 3 episodes at $1,500 each per week, you would put **5** under **Unit** and **3** under **Number** and **$1,500** under Amount. The **Estimate** column is the result of $3 \times 5 \times 1,500$ ($22,500). If you hired one animator at $1,400 and the other two at $1,600, the **Actual** would read $23,000.

The Budget Form in Chapter 12, "Budget," may be filled by hand, or you may build it in a spreadsheet program such as Microsoft Excel or Corel Quattro Pro and let the computer do all your calculating.

Appendix 2
Digital to Film Transfer Facilities and Film Recording Service Bureaus

ACME Digital Filmworks
Contact: Stephen Hagel
403-283-3950
Calgary, Alberta, Canada
steve@acmeworksdf.com
www.AcmeWorksDF.com
Specializes in animation.

CFI, Consolidated Film Industries
323-960-7444
Los Angeles, CA
www.cfi

Cinesite
323-468-4400
1017 N. Las Palmas Ave.
Los Angeles, CA 90038
www.cinesite.com

Digital Devoid
800-4Devoid
Miami, FL
www.DigitalDevoid.com

DFRFX Film Recording and Effects
Bob Durrenberger
858-578-3363
Mailing Address: (Online business only; no commercial office space)
10606 Camino Ruiz, Suite 8, #244
San Diego, CA 92126
www.dfrfx.com
Low-cost transfers from digital or tape to 35 mm.

Digital Image
Contact: David Donaldson
818-840-7100
2820 W. Olive Ave.
Burbank, CA 91505
Also in London and Singapore

Figure A2-1 Digital Devoid logo
on their Website.

Figure A2-2 DFRFX logo on their
Website.

DuArt Film and Video
212-757-4580
800-52 Du-Art
245 West 55th St.
New York, NY 10019
www.duart.com

Moving Images
212-953-6999
227 East 45th St.
New York, NY 10017

Sony Pictures High-Definition Center
310-244-7433
10202 W. Washington Blvd.
Capra Bldg., Suite 209
Culver City, CA 90232

Title House Digital
323-469-8171
www.TitleHouse.com

Upgrade Technology, Inc.
732-833-6782
11 Cleveland Court
Jackson, NJ 08527
www.UpgradeTech.com

WRS Motion Picture and Video Laboratory
310-559-9809
3767 Overland Ave., Suite 111
Los Angeles, CA 90034
Offers student discounts.

Appendix 3
Supplies

Animation Toolworks
877-625-6438
www.AnimationToolworks.com
The makers and distributors of the Video Lunchbox Sync for pencil testing and stop-motion animation.

Cartoon Carpentry
818-999-0357
www.CartoonCarpentry.com
Custom animation desks.

Cartoon Colour Company
800-523-3665
9024 Lindblade St.
Culver City, CA 90232-2584
www.cartooncolour.com
Catalogue and online supplier of animation supplies and books.

Cartoon Supplies
www.CartoonSupplies.com
Animation supplies and books.

Central Tool Co., Inc.
317-485-5275
461 E. Michigan St.
Fortville, IN 46040
www.CentralTool.com
High-quality aluminum animation disks and pencil holders.

Chromacolor International
403-250-5880
1410 28th St., NE
Calgary, Alberta, Canada T2A 7W6
www.chromacolor.com
Catalogue and online supplier of animation supplies and book.

Dick Blick
800-447-8192
www.DickBlick.com
Wide selection of art supplies.

Figure A3-1 Cartoon Colour catalogue.

Figure A3-2 Logo from Lightfoot Website.

Lightfoot Ltd.
909-693-5165
36125 Travis Ct.
Temecula, CA 92592
www.lightFootLtd.com
Animation supplies and books.

Pearl Art, Craft, and Graphic Discount Centers
800-221-6845
www.PearlPaint.com
Wide selection of art supplies.

Rocky Mountain Arts
877-205-8332
246 Steward Green SW, Suite 1853
Calgary, Alberta, Canada T3J 2C8.
www.vedaeyeland.com
Animation kits, manuals, and supplies.

Showbiz Books
www.ShowbizBooks.com.
They list 391 animation books.

Appendix 4
Software

Students and faculty members may purchase software at discounted academic prices from either the manufacturer or academic vendors. You will need to prove your academic status to get these rates, but the savings is often worth it.

The Web links below will lead you to the latest information on each of the software programs. Many of these sites also offer tutorials and FAQs.

ACADEMIC SOFTWARE VENDORS

Academic Software
1-800-466-4443
www.academicsoftware.com

Academic Superstore
1-800-817-2347
www.academicsuperstore.com

Adobe Educational Sales
www.adobe.com/education

Campus Tech
1-800-543-8188
www.campustech.com

CCV Software
1-800-843-5576
www.ccvsoftware.com

Creation Engine
1-800-431-8713
www.creationengine.com/

EDTECH Computer Products and Services
www.ccinet.com

Journey Education Marketing
1-800-874-9001
www.JourneyEd.com

Micro Master Software
1-800-543-8188
www.micromasteronline

School World Educational Software
1-800-657-1200
www.schoolworld.com

Figure A4-1 Journey Ed Website.

Figure A4-2 School World
Educational Software Website.

PAINT SOFTWARE

Adobe Photoshop
www.adobe.com
Compatibility: PC/Mac
Windows: 98/Me/NT4 Service Pack 6a/2000 SP2/XP +
Mac: 9.1, 9.2, Mac OS X +

Corel Photopaint
1-800-772-6735
www.corel.com
Compatibility: PC/Mac
Windows: 98/Me/NT/2000/XP +
Mac: 8.6–9.2, Mac OS X +

Procreate Painter
1-800-772-6735
www.procreate.com
Compatibility: PC/Mac
Windows: 98/Me/NT4/2000 +
Mac: 8.6 or higher

Figure A4-3 Adobe Photoshop.

Figure A4-4 Procreate Painter.

Figure A4-5 AXA.

INK AND PAINT SOFTWARE

AXA
www.axasoftware.com
Compatibility: PC
Windows: 2000 +
AXA is on the enclosed CD-ROM.

Digicel
www.digicelinc.com/
Compatibility: PC, Mac by 2003
Windows: 95/98/Me/2000/XP +
Digicel is on the enclosed CD-ROM.

Cambridge Animation Systems—Animo
www.animo.com/
Compatibility: PC/Mac
Windows: NT/2000 +
Mac: OS X +
Animo is included on the CD-ROM.

Crater Software's CTP
www.cratersoftware.com/home.html

Software 369

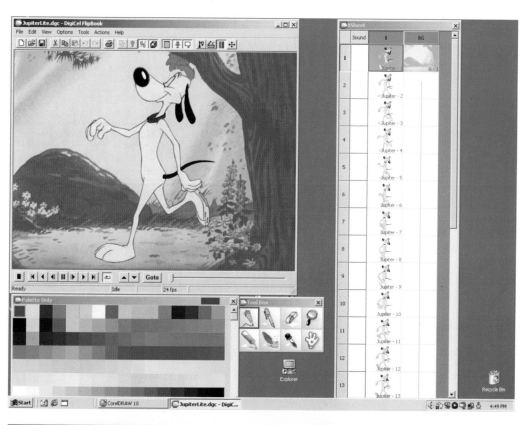

Figure A4-6 Digicel screen capture.

Figure A4-7 Animo.

Figure A4-8 CTP.

Figure A4-9 Pegs.

Compatibility: PC
Windows: 95/98/NT4 Service Pack 6a +

Macromedia FLASH
www.macromedia.com/software/flash/
Compatibility: PC/Mac
Windows: 98/Me/NT4/2000/XP +
Mac: 9.1 or higher, Mac OS X +

Pegs
www.mediapegs.com
Compatibility: PC
Windows: NT/2000 +

Toonboom
www.toonboom.com
Compatibility: PC/Mac
Windows: 98/Me/2000/XP +
Mac: OS X +

Toonz
www.divideo.it/
Compatibility: PC
Windows: NT/2000 +
IRIX: 6.5 +
Linux

Figure A4-11 Toonz screen capture.

US Animation
www.usanimation.com
Compatibility: PC
Windows: NT/2000 +
Linux: Red Hat 7.0/7.2 +
IRIX: 6.5 +

COMPOSITING SOFTWARE

Adobe After Effects
www.adobe.com/products/aftereffects/main.html
Compatibility: PC/Mac
Windows: 98/Me/2000/XP +
Mac: 9.1, 9.2.1 or Mac OS X +

Figure A4-12 Adobe After Effects.

Aura
www.newtek.com/products/aura/index.html
Compatibility: PC
Windows: NT/2000 +

Boris Red
Compatibility: PC/Mac
Windows: All +
Mac: 9.x or Mac OS X

Combustion
www.discreet.com/products/combustion/
Compatibility: PC/Mac
Windows: NT/2000 +
Mac: 9.x or Mac OS X +

Commotion/ Commotion Pro
www.pinnaclesys.com/
Compatibility: PC/Mac
Windows: 98/NT 4 Service Pack 6/2000 +
Mac: 8.6–9.2 +/Mac OS X +
Commotion Pro is on the enclosed CD-ROM.

Digital Fusion
www.eyeonline.com/
Compatibility: PC
Windows: 2000 +

Figure A4-13 Boris Red.

Figure A4-14 Commotion Pro.

Figure A4-15 Adobe Premiere.

Shake
www.nothingreal.com
Compatibility: PC/Mac
Windows: NT4/2000 +
Mac: by 2003

EDITING SOFTWARE

Adobe Premiere
www.adobe.com/products/premiere/
Compatibility: PC/Mac
Windows: 98/Me/2000/NT4 Service Pack 6/XP +
Mac: 9.x or Mac OS X +

Edit
www.discreet.com/products/edit/
Compatibility: PC
Windows: 2000 +

Final Cut Pro
www.apple.com/finalcutpro/
Compatibility: Mac
Mac: 9.2.2 or Mac OS X +

Speed Razor
www.in_sync.com/public_website/index.cfm
Compatibility: PC
Windows: 2000/NT4 +

Vegas Video
www.sonicfoundry.com/products/
Compatibility: PC
Windows: 98SE/Me/2000/XP +

AUDIO SOFTWARE

Acid
www.sonicfoundry.com/products/
Compatibility: PC
Windows: 98SE/Me/2000/XP +
Music looping and composition.

Cool Edit Pro
www.syntrillium.com/cep/
Compatibility: PC
Windows: 95/98/Me/NT/2000/XP +
Multitrack audio editing.

Magpie/ Magpie Pro
www.thirdwishsoftware.com
Compatibility: PC/Mac
Windows: 95/98/Me/NT/2000 +
Mac: 8.1 +

Figure A4-17 Vegas Video.

Lip sync software for 2D and 3D applications. The PC Magpie demo and the Mac Magpie Pro demo are on the enclosed CD-ROM.

ProTools
www.digidesign.com/
Compatibility: PC/Mac
Windows: 98/Me/2000 +
Mac: 9.x +
Multitrack audio editing.

Smart Sound/Smart Sound Sonic Fire Pro
www.sonicdesktop.com/
Compatibility: PC/Mac
Windows: 95/98/Me/2000/NT4/XP +
Mac: 9.x or Mac OS X +
Semi-custom music composition.

Figure A4-18 Smart Sound Sonic Fire Pro.

Sound Forge
www.sonicfoundry.com/products/
Compatibility: PC
Windows: 98SE/Me/2000/XP +
Audio recording and editing.

MISCELLANEOUS PROGRAMS

A Better Finder Rename
www.publicspace.net
Compatibility: Mac
Mac: 9.x or Mac OS X +
A file-renaming shareware for Apple Macintosh systems.

Quick Rename
www.kindreds.net/quickrename/
Compatibility: Mac
Mac: 7.5–9.x or Mac OS X +
A Macintosh file-renaming software.

Rename It
fileutil.tripod.com/zipfiles/rname_it.zip

Figure A4-19 Sound Forge.

Figure A4-20 Rename It.

Compatibility: PC
Windows: 95/98/NT4 +
A PC file-renaming freeware. Rename It is on the enclosed
CD-ROM.

RenameWiz
www.renamewiz.com
Compatibility: PC
Windows: 95/98/Me/2000/NT4/XP +
A PC file-renaming software.

1−4a Rename
www.1_4a.com/rename/
Compatibility: PC
Windows: 95/98/Me/2000/NT4/XP +
A PC file-renaming freeware.

Appendix 5
Books

At A&S Animation, we are constantly referring to books for inspiration and information. Following is a short list to help get your library started. *The Art of . . .* books by many publishers. Inspirational art and design of most of the big-budget animated features that come out each year. They showcase conceptual art, designs, storyboards, and more.

Acting for Animators by Ed Hooks, published by Heinemann Drama, 2001. Animating is acting. Discusses ways animators can enhance the acting of their characters.

Aladdin: *The Making of an Animated Film* by John Culhane, published by Hyperion, 1993. Shows the development and production art of the feature film.

Alexeieff: Itinééraire d'un Maîître/Itinerary of a Master, edited by Giannalberto Bendazzi, published by Dreamland in conjunction with the Annecy Festival. Anthology of articles on Alexandre Alexeieff by various international authors. Softcover, 318 pages, bilingual in French and English, black-and-white illustrations with 16 color pages.

Animals in Motion and *The Human Figure in Motion* by Eadweard Muybridge, published by Dover, 1957 and 1955, respectively. Wonderful collections of sequential photos of people and animals in motion against a grid background. The best visual reference you can have to determine how a person or animal moves when walking, jumping, running, etc.

Animating the Looney Tunes Way by Tony Cervone, published by Foster Books, 2000. Includes model sheets of the Warner Bros. characters.

The Animation Book by Kit Laybourne, published by Crown Publishers, 1998. A great book that introduces the different styles of animation to readers. Laybourne also covers the theory of motion, art materials, and step-by-step samples of many different animation techniques.

Animation from Script to Screen by Shamus Culhane, 1990. A classic book about animation. There is no recent technology in this book; it goes over the old painted cel and film process of animation.

Animation Magic by Don Hahn, published by Disney Press, 1996. A quick review of producing animated films the Disney way using examples from many of their silver age features, from *The Little Mermaid* to *The Lion King*.

The Animator's Survival Kit by Richard Williams, the director of *Who Framed Roger Rabbit?*, published by Faber and Faber, 2001. A new classic. Simply the best instructional book on the principles, methods, and formulas for animating ever written. It is very easy to read with incredible examples. Extremely inspiring.

The Art of Animal Drawing by Ken Hultgren, published by Dover, 1993. Great examples of construction, action analysis, and caricature of animals.

The Art of Walt Disney by Christopher Finch, published by Harry N. Abrams, Inc., 1983. This book covers not only the animation art of the early Disney features, but also the techniques employed and the art and design of the early theme parks.

Batman Animated by Paul Dini and Chip Kidd, published by HarperCollins, 1998. Mostly a book for fans of the 1990s animated series. Beautiful art and great stories. Of the books on animation, it has one of the best layouts.

Bridgman's Complete Guide to Drawing from Life by George Bridgman, published by Wings Books, 1992. The bible for breaking the human form into elements for rendering. The book covers bone structure, muscle structure, mass, turning, and draping. Includes more than 1,000 illustrations of the human form.

Cartoon Animation by Preston Blair, published by Walter Foster Publishing, Inc., 1994. This is a great book showing how to illustrate animation and make characters move properly. Many great illustrations.

Cartoon Capers: The History of Canadian Animators by Karen Mazurkewich, published by McArthur and Company, 2000. Softcover, 308 pages, hundreds of black-and-white illustrations and photos, and 16 color pages of stills and cels from Canadian cartoons. In-depth coverage of Canadian animators chronologically, geographically, by topics, and by individual animators.

Chicken Run: *Hatching the Movie* by Brian Sibley, published by Abrams, 2000. Hardcover, 191 pages, 620 illustrations,

430 in full color. Detailed description of the making of the claymation movie.

Chuck Amuck by Chuck Jones, published by Farrar Straus Giroux, 1989. A fascinating history of the famous animator with lots of great photos and art.

Creating 3D Animation by Peter Lord and Brian Sibley, published by Abrams, 1998. Shows the process of stop motion and claymation.

Disney Animation: The Illusion of Life by Frank Thomas and Ollie Johnston, published by Abbeville Press, 1984. Considered by many to be the first bible of animation. The animation masters discuss the principles of animation, how they did it, the use of references, developing story, developing characters, and acting.

Film Directing, Shot by Shot by Steven Katz, published by Michael Weiss Productions, 1991. Written for live action production, but every aspect of storytelling is applicable to animation. Everything from visualizing a story, to camera moves, to framing and composition is covered.

Guide to Computer Animation by Marcia Kuperberg, published by Focal Press, 2002. Covers a wide range of different areas of animation: 2D, 3D, Gaming, and Web/multimedia. Includes tutorials and self-tests.

The Hand Behind the Mouse by Leslie Iwerks and John Kenworthy, with an introduction by Leonard Maltin, published by Disney Editions, 2001. Hardcover, 264 pages, 16 pages of black-and-white photographs. Though Ub Iwerks is most famous for his role in creating Mickey Mouse, his greatest talent was probably not as an animator. While working as a film engineer for the Disney Studio for three decades, Ub probably came closest at the Disney Studio to wearing the mantle of "genius" for a string of innovations and inventions that contributed as much to Hollywood magic as any shadow cast by a mouse.

Hayao Miyazaki: Master of Japanese Animation by Helen McCarthy, published by Stone Bridge Press, 1999. Softcover, 239 pages, with black-and-white illustrations and 8 pages of color inserts. A small biography that is mainly a breakdown of all his animation movies by origins, art, and technique, as well as the characters, the story, and commentary.

Hollywood Cartoons: American Animation in Its Golden Age by Michael Barrier, published by Oxford University Press, 1999. Hardcover, 648 pages, some black-and-white illustrations. The history of Hollywood animation through over 200 interviews.

How to Draw Animation by Christopher Hart, published by Watson Guptill, 1997. Shows a very cartoony approach to character design. Can be great for inspiration for that style of character design. Hart nicely describes the physical attributes that make up different types of characters.

How to Write for Animation by Jeffrey Scott, published by Overlook Press, 2002. Practical and insider information on writing for animation series by this three-time Emmy-winning writer.

My Life As a 10-Year-Old Boy by Nancy Cartwright, with a foreword by Dan Castellaneta, published by Bloomsbury Publishing, 2000. Hardcover, 271 pages, 16 pages of black-and-white photographs. The inspired casting of the voice artists on *The Simpsons* has been an enormous contribution to that show's success. It made bona fide celebrities out of the entire unseen cast to a degree that is unparalleled in television animation.

Paper Dreams: The Art and Artists of Disney Storyboards by John Canemaker, published by Hyperion, 1999. Over 70 years of Disney storyboards and stories.

Producing Animation by Catherine Winder and Zahra Dowlatabadi, published by Focal Press, 2001. Deals with the production structure of large features and TV series. Very in-depth treatment and extremely helpful for setting up a large animation production.

Secrets of Clay Animation Revealed by Marc Spess, published by MinuteMan Press, 2001. The best book around detailing how to work with and animate clay. It's available in softcover and as an e-book at www.AnimateClay.com.

Space Jammin': Michael and Bugs Hit the Big Screen by Charles Carney and Gina Misiroglu, published by Rutledge Hill Press, 1996. Thoroughly covers, with text, art, and photos, the development and production of the feature *Space Jam*, which mixed live action and cel animation.

Figure A5-1 *Producing Animation* by Catherine Winder and Zahra Dowlatabadi, published by Focal Press, 2001.

Storyboards: Motion in Art, 2nd Edition by Mark Simon, published by Focal Press, 2000. My book on storyboarding, which covers every aspect of storyboarding for animation and live action. The book covers both the business and the art of storyboarding, with hundreds of examples and lots of interviews and practical advice.

Timing for Animation by Harold Whitaker and John Halas, published by Focal Press, 2001. Thorough explanations of proper spacing between animation drawings and how to get

Figure A5-2 *Storyboards: Motion in Art, 2nd Edition* by Mark Simon, published by Focal Press, 2000.

the maximum dramatic effect. The authors cover how to estimate timings, how to mark them down, and how timings affect the look of your animation.

Too Funny for Words: Disney's Greatest Sight Gags by Frank Thomas and Ollie Johnston, published by Abbeville Press, 1987. Some commentary, but mostly richly illustrated examples of sight gags. Includes finished art, storyboards, and rough animation.

Treasures of Disney Art by John Cane Maker and Robert Abrams, published by Abbeville Press, 1982. A large and wonderful book on the great art of early Disney animated features.

Figure A5-3 *Timing for Animation* by Harold Whitaker and John Halas, published by Focal Press, 2001.

Walt Disney's Nine Old Men and the Art of Animation by John Canemaker, published by Hyperion, 2001. Hardcover, 310 pages, richly illustrated throughout, including photographs and animation artwork. Thorough history of the early Disney studio years.

Appendix 6
Periodicals

It is important to stay current with trends and business related to animation. Many of these periodicals appear online and in print. Special animation issues of *Hollywood Reporter*, *Daily Variety*, *Markee*, *Post*, and other general entertainment industry magazines include many advertisements and articles relevant to our industry.

Animation Blast
www.AnimationBlast.com
Unfiltered animation news and commentary. They do not regurgitate studio press releases. The focus is on the animation artists and their art.

Animation Books
www.Animation-books.com
A site for animators, enthusiasts, and writers, bringing attention to noteworthy stuff in print.

Animation Journal
www.AnimationJournal.com
Animation Journal is the only peer-reviewed scholarly journal devoted to animation history and theory. Its content reflects the diversity of animation's production techniques and national origins.

Animation Magazine
www.animationmagazine.net
The main printed monthly periodical on animation. It also has a daily e-mail newsletter.

Animation Meat
www.animationmeat.com
Incredible Website with true animation techniques, tips, and knowledge gathered from numerous sources.

Animation World Network
www.awn.com
An online magazine with a daily e-mail newsletter and a huge database of animation schools and festivals. Each month it offers a downloadable PDF file of the magazine.

Figure A6-1 *Animation Magazine.*

Anime in America
www.imbriaart.com/AIA/anime.html
A magazine written by anime fans for anime fans.

@anime
www.atanime.com/
An online magazine dealing with anime and manga
(Japanese animation and comics).

ASIFA (International Association of Animators) Website
asifa.net/
This site is updated monthly with news from members. The
Association was founded in the firm belief that the art of
animation can be enriched and greatly developed through
close international cooperation and the free exchange of
ideas, experience, and information between all who are
concerned with animation.

Sunday, June 02, 2002 Search [Articles ▼] [] [GO]

ANIMATION WORLD
MAGAZINE
Page One

SECTIONS
People
Profiles
Reviews
Tutorials

SPECIAL FEATURES
Gaming
Production
Technology
Voice Acting

COLUMNS
Editor's Notebook
Dr. Toon
The Animation Pimp
Producing Animation
Career Coach
Vilppu's How To
Anime Reviews

ACROBAT VERSION
Current Acrobat Issue
Back Issues

FIND
Articles by Date
AWN Media Kit
Contact AWN

ALSO ON AWN.com
AWN Home
Headline News
Career Connections
Student Corner
School Database
AWN Store
Animation Showcase
Web Animation Guide

Animation World Magazine: Page One

Animatin' in Adawe
By Chris J. Robinson
From studios to independents to schools, Chris Robinson details the animation scene in Ottawa, from its humble, scientific beginnings to its current bubbling state. [May 31, 2002]

New from Japan: Anime Film Reviews
By Fred Patten
Fred Patten reviews the latest anime releases including *Astro Boy, Devil Hunter Yohko: The Complete Collection, I'm Gonna Be An Angel, Love Hina* and *Macross Plus Movie Edition.* [May 31, 2002]

Spirit: A Longshot Or A Sure Bet?
By J. Paul Peszko
J. Paul Peszko looks at the risks that DreamWorks conquered by bringing *Spirit* to the screen. [May 23, 2002]

How to Draw Animation: Pushing an Expression
By Christopher Hart
Christopher Hart starts a series of six tips on how to bring animated characters to life. [May 29, 2002]

Waking Life and Liquid Caricature
By Chris Lanier
Chris Lanier explores the purpose and meaning of caricature from its very inception to its latest use in the "rotoscoped" *Waking Life.* [May 24, 2002]

Other Top Stories

DVD Review: Waking Life
By Chris Lanier
Chris Lanier reviews the new *Waking Life* DVD. If you liked the film, or haven't seen it yet, this DVD is the way to go. Extra audio tracks, missing scenes, technology demonstrations, the short film *Snack and Drink* and more, are all included. [May 24, 2002]

Between Business and Pleasure: A Preview of Annecy '02

DRAW! Magazine
www.actionplanet.com/front/draw.html
It's a how-to art magazine with demonstrations from some of the top pros in comics and animation.

kidscreen Magazine
www.brunico.com
A children's entertainment magazine.

Figure A6-2 *Animation World Network* online magazine.

Appendix 7
Animation Schools

A complete list of animation schools is far too big to print here. There are two great online sources that are constantly updated. These lists showcase both 2D and 3D schools from all over the world (Figure A7-1).

If you are having trouble deciding where to go to school, you can try two things. One, contact a couple of studios you would like to work at and ask them where they scout for new talent. This tells you where some of the best teaching is as well as where you are more likely to be seen. Two, ask some industry professionals about the schools you are thinking about.

Once you've asked those questions, Dan Sarto of Animation World Network suggests you do three things to pick the right school:

1. Determine your interests and future goals. What type of animation do you want to do? Do you want to work at a big studio or at a gaming company? Do you want to do traditional or CG animation?

2. Are you looking for "training" or "an education"? Training programs teach you specific skills or software applications and may only take a few days or weeks. An education delves deep into theory, related fields of study, and offers a much more thorough understanding of animation. I would also add to this list the importance of understanding the business as well as the art of animation. A thorough understanding of business is not taught at most art schools. Although animation is fun, it is also a business.

3. Get your hands dirty. You need to do your research. What software do the schools teach? Who are the teachers? What is the curriculum like? Visit the schools and see what you think. Talk to the students. Talk to ex-students— graduates and those who left early. Talk to studios. Find out as much information as you can to make the right decision for your career.

ONLINE ANIMATION SCHOOL LISTS

Animation World Network
www.AWN.com

Figure A7-1 AWN (Animation World Network) online list of animation schools: www.AWN.com.

Animation Magazine Online
www.AnimationMagazine.net

PRINTED ANIMATION SCHOOL LIST

Animation Industry Directory
Animation Magazine
30101 Agoura Court, Suite 110
Agoura Hills, CA 91301-4301
Animagedit@aol.com
A yearly directory of schools, production companies, festivals, licensing companies, and more published by *Animation Magazine*.

ANIMATION EVENTS

Certain animation events, such as the Animation Celebration and SIGGRAPH (computer graphics interactive techniques organization), have animation schools as exhibitors. You can not only see what the schools have to offer, but also you can often show your portfolios to the schools.

Annecy
www.annecy.org
The top-ranking competitive festival entirely dedicated to animation. Yearly festival in June in Annecy, France.

MIFA
International animated film market. Runs concurrent with Annecy, also in Annecy, France.

SIGGRAPH
www.siggraph.org
Yearly conference each fall.

World Animation Celebration (WAC)
Tel: 818-575-9615
Fax: 818-575-9620
30101 Agoura Court, Suite 110
Agoura Hills, CA 91301
www.WACfest.com
Sponsored by *Variety* and *Animation Magazine*.

Appendix 8
CD Contents

The enclosed CD-ROM has demo software and PDF descriptive files of many of the products mentioned in this text. It also has movie files of *Timmy's Lessons in Nature*, Lesson 3, which is profiled in this book. The movie files consist of the first animatic with storyboards, the second animatic with some rough animation, and the final special edition of the completed short.

We produced a custom version of Lesson 3 for this book. We added a scene in which the fox speaks one line, so that we could discuss breaking down the dialogue and working with phonemes. This version of the short may only be found in this book.

There are also demo rotoscope live-action files, rotoscope animation, and a sample of how to animate smoke—with each step of the process demonstrated according to the steps outlined in Chapter 6, "Tricks of the Trade." For a complete overview of the file structure for the CD-ROM, see Figure A8-1.

The video files are .mov files and are set at 320 × 240 running at 15 fps. They should play fine from the CD, but they will definitely play better if you copy them to a fast hard drive.

SAMPLE MOVIES

- Lesson 3, animatic of storyboards.
- Lesson 3, animatic with rough animation.
- Rough animation of Timmy running.
- Lesson 3, final special edition animation.
- Smoke animation example from Chapter 6, "Tricks of the Trade." Each step of the animation is presented twice along with a final composite. This animation runs at 30 fps to allow you to review the animation frame by frame. It will run better if you copy it to your hard drive.
- Scene 4, sample lip sync Magpie video.avi. The video of an animated mouth built by Magpie.

ROTOSCOPING

- Video footage to rotoscope.

Figure A8-1 File structure of the enclosed CD-ROM.

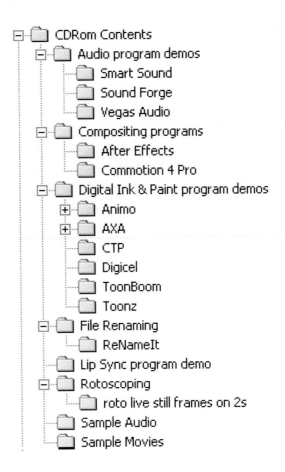

- Video footage exported to sequential files to print out for rotoscoping.

- Rotoscoped animation example.

SAMPLE AUDIO

- Scene 6, Fox audio.wav.

- The fox dialogue for Lesson 3.

DEMO PROGRAMS

Digital Ink and Paint

- Digicel.

- AXA—Review the Axa.hlp file for installation instructions and how to run the software.

- CTP, with a sample scene.

- Animo, with a sample scene.

- Toonz brochure in PDF format.

- Toonboom brochure in PDF format.

Compositing

- Commotion Pro working demo.

- Adobe After Effects. An overview PDF file and a link to the Adobe site to download the latest demo.

Audio

- Sound Forge.

- Vegas Audio.

- Smart Sound.

Lip Syncing

- Magpie with a demo from this book.

File Renaming

- Rename It (freeware).

Appendix 9
Patronage and Credits

PATRONAGE

I hope you have enjoyed my book. Everyone involved with it has worked very hard to make this book as comprehensive as possible. We would all appreciate your patronage. Contact information for all the software vendors are listed in Appendix 4, "Software." There was no better place within the text for contact information on these last two companies, one of which is mine, so they are included here.

A&S Animation, Inc.
Contact: Mark Simon
407-370-2673
www.FunnyToons.tv
Animation development and production

Sound"O"Rama
Contact: K. C. Ladnier
407-903-1111
www.SoundORama.com
Original music composition and sound design.

CREDITS

• All *Timmy's Lessons in Nature* images, © 2001 A&S Animation, Inc. All Rights Reserved.

• The Cartoon Network Logo, *Dexter's Laboratory, Ed, Edd, and Eddy, Samurai Jack, Courage the Cowardly Dog, The Powerpuff Girls*, and all related characters and elements are trademarks of Cartoon Network © 2002. An AOL Time Warner Company. All Rights Reserved. (Except for the photo of Linda Simensky. I'm pretty sure she still owns her own likeness. I think so, anyway.)

• All logos and box images of the products displayed within this text are copyright and/or trademarked to the parent company of those products.

• *Rugrats, Wild Thornberrys*, and *Rocket Power* images © 2002 Viacom International Inc. All Rights Reserved.

• *Bedlam* and *Hector* images © Alison Snowden and David Fine. All Rights Reserved.

• Spike & Mike logos and *Hut Sluts* © Mellow Manor Productions. All Rights Reserved.

Index

Form 1 Storyboard Form for TV Production.

Project:

Form 2
Storyboard
Form for Film
Production.

Page:

Project:

Form 3 Storyboard Form for Thumbnails.

Date

Project_____

Artist	Scene #	Scene Description	Keys	Inbetweens	Clean-ups
		Total			

Form 4 Who and What Form.

Scene Approval Form

Production:	Scene:	Footage/ Frames:	Dope Sheet Dates:

Name	Approved	Date		Character(s):		
Layout Deadline						
Background Deadline						
Animator Deadline						
Inbetweens Deadline						
Clean-up Deadline				**Notes**		
Effects Animator Deadline						
Effects Clean-up Deadline						
Animation Checker Deadline						
Color Model Deadline						
Final Scan Deadline				**Animation Levels**		
Ink & Paint Deadline				1		
Composite Deadline				2		
				3		
				4		
Deadline				5		
				6		
Deadline				7		
				8		
				9		

Boards

A&S Animation - Scene Approval

Form 5 Scene Approval Form.

SHOW:

SCENE	TITLE					CLIENT				SHEET	
										Dates/Revisions	

FRAME	DIALOGUE	7	6	5	4	3	2	1	B/G	CAMERA INSTRUCTIONS
1										
2										
3										
4										
5										
6										
7										
8										
9										
0										
1										
2										
3										
4										
5										
6										
7										
8										
9										
0										
1										
2										
3										
4										
5										
6										
7										
8										
9										
0										
1										
2										
3										
4										
5										
6										
7										
8										
9										
0										
1										
2										
3										
4										
5										
6										
7										
8										
9										
0										

A&S Animation, Inc Dope Sheet

Form 6 Dope Sheet.

Project Tracking Form

Project: Date:

Scenes	Description	Scene Length	Total Time	Script	Char Design	Boards	Audio Rec	Audio Edit	Animatic	Revised Boards	Queue's	Key Anim.	Inbetweens	FX	Clean-up	CG	BG Layouts	BG Final	Scans	Ink & Paint	Revisions	Layer Comps	Composite FX	Sc Comps	SFX	Editing	Music	Final Comp

Form 7 Project Tracking Form.

Artist's Scene Form

assigned _____
deadline _____

Project _____

Artist _____

Scene _____ Sc. Length _____

Frames/Cels _____

BG _____

Character(s) _____

Notes:

Storyboards: